it's a BIRD
it's a PLANE
it's

Tasha Shepard Ext. Metropolis - Day 407-0
Final

RMAN

THE COMPLETE HISTORY
THE LIFE AND TIMES OF THE MAN OF STEEL
by LES DANIELS

in

COLOR

Art Direction and Design by CHIP KIDD

CHRONICLE BOOKS
San Francisco

Photographs by GEOFF SPEAR

Design assistance by Chin-Yee Lai

Copyright © 1998 by DC Comics

SUPERMAN CREATED BY JERRY SIEGEL AND JOE SHUSTER

Library of Congress Cataloging-in-Publication Data

Daniels, Les, 1943–
 Superman: the complete history / by Les Daniels.
 p. cm.
 ISBN 0-8118-2162-5
 1. Superman (Fiction character) in mass media. I. Title.
P09.S94D36 1998 98-5836
700'.451–dc21 CIP

Printed in Hong Kong

Distributed in Canada by Raincoast Books
8680 Cambie Street
Vancouver, British Columbia V6P 6M9

10 9 8 7 6 5 4 3 2

Chronicle Books
85 Second Street
San Francisco, California 94105

www.chroniclebooks.com

Visit DC Comics online at keyword DCComics on America Online or at http://www.dccomics.com

Opposite: The original costume worn by George Reeves on the black-and-white episodes of *The Adventures of Superman*.

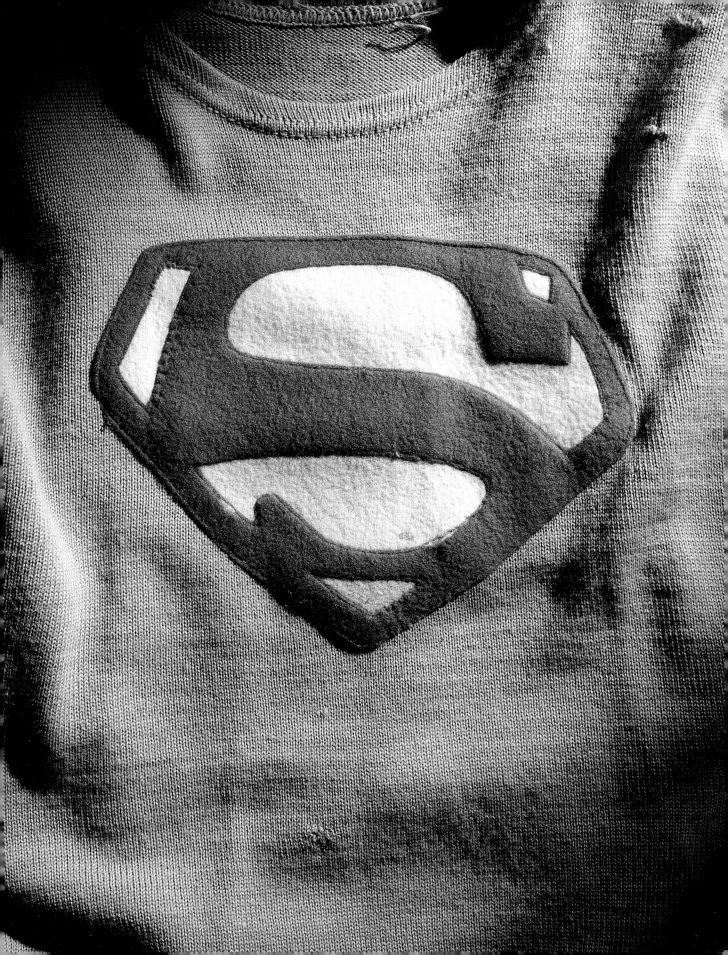

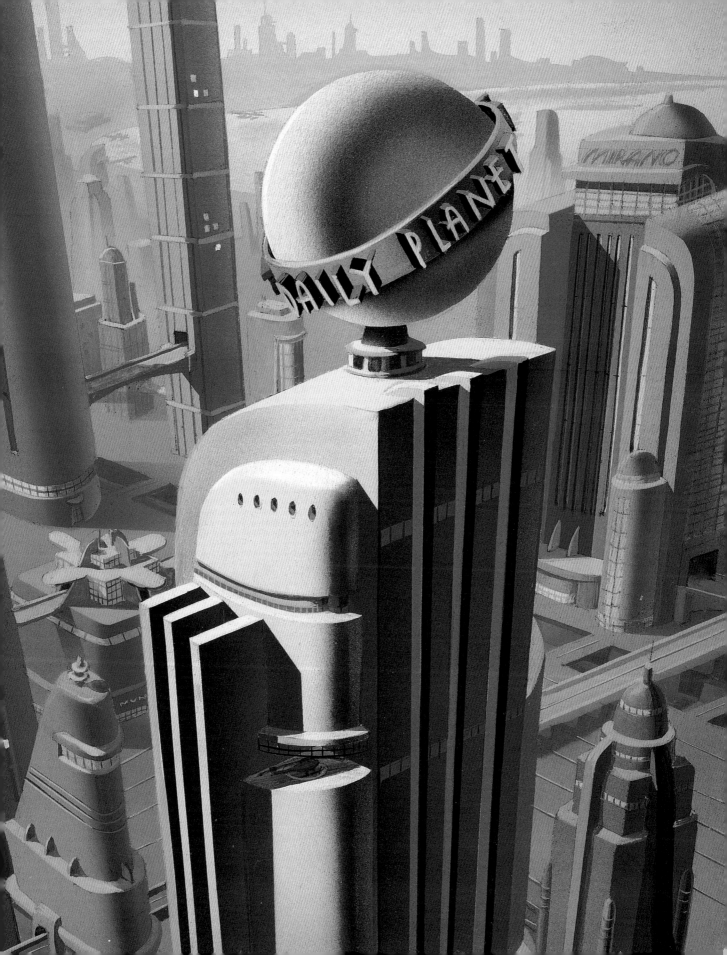

CREATION

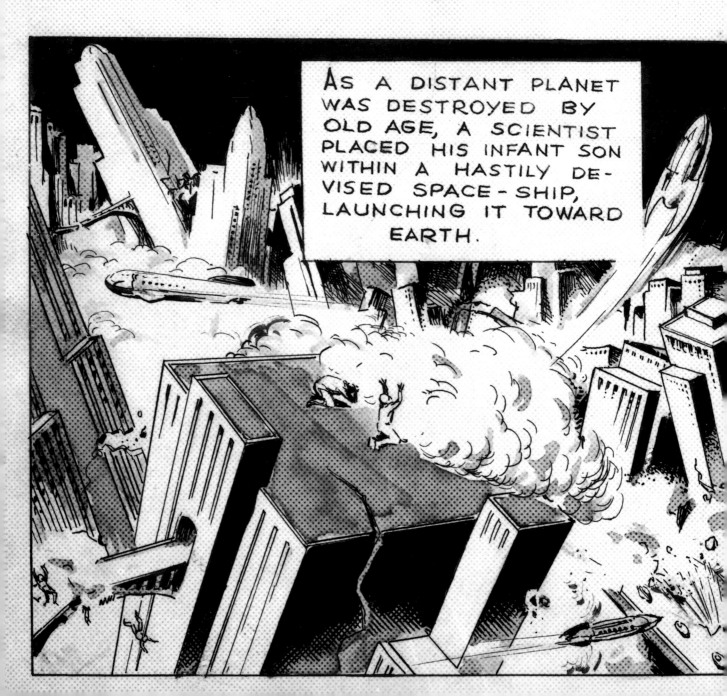

When Superman burst onto the scene sixty years ago there had never been a character quite like him, and he remains unique today. The innumerable imitators who followed in his wake have acknowledged his primacy by taking on the title of super hero, but Superman did more than start the trend that came to define the American comic book. His influence spread throughout all known media as he became a star of animated cartoons, radio, recordings, books, motion pictures, and television, while his image appeared on products ranging from puzzles to peanut butter. He is perhaps the first fictional character to have been so successfully promoted as a universal icon, yet he also continues to remain a publishing phenomenon whose adventures appear in no fewer than five monthly comics magazines. This triumphant mixture of marketing and imagination, familiar all around the world and re-created for generation after generation, began humbly with an infant art form in search of a subject, and two teenagers with an improbable idea.

Jerry Siegel and Joe Shuster, both born in 1914, first met around 1931 when they were students at Glenville High School in Cleveland. Shuster, a native of Toronto, had recently moved into the neighborhood, and Siegel sought him out after hearing that the new arrival was an artist. "Joe and I were tremendous science fiction fans," recalled Siegel. Their friendship was forged out of a shared enthusiasm for the first magazines to publish the genre regularly, including *Amazing Stories* and *Weird Tales.* They were also interested in films, particularly those that showcased the swashbuckling exploits of silent screen star Douglas Fairbanks. In addition, they were fascinated by the newspaper comic strips of the day. "At the time that we became interested in the comics field," Siegel said, "the two outstanding adventure strips were *Buck Rogers* and

Tarzan." Drawn by Dick Calkins and Harold Foster, respectively, these two features had introduced new elements of fantasy into the field when they first appeared in 1929. Comic books were still almost unheard of, so Shuster clipped and saved the colorful Sunday pages drawn by his favorite artists.

Tarzan represented the primitive past and Buck Rogers flew into an improbable future, but together they brought fantastic action to newspaper strips.

Conventional wisdom held that such interest in the more lurid aspects of the day's pop culture did not bode well for two poor boys living in the depths of a disastrous economic depression, but the pair clung to the hope that such escapism might also provide them with an actual avenue of escape from the gray realities of daily life. When no money could be found to heat the Shuster apartment, Joe had to wear gloves while drawing. Jerry's after-school job as a delivery boy brought in four dollars a week to help keep his family afloat.

Most of the boys' energy was directed toward work on their school paper. Joe drew humorous cartoon features for the *Glenville Torch,* and most of Jerry's prose had a similarly comedic slant. Among his contributions was a series of short stories, illustrated by Joe, about "Goober the Mighty." This character was a parody of Tarzan, and the mockery indicated a certain amount of ambivalence about the idea of aggressive, muscular heroes. "In a fit of superhuman energy," Siegel wrote of Goober, "he snapped a twig between two great hands."

This unpublished first panel of the oft rejected *Superman* newspaper strip shows the end of a world as the hero's home planet is destroyed.

. . . cartoonist Joe Shuster . . .

Still, these tales from 1931 represent the first time the team toyed with the idea of a powerful protagonist. When they returned to the theme again, the superman they created would be a villain.

Joe Shuster endorses eating in this noncontroversial political cartoon for the Glenville High *Torch* for November 29, 1933.

Outside their worlds of fantasy, Siegel and Shuster were classic nerds: bespectacled, unathletic, shy around girls. It's hardly surprising, then, that many of their dreams centered on omnipotence. While Shuster applied himself to lifting weights, Siegel began envisioning a man of limitless might. Given his unarticulated agenda of creating a modern myth that would both embody adolescent angst and offer a palliative for its pains, it's hardly surprising that it took Siegel several years to come up with the final version of Superman. What's amazing is that he ever got there at all.

While they found some satisfaction in amusing their fellow students, Siegel and Shuster's goals were a little loftier. In fact, Siegel was regularly submitting samples of his prose to the science fiction pulps, but no sales resulted. Eventually they decided to start their own little magazine, with Jerry as editor and Joe as art editor. Entitled *Science Fiction,* the mimeographed publication made its debut in October 1932. The preceding month, two New York youngsters named Mort Weisinger and Julius Schwartz had started a journal of news and gossip called *Science Fiction Digest.* These magazines, available by mail to those in the know but unseen by the general public, constituted a method of networking long before the dawn of the computer era. "One of our first subscribers was someone named Jerry Siegel from Cleveland, and he said he loved the magazine," said Schwartz, who believes it helped inspire Siegel to start a magazine where he could publish his own fiction. "Jerry wrote story after story," recalled Schwartz, "and got rejection after rejection."

"Joe and I enjoyed the pulp magazines and we two wanted to come up with some sort of heroic character," Siegel said. Pulp protagonists of note included a dark avenger called the Shadow and a scientific mastermind called Doc Savage; even the comic strip favorites Tarzan and Buck Rogers had first appeared in prose form in the rough paper

This art deco cover made Siegel and Shuster's mimeographed fan mag *Science Fiction* look slicker than it really was. This publication was home to the original version of Superman.

pages of the pulps. Siegel and Shuster made *Science Fiction* (subtitled "The Advance Guard of Future Civilization") look as much like one of the professional pulp magazines as they could, with Joe's illustrations drawn in a strong style that stood up to the crude printing process. Acting as his own editor, Siegel published his short story "The Reign of the Superman" in the third issue of *Science Fiction* (January 1933). His first strongman, Goober the Mighty, had been a clown, and his first Superman, Bill Dunn, would be a megalomaniac.

P U L P F I C T I O N

The word *pulp* is tossed around quite casually today to describe various sorts of lurid narratives, but the term originally applied to magazines printed on cheap, coarse paper made from wood pulp. The format, which was introduced by *Argosy* in 1897, really came into its own during the decades between World War I and World War II, when hundreds of pulps costing pennies apiece vied for attention on the newsstand. Lurid, full-color paintings on the covers made the magazines memorable, and so did some of the stories on the inside. Writers produced quickly for low rates, but they created vivid characters like Tarzan, Buck Rogers, the Shadow, Doc Savage, and Conan. The pulps provided opportunities for specialists in science fiction like Ray Bradbury, Isaac Asimov, and H. P. Lovecraft, and for masters of detective fiction like Dashiell Hammett, Raymond Chandler, and Erle Stanley Gardner.

Pulp fiction, which specialized in action rather than introspection, helped inspire a generation of comic book writers like Jerry Siegel, and many comic book publishers got their start in the pulps. Harry Donenfeld, who became a partner in DC Comics, was most active as a distributor but was also a backer of Culture Publications. This company produced a line of sexy pulps with the word *spicy* in their titles; the prose may not have been deathless, but the covers featuring scantily clad women in improbable peril have become campy collectors' items.

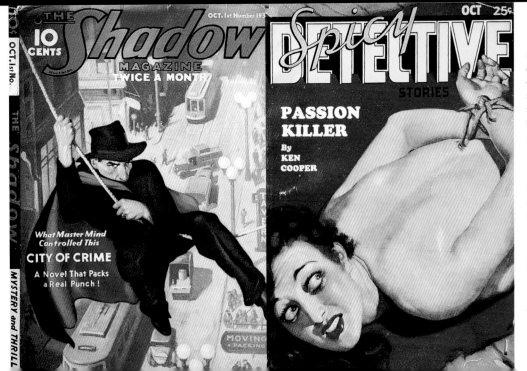

Doc Savage was called "the Man of Bronze" and sometimes described as a superman by pulp author Kenneth Robeson (Lester Dent). Doc's publisher, Street and Smith, also released stories of the sinister Shadow by Maxwell Grant (Walter Gibson). The dame in distress on H. J. Ward's *Spicy Detective* cover did not survive to get her own series.

"The Reign of the Superman" is set pointedly in the Depression of the 1930s. Bill Dunn is a homeless derelict snatched from a breadline by Professor Ernest Smalley, who needs a subject for an experiment. In a variation on the Frankenstein theme, Smalley creates a monster called the Superman out of Dunn. After being treated with an unknown chemical, Dunn escapes and gradually achieves extraordinary mental powers, which begin with telepathy and expand until he can control the thoughts of any individual he chooses to possess. As a diversion he casts his mind into outer space and views a battle between strange creatures on the planet Mars, but his more practical goal is to achieve wealth, first through mental mugging, then through gambling and stock manipulation. When

"THE REIGN OF

Jerry Siegel's first Superman story features an ugly, evil Superman who seems completely different from the later incarnation that is so well known today. Yet there are interesting points of comparison between the two versions. The first Superman was an Earthling, but his powers came from exposure to an element found in a meteor from outer space. So the extraterrestrial concept was already in place, as was the notion of an alien rock with great powers (later to be introduced as a menace to Superman called kryptonite). And years before the creation of Clark Kent, Siegel paired his wicked but seemingly omnipotent Superman with a reporter who was not quite

Smalley realizes what he has wrought, he plans to take the treatment himself, but he is killed by the Superman, who will tolerate no rivals. Dunn uses his powers to disrupt a peace conference, reasoning that war and chaos will pave the way for his conquest of the planet. The world is spared at the last minute when the effects of the experiment wear off, and Dunn shuffles away to be a forgotten man again.

Siegel seemed to be saying that the powers he could imagine would be too much for any mere human to handle, and that was the end of Superman—at least for the time being.

• • •

As a rule, Siegel had been writing prose, but now he and Shuster began to experiment with ideas for newspaper comic strips. Their initial effort, according to Siegel, was a strip entitled *Interplanetary Police.* In his magazine *Science Fiction,* Siegel announced that the feature had "received the approval of a newspaper syndicate and is now in the process of being revised." In fact, as he admitted later, the strip had been turned down with words of faint praise by the United Features Syndicate, but the duo remained enthusiastic. Before long they were announcing that *Interplanetary Police,* like *Buck Rogers,* "has been written up in radio-play form." Again, the idea of a broadcast appears to have been wishful thinking, but Siegel wouldn't

THE SUPERMAN"

as helpless as he seemed. The fact that the two of them were meant to be part of a matched set was emphasized by Joe Shuster's bold drawings showing the duo confronting each other on facing pages of the magazine.

Siegel also employed some in-jokes. He published the story under the alias Herbert S. Fine, combining his mother's maiden name with the first name of the cousin who had introduced him to Joe Shuster, and he called his reporter hero Forrest Ackerman in honor of the science fiction fan who would later edit the magazine *Famous Monsters of Filmland* and coin the term *sci fi.*

quit. Among his other ideas was a strip about a pair of friends whose invention enables them to see through anything and view events taking place anywhere—a mechanical device that anticipated Superman's X-ray vision. "When we presented different strips to the syndicate editors, they would say, 'Well, this isn't sensational enough.' So I thought, I'm going to come up with something so wild they won't be able to say that," Siegel reported. *Science Fiction* expired with its fifth issue early in 1933, but by then Jerry and Joe had their eyes on a new medium beginning to come into prominence: the comic book.

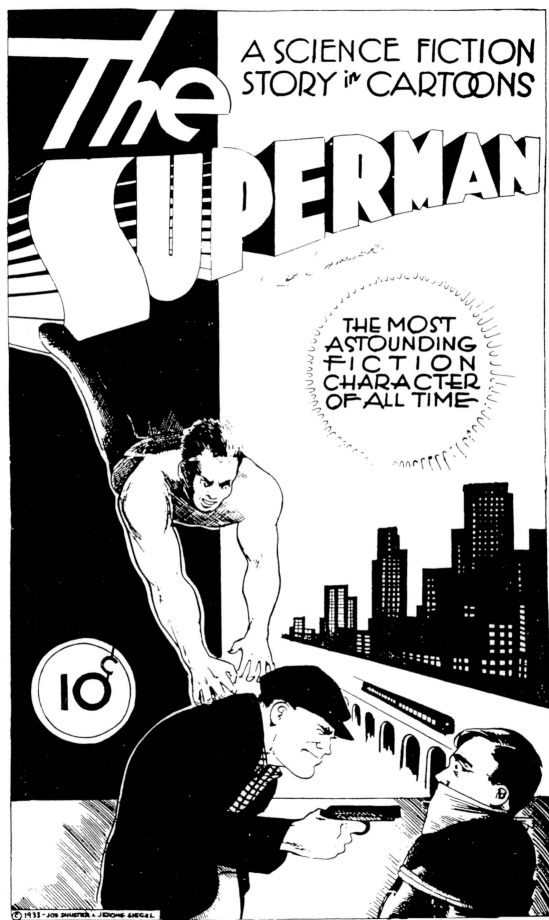

This 1933 inked cover is all that remains of the first, never-published Superman comic book. The crime-fighting hero is rescuing a trussed-up citizen who looks suspiciously like writer Jerry Siegel.

Popular newspaper comic strips had been reprinted in book form from time to time since the turn of the century, but not in a consistent format and not as periodicals appearing for sale regularly. In 1933, M. C. Gaines, a salesman at New York's Eastern Color Printing, hit on a scheme for keeping the firm's color presses in operation: the large sheets used for Sunday comics could be folded down to produce a pamphlet roughly seven by ten inches. The result was a thirty-two-page commercial giveaway called *Funnies on Parade.* The following year, another collection of newspaper reprints, *Famous Funnies,* hit the newsstands priced at ten cents. It was a hit. "As soon as we saw a comic book, we just took to that immediately," said Siegel. However, since *Famous Funnies* published only work that was already successful in newspapers, it really was not a market for them. What actually caught their interest was something considerably more obscure.

At the same time that M. C. Gaines was creating the format that would put comic books on the map, a Chicago outfit called Consolidated Book Publishers released a large comic book, with black-and-white interior pages, called *Detective Dan: Secret Operative No. 48.* Siegel and Shuster noticed that the story, written and drawn by Norman Marsh, was original, and not a reprint of an already established strip. In addition, the magazine promised further adventures "in the next issue." Siegel and Shuster enthusiastically put together a new comic book story, complete with a cover bearing the slogans "A Science Fiction Story in Cartoons" and "The Most Astounding Fiction Character of All Time." The title of this offering, promptly submitted to Consolidated, was *The Su-*

The appearance of the early comic book *Detective Dan* inspired Siegel and Shuster to create a Superman story in the same format.

perman. The publisher responded on August 23, 1933: "We have delayed in replying until we could give the matter of 'The Superman' deliberate consideration. Should we desire to put out another edition of DETECTIVE DAN, if the author and artist is not agreeable, we then will be glad to take the matter up with you, with a view of publishing 'The Superman' instead of DETECTIVE DAN."

With the optimism of youth, Siegel and Shuster took Consolidated's very cautious reply as a good sign. As events transpired, the promised second issue of *Detective Dan* never materialized. Cartoonist Marsh may already have pulled out: his character showed up in newspapers as *Dan Dunn* in September 1933 and enjoyed a ten-year run. In any case, Consolidated decided to get out of the comic book business. Devastated, and convinced that his work was somehow to blame for this latest setback, Joe Shuster burned every page of *The Superman.* Only the cover has survived, rescued from the flames by a prescient Jerry Siegel. He continued his delivery job, while Shuster became a street vendor selling ice cream. Their high school graduation was only months away, their prospects dim.

Just exactly what the 1933 Superman might have been like remains a matter for speculation. "The Superman character was in the process of evolution," Siegel said. Decades later, Shuster suggested that this incarnation of Superman might have worn a cape, but usually he and Siegel agreed that no special costume was in evidence, and the surviving artwork bears them out. The most important point on which they are clear is that this version of the hero had no superpowers. Although big and strong, he was strictly human, and his name was sheer hyperbole. Again, this suggests that Siegel wasn't quite comfortable about presenting uncanny powers as part of a heroic ideal, and by this time he had definitely decided that the Superman should be a good guy. If this character were to appear in his own regularly scheduled comic book, Siegel had concluded that making him virtuous rather than villainous was simply "sensible." When asked for more information about this lost 1933

Superman, Siegel and Shuster inevitably ended up comparing him to Slam Bradley, a two-fisted adventurer they later created for the first issue of *Detective Comics* (March 1937). If so, this Superman was a generic character based on a variety of sources from the pulps and the strips, and hardly as remarkable as the third and ultimate Superman, whose creation was just around the corner.

With so many different versions bearing only the slightest similarity to one another, it's significant that Siegel and Shuster stuck with the name Superman, but they never explained what its attraction for them was. The term, originally *Übermensch,* had been coined in 1883 by the German philosopher Friedrich Nietzsche to suggest an individual whose creativity transcended ordinary human limitations (it was misappropriated by the Nazi party, which took power in Germany in 1933). Most likely Siegel picked up the term from other science fiction writers who had casually employed it before him, but the determination of this young Jewish-American to find a personality that matched the word was finally so successful that his concept is

remembered today by hundreds of millions who may barely know who Nietzsche is.

Late in 1934, the concepts that had been bubbling in the back of Siegel's mind finally coalesced into a new formula. In an oft repeated tale, he described the excitement that kept him awake one night writing scripts for a third take on Superman, and sent him rushing over to Shuster the next morning. "When we got together to work out the idea, we talked about the character a great deal, and I made sketches," Shuster said. The superpowers were back, but now they were physical rather than mental, a decision that made the character at once more visual and less sinister. The new character was the ultimate acrobat and strongman. He was in the tradition of the mighty heroes who are legendary in every culture, from Samson and Hercules to Beowulf, and he fought against crime and tyranny and social injustice. An immigrant of sorts, he became the champion of the American way. "Let's put him in this kind of costume," Shuster remembered suggesting, "and let's give him a big *S* on his chest, and a cape, make him as colorful as we can and as distinctive as we can."

If Superman's tights and cape suggested a circus performer,

they were also standard equipment for the humanoid denizens of outer space familiar to Siegel and Shuster from the pulp magazines, and from comic strips like Alex Raymond's *Flash Gordon,* which had made its debut at the beginning of the year. Their new Superman was an alien, sent to Earth in a rocket when his father realized that a cataclysm was about to destroy their planet, Krypton.

The idea that Superman came from such a distant world seemed to liberate the writer's imagination. Siegel had previously envisioned mighty men who were fools or fiends, but with the new Superman he had a hero who was not entirely human, and thus might logically be immune to human weaknesses. Now his omnipotence would not have to be either a threat or a joke. And in presenting an otherworldly being, Siegel seems to have touched upon a mythic theme of universal significance. Superman recalled Moses, set adrift to become his people's savior, and also Jesus, sent from above to redeem the world. There are parallel stories in many cultures, but what is significant is that Siegel, working in the generally patronized medium of the comics, had created a secular American messiah. Nothing of the kind was consciously on his mind, apparently: his explanation for dropping Superman down from the sky was that "it just happened that way." And Shuster echoed him: "We just thought it was a good idea."

Another good idea, and another way of taking the curse off a character with too much power, was to provide him with a dual identity. This was hardly unprecedented: the pulp and radio hero the Shadow had another identity, as did the title character in *The Mark of Zorro,* starring film favorite Douglas Fairbanks. Such alter egos, however, were generally wealthy aristocrats who pretended they just couldn't be bothered to take a stand against evil. Superman's other self, Clark Kent, was a horse of another color, since Siegel and Shuster stripped him of any vestige of the exotic.

They patterned him after themselves, almost masochistically, making him timid, myopic, working class, and socially maladroit. And they provided him with good qualities, like intelligence, integrity, and industry. The implied social commentary served, once again, to render omnipotence lovable, because Superman deliberately took on characteristics that he wisely understood were admirable, but which would nonetheless render him undesirable among mere mortals.

• • •

The disguise of mere human goodness concealing an even greater goodness was ironically perfect: nobody imagined that the decent, bumbling Clark Kent might be the infallible Superman. Yet, to make the joke perfect, to solidify Siegel and Shuster's mockery of the adolescent environment that had never quite accepted them, there had to be a witness. She was apparently part of this newest Superman scenario from the beginning, and her name was Lois Lane.

With his background working on the high school newspaper, it seemed natural for Siegel to make Clark Kent a reporter, and to give his character a relationship with a female colleague similar to one he had experienced himself. Siegel had had his share of adolescent crushes, including one on a student named Lois Amster. He confessed to this infatuation in later life, while insisting that "the less said about it, the better," and there is little doubt that the pretty and popular Lois gave her name and something of her personality to her comics counterpart. Since Siegel evidently never seriously approached Lois Amster, nobody knows if she

would have treated him with the same disdain that Lois Lane maintained for the humble Clark Kent, but when Amster was interviewed about their relationship (or lack of one) half a century later, she recalled only that Siegel "used to stare at me. He was a strange guy, and I never had any friendship or conversation with him." In 1934,

The original Clark Kent? Walter Dennis, science fiction fan and newspaperman, sent Siegel his photo in 1930 and may have served as the model for Superman's alter ego.

however, Siegel could alleviate whatever unhappiness he felt by envisioning the ultimate version of an almost universal fantasy: of containing hidden qualities that would someday command everyone's admiration. Siegel viewed Superman's disguise as Clark Kent as a joke on Lois Lane, but there was a more telling irony in the fact that the unprepossessing Siegel actually did have remarkable powers, that his talent and imagination would bring pleasure to generations yet unborn.

On one level Lois Lane can be seen as a shallow gal who dismisses a decent guy (Clark, her coworker) while dreaming about a muscular member of another species. From today's perspective, it's easy to denounce Lois as the misogynistic fantasy of a disappointed male. Yet both men and women can relate to the pain of being judged by superficial standards, thus giving Clark Kent's trials and Superman's triumphs a broad appeal.

Lois Lane was redeemed by many positive qualities, including courage, independence, and ambition. Some of these traits can perhaps be attributed to another young woman whom Siegel and Shuster met while they struggled to set Superman flying. Joanne Carter started out as an artist's model for Joe Shuster; years later she would become Jerry Siegel's wife. Theoretically, she was hired simply to pose for drawings, yet there seems little doubt that her spunk, enthusiasm, and determination had a real effect on the personality of Lois Lane. "There we were, three gutsy kids, all with a rapport, somehow drawn together by fate," she recalled in 1996, shortly after her husband's death. "And we hit it off as friends right away."

"I wanted to make the strip more realistic and true to life," Joe Shuster said, which was "the main reason" for hiring a model. To the best of his and Joanne's recollection, their work together, which may have taken place as late as 1937, involved preparing new versions of the strips originally drawn in 1934. In all that time, the third version of Superman had failed to find a publisher. The perfectionist Shuster worried that his drawing might have been to blame, so he answered a classified ad in the *Cleveland Plain Dealer* placed by a model looking for work. Joanne Carter, a self-described "skinny little kid," had audaciously taken the ad

Glenda Farrell as Torchy Blane (left) with Barton MacLane and Winifred Shaw.

"SMART BLONDE" *(The Adventures of Torchy Blane)* with GLENDA FARRELL·BARTON MacLANE - A Warner Bros. Picture
WINIFRED SHAW

A N O T H E R L O I S L A N E

The assertive, adventurous female reporter typified by Lois Lane has also appeared in film, most notably in the classic comedy *His Girl Friday,* and some commentators have suggested that Rosalind Russell's peppery portrayal in that film may have had an influence on Lois. In fact, the only possible influence would have been the other way around, since Lois was already appearing in comic books and a newspaper strip by the time *His Girl Friday* was released in 1940.

However, Jerry Siegel, an inveterate film fan, did pick up ideas from an actress. "He got the inspiration for Lois Lane from a movie star before Rosalind Russell," Joanne Siegel said. "Her name was Glenda Farrell and she played a girl reporter, very fast-talking, and she always got the story." Farrell played reporter Torchy Blane in seven entries of a nine-film Warner Bros. series that ran from 1936 through 1939, based on pulp stories by Frederick Nebel. Billed by the studio as "the Lady Bloodhound with a Nose for News," Torchy got her start in a movie entitled *Smart Blonde,* to distinguish her from the "dumb blondes" that were a Hollywood stereotype, but in later films her hair turned darker. Played once by the coincidentally named Lola Lane, Torchy was the type who thought nothing of parachuting into the ocean to get a scoop about events on a passing ship. In the 1939 series finale *Torchy Plays with Dynamite,* Torchy was portrayed by Jane Wyman, who would marry and then divorce future president Ronald Reagan before winning an Oscar for 1948's *Johnny Belinda.*

because she couldn't think of any other way to earn money, and when she arrived at the Shuster family's apartment a comedy of errors ensued. Although he may have been too polite to say so, the artist was apparently expecting someone a bit more voluptuous, while the young model couldn't believe that the awkward adolescent who answered the door could be the "Mr. Shuster" who had hired her. A brief conversation revealed that she had no experience beyond posing in front of her bedroom mirror, but that may have struck a chord with Shuster, who often looked at his own reflection while trying to capture facial expressions. With his mother chaperoning, the pair set to work in a poorly heated room. "I was turning blue in my sister's bathing suit that was too big," Joanne recalled. "He said, 'Never mind, I'll put a bit more here and a bit more there.' But he used my face and my hairdo and my poses.

"I was very much excited about the strip," said Joanne. Also excited was Jerry Siegel, waiting in the Shuster living room for a look at the model whose hour-long session was costing $1.50. "He was flipping through a magazine very fast, very impatient, when we came out," Joanne remembered. "I said I loved Superman because Joe had told me all about it. Jerry was so wound up, so full of energy. He said, 'Superman is going to fly like this,' and he took a flying leap from the chair and crashed into the couch. Then he went over to Joe and grabbed him around his shirt and said, 'This is the way Superman is going to lift the bad guy, then just toss him and he'll go straight through that wall.' And I said, 'Wow!'"

"We inspired each other," said Joe Shuster, and in fact the creators of Superman needed all the encouragement they could get. At that point nobody in a position of power could see much potential in the character. The young men intended to sell their new hero in comic strip format, since comic books were still fairly experimental, and usually reprinted newspaper strips anyway. Still, Siegel recalled submitting Superman to the reprint book *Famous Funnies* and having his package returned

unopened. A 1934 query to the editor of the coincidentally titled company Super Magazines, Inc., elicited some interest, but no business resulted. Siegel was once again suggesting a Superman comic book (and in fact comic books would even-

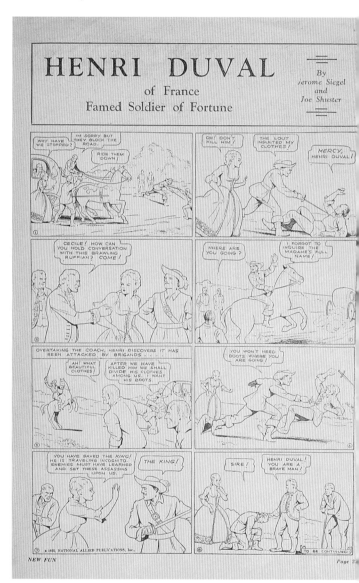

Siegel and Shuster's first professional sale was this brief tale of swordplay.

tually give them their first sales), but the pair clearly preferred to save Superman for the more prestigious and lucrative newspaper format.

Siegel and Shuster's first professional sale came in 1935, to a struggling publisher named Major

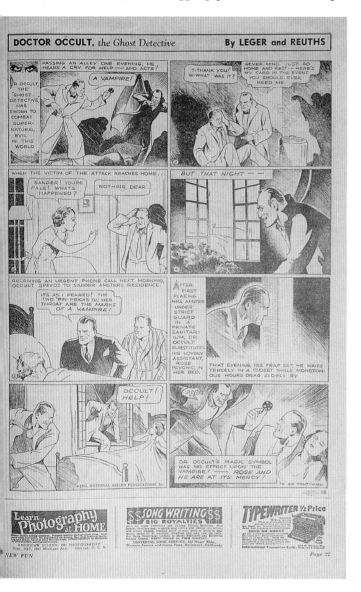

Making his debut alongside Henri Duval was Dr. Occult, a psychic detective "sworn to combat supernatural evil in this world."

Malcolm Wheeler-Nicholson. His shoestring operation, National Allied Publishing, was producing comic books composed of original material, at least in part because he couldn't afford the rights to proven successes. A former army officer and pulp magazine writer, Wheeler-Nicholson launched his first comic book, *New Fun,* that February. Tabloid size and printed in inexpensive black and white, this maiden effort from National was a landmark: it inaugurated the appearance of regularly published comic books featuring new material. (National was also the start of industry powerhouse DC Comics.) The company looked shaky to Siegel and Shuster, however (certainly no place for Superman), and the work they offered was correspondingly perfunctory. Still, they got a favorable response to their first submission in a June 6 letter from the major: "I am enclosing herewith a pencil sketch which seems to have been lost in the shuffle here, as it appeared to be simply a piece of wrapping paper. I believe that there are possibilities in this sketch and in the idea. We would be willing to give it a tryout in the magazine if your completed job stands up with what the pencil sketch would seem to show." Some desperation showed on both sides here, with Shuster still too broke to afford real drawing paper, and Wheeler-Nicholson willing to encourage an apparently amateurish offering, but the deal was struck. "Henri Duval of France, Famed Soldier of Fortune," a single-page swashbuckler doubtless inspired by Siegel and Shuster's favorite Douglas Fairbanks, took its first bow in *New Fun* #6 (October 1935).

"Henri Duval" may have been the team's first sale, but it ran for only four installments. The same issue of *New Fun* introduced their far more significant feature "Dr. Occult, the Ghost Detective." Historical swordsmen never proved to be a big draw in comics, but fantasy and horror had their place, and the first episode of "Dr. Occult" showed the heroic investigator battling a vampire. Emboldened by these two sales, even though the stories were each just one page of black and white, Siegel decided to offer Superman to Wheeler-Nicholson.

Tough guy Slam Bradley had no superpowers, but Jerry Siegel said that the character had "some of the impact we planned to use later in Superman." The stereotyped Asian villains were commonplace in the first issue of *Detective Comics* (March 1937).

In *Adventure Comics* #16 (June 1937), Siegel and Shuster used the Junior Federal Men Club to drum up interest in their work.

On October 4, 1935, the publisher replied: "The Superman strip is being held for an order now pending from a national syndicate. It is my own idea, based on a lot of experience in selling in the syndicate game, that you would be much better off doing Superman in full page in four colors for one of our publications. I consider our magazines primarily catalogues of features and the selling resistance is considerably less for color stuff than it is on daily black and white. We also have pending an order for a sixteen-page tabloid in four colors in which we could include Superman around the first of the year, if we have it in colors and running. Use your own judgment on this. I think myself that Superman stands a very good chance."

Taking the major's advice to use their own judgment, Siegel and Shuster decided to turn him down. Wheeler-Nicholson's plans were vague, all based on "pending" deals, and he seemed to be admitting that he published his books only in the hope of selling something from them to the newspaper syndicates. More to the point, Siegel and Shuster knew he was on shaky financial footing because they, like many of his contributors, had trouble getting paid. They felt they had to hold on to Superman; at the same time they continued to supply Wheeler-Nicholson with more conventional material.

They were on hand for the second issue of the company's new comic book, *New Comics,* with "Federal Men" (January 1936). Concerning the adventures of government agent Steve Carson, this was soon the key feature in *New Comics,* which became *New Adventure Comics* and then *Adventure Comics.* Capitalizing on headlines about the newly formed FBI, Siegel kept up reader interest in "Federal Men" with a variety of colorful crimes, while

Shuster's art became more polished and professional. The pair launched a fan club, the Junior Federal Men, and when some girls protested about the name, they were invited to join too. The story for January 1937 concerned the "Federal Men of Tomorrow," allowing the creators to indulge their passion for science fiction and to name one futuristic character Jor-L (sounding suspiciously like Superman's alien father).

The most remarkable misappropriation of Superman material came in some "Dr. Occult" stories published in issues #14 through #16 of *More Fun Comics.* Beginning in October 1936, Dr. Occult acquired immense strength, the power of flight, a blue costume, and a red cape. Siegel and Shuster, working under the pseudonyms Leger (sometimes Legar) and Reuths, were clearly giving their favorite character a tryout. Meanwhile, they

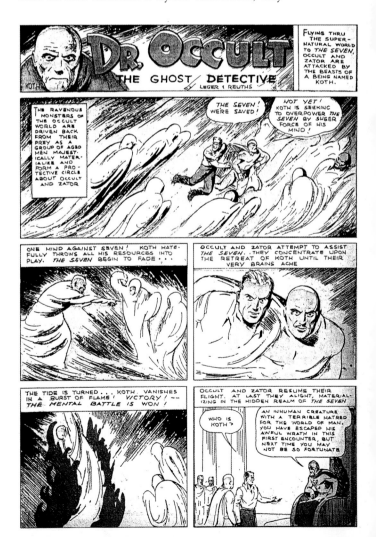

This episode from *More Fun* #14 (October 1936) is part of a continued story that shows Dr. Occult acting more and more like Superman

had the disconcerting experience of watching Wheeler-Nicholson farm a Dr. Occult episode out to another publisher, who put it in *The Comics Magazine* #1 (May 1936) under the title "Dr. Mystic, the Occult Detective." By this time Wheeler-Nicholson was floundering toward bankruptcy, and he was able to launch his third title, *Detective Comics,* only by going into partnership with his distributors, Harry Donenfeld and Jack Liebowitz. For the first issue of *Detective Comics* (March 1937), Siegel and Shuster supplied "Slam Bradley," which they always described as close to their second version of Superman, the one Shuster had burned when it failed to sell. Slam himself, "ace free lance sleuth, fighter and adventurer," is introduced in a full-page splash panel battling four opponents at once. "Altho' outnumbered, Slam is having a swell time!"

The same could hardly be said for Superman, whose career seemed to be stalled during the years when Siegel and Shuster were creating so many comparatively commonplace characters. In 1936, Jerry Siegel approached comic book pioneer M. C. Gaines, then producing *Popular Comics* for Dell Publishing, with the idea of putting Superman into that comic book with its established newspaper strips (once again, the hope was that Superman might be subsequently syndicated). Their plan was rejected, and in 1937 Siegel took the same idea to *Tip Top Comics,* which was published by the United Features Syndicate and featured such Siegel and Shuster favorites as Tarzan. They were told a deal was in the works, and were crushed when it didn't come through. It does seem odd that the team employed this back-door approach rather than approaching the syndicates directly—perhaps they were following the lead suggested in Wheeler-Nicholson's letter of 1935, or remembering what happened to *Detective Dan* in 1933. The ultimate rejection letter from *Tip Top Comics,* dated February 18, 1937, stated that while the Superman strip was "attractive because of its freshness and naïveté," it was "still a rather immature piece of work," and thus by implication not suited to adult newspaper readers. This was not quite as shortsighted as it now seems, since indeed it would be kids who eventually turned Superman into a hit.

A possible break came when Siegel and Shuster received M. C. Gaines's letter of November 30, 1937. Gaines, who wore many hats, was involved with the McClure Newspaper Syndicate, and continued his association with Eastern Color Printing, which was printing all Wheeler-Nicholson's books. Gaines, who had

Toronto's imposing *Daily Star* building, erected in 1929, helped inspire Joe Shuster's vision of Metropolis.

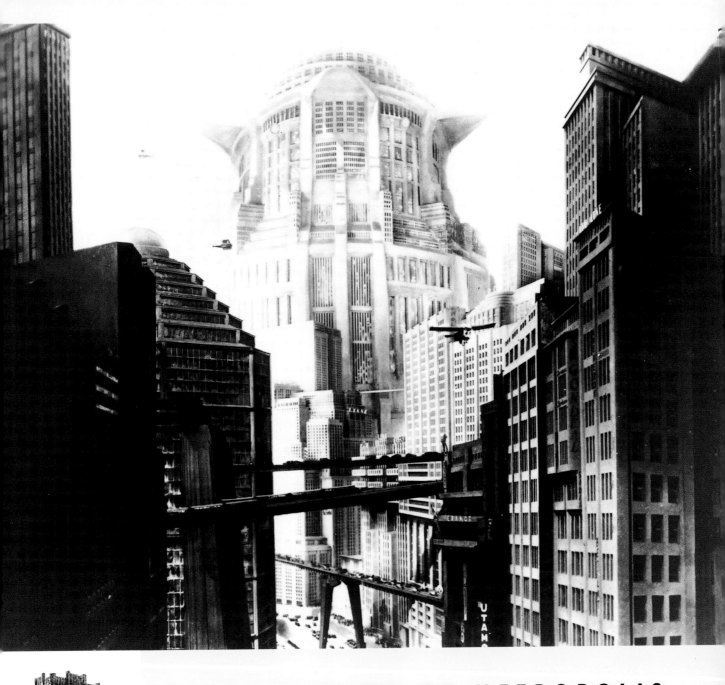

THE MAKING OF METROPOLIS

When it came time to name the city where Superman would make his home base, Siegel and Shuster chose "Metropolis." The choice was a tribute to the finest science fiction film of the silent era, German director Fritz Lang's *Metropolis* (1926). This epic about class warfare in a futuristic city was thematically confused (especially after it was edited into several different versions for international release), but visually it was spectacular. Superman's Metropolis is widely assumed to be a stand-in for New York, and Lang often said that he was inspired to make the movie when he saw New York's skyline from aboard ship during his first visit to the United States in 1924. That was just a show-biz story, however—Lang had actually announced the film and its title months before his trip.

The skyscrapers that towered over Superman's Metropolis were inspired not by Manhattan or even by Cleveland, but by Joe Shuster's hometown of Toronto. He had worked as a paperboy selling Toronto's *Daily Star,* and that was the name of the newspaper where Clark Kent worked until an editorial decision changed it to the *Daily Planet.* "Whatever buildings I saw in Toronto remained in my mind," said Shuster, "and came out in the form of Metropolis."

SUPERMAN!

NOT JUST AN ORDINARY ADVENTURE STRIP BUT

WHOLE WHEAT

LAUGHS —
THRILLS —
SURPRISES!

FANTASTIC SENSATION

A NEW PERS GREETS THE YOU

ONCE IN A GREAT WHILE A STRIP APPEARS THAT SWEEPS INTO THE LIFE-BLOOD OF THE NATION BY SHEER RUGGED NARRATIVE POWER

THE SUPER-STRIP OF THEM ALL!

MEET THE GROWING DEMAND NEW ORIGIN MATERIAL WE FINALLY STRIP WE SINCERELY WILL

REVEALS BEFORE IN THE HISTORY OF THE WORLD HAS MAN AND KNOWN HIS EQUAL

THE GREATEST SUPER-HERO OF ALL TIME!

SWEEP THE NATION

SEEN

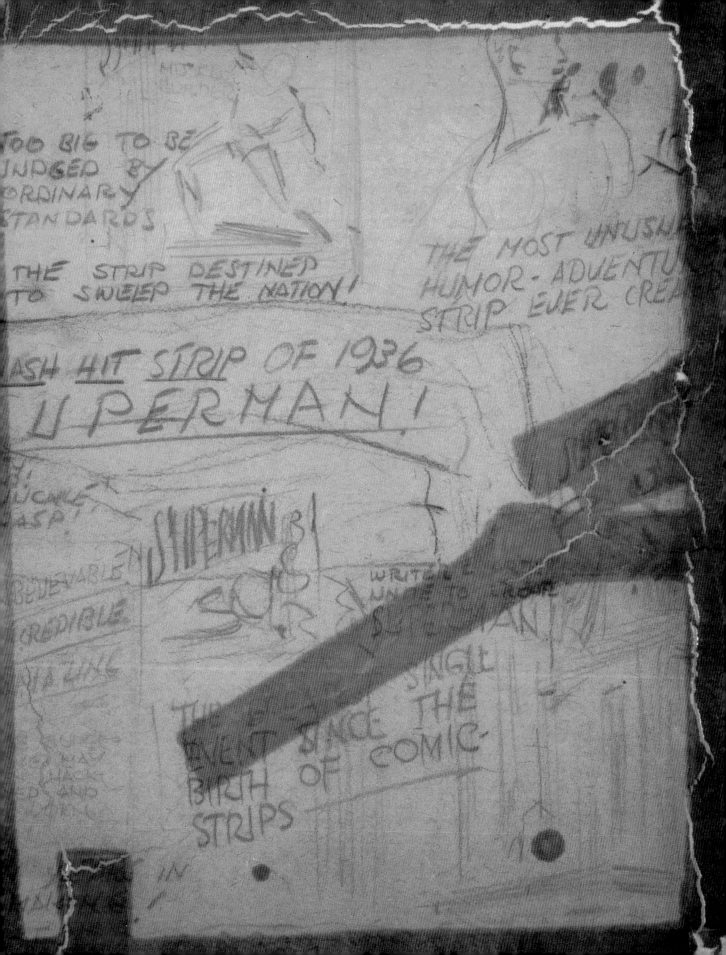

Overleaf: Shuster's prophetic sketches name Superman "the smash hit strip of 1936" (two years before it was published), and predict the character's effectiveness in merchandising products like cereal. The term *super-hero* is also introduced, but who's that big woman?

CLARK KENT

ONE AND

kept an eye on Siegel and Shuster, was now soliciting work from them: "We are working on an idea entirely apart and separate from such comic books and we are looking for several good features, each weekly story to consist of eight complete tabloid pages." Siegel sent him "Superman," and in December visited National's New York offices, now known as Detective Comics, Inc. By then the writing was on the wall: Wheeler-Nicholson was bankrupt. Donenfeld and Liebowitz, his distributors, were taking over the business and planning a new publication called *Action Comics.* In an incredibly convoluted chain of events, Liebowitz asked Gaines whether he had any material suitable for the new comic book, and Gaines, whose plans for the new tabloid were stalled, asked Siegel for permission to offer "Superman" to *Action Comics.*

Vin Sullivan, editor of *Detective Comics* and the proposed *Action Comics,* wrote to Siegel on January 10, 1938. "I have on hand several features you sent to Mr. Liebowitz in connection with the new magazine that is still in the embryonic stage. The one feature I liked best, and the one that seems to fit into the proposed schedule, is that 'Superman.' From the drawing I can readily see that Joe Shuster was the person who handled the pen-and-ink end of the job. With all the work Joe is doing now, would it be possible for him to still turn out thirteen pages of this new feature?"

Siegel and Shuster had been trying to sell Superman for years and had never had a substantial offer. They still believed that comic book publication might be the route to newspaper syndi-

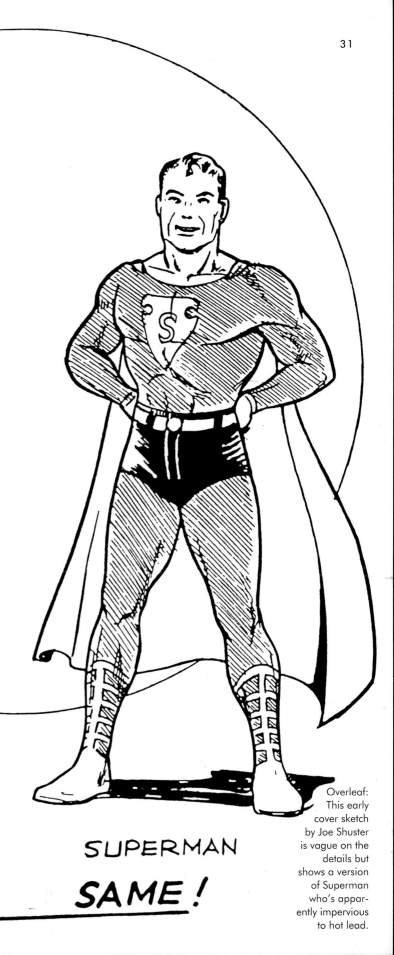

SUPERMAN

SAME !

Overleaf: This early cover sketch by Joe Shuster is vague on the details but shows a version of Superman who's apparently impervious to hot lead.

cation, and they knew that the new owners of Detective Comics, Inc., were far more solvent than Wheeler-Nicholson. The new offer seemed like the way to go, and they agreed to turn out thirteen pages of Superman.

On February 1, Sullivan returned the daily strips of *Superman* to Siegel and Shuster, requesting that they be cut up and pasted together into comic book format. In a February 4 letter, he urged them to "shoot the works"—PRONTO! "Those thirteen pages will have to be in the office here within three weeks' time, so I think you'll have to apply a bit of pressure . . . and remember, eight panels per page. Regards to Joe and make this first release (and the others too) the very best . . . the initial issue of any magazine should be without imperfections."

Sullivan requested a standardized eight panels per page, each of identical size, but Siegel and Shuster had been experimenting with larger images for some time and in the finished product they included pages with as few as five large panels. They just couldn't bear to dilute the impact of their dream project. Siegel even decided what the cover of *Action Comics* #1 (June 1938) should be, as Sullivan said in his February 4 letter: "You'll note that we already used one of those panel drawings of 'Superman' as you suggested in your recent letter."

It had taken five years, but now the painstakingly perfected version of Superman was finally about to appear in print. At last, here was proof that we had something that was very different . . . and I just KNEW deep in my heart that the public really would flat-out love him.

"All this time we really felt that we had something that was very different. Something that the public really would take to its heart." —Jerry Siegel

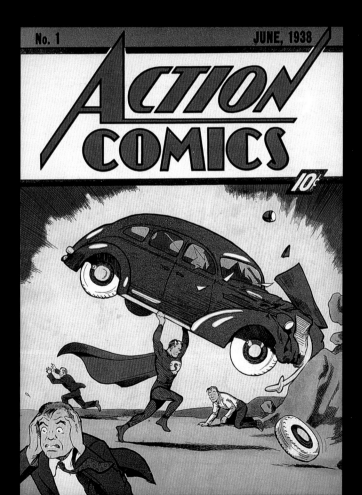

EXPLOSION

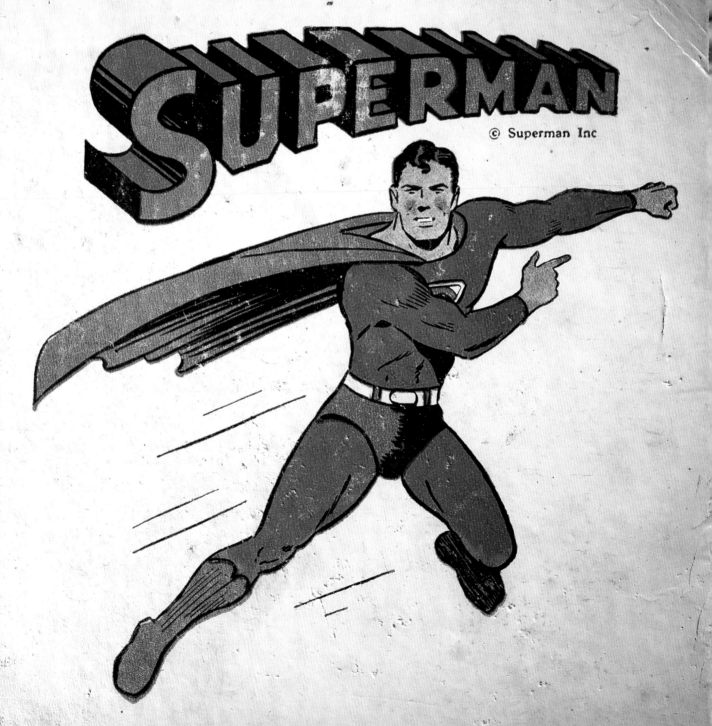

After the debut of Superman in *Action Comics* #1, Jerry Siegel recalled that "there was a long silence for a while, then Joe and I got wind that our creation was a success." The first intimation that things might be going well came when Siegel visited his editor Vin Sullivan in New York and was shown a few news clippings indicating that Superman was making a splash. "The publishers themselves didn't quite realize the power of Superman until they learned that at the newsstand people were asking not for *Action Comics,* but for that magazine with Superman in it," Siegel said. Publisher Jack Liebowitz cautiously kept the print runs low for the first few issues, even featuring some of the publication's other characters on the covers, until a survey showed exactly which series was drawing the customers. After the eleventh issue Superman was never off the cover again, and sales were nearing half a million. Soon that would be doubled.

Superman's creators, writer Jerry Siegel and artist Joe Shuster, at the height of their success.

Nobody but Siegel and Shuster had exhibited much faith in Superman; Jack Liebowitz called the decision to run the feature "a pure accident," and Vin Sullivan stated that he simply found it "interesting." Publication of the first Superman story was essentially an experiment, with no attendant publicity or promotion, and it was actually the ordinary reader who made the character a star. "I never tried to write down," Jerry Siegel said. "I just wrote stories that I enjoyed, and I was hopeful that if I enjoyed it then other people would. I have a great healthy respect for the fans. I didn't care what their age was, I tried to write up to them. That was my ideal. This was a super character, and I wanted to do right not only by the character but also by the reader."

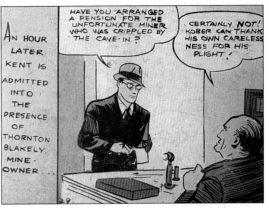

Printed in *Action Comics* #3 (August 1938) and reprinted in *Superman* #1, this story about unsafe conditions for miners was one of Jerry Siegel's favorites.

One way Siegel and Shuster reached out to the audience was by dealing with the social problems of the day. The thirteen pages of Superman's adventures in *Action Comics* #1 include episodes centered on unjust imprisonment, spousal abuse, and corrupt government officials. Subsequent issues included stories on labor relations, disarmament, and drunken driving. "Superman himself didn't take the whole thing that seriously, except that he was very serious about helping people in trouble and distress, because Joe and I felt that very intensely," Siegel said. "We were young kids and if we wanted to see a movie we had to sell milk bottles, so we sort of had the feeling that we were right there at the bottom and we could empathize with people. Superman grew out of our feelings about life. And that's why, when we saw so many similar strips coming out, we felt that they were perhaps imitating the format of Superman, but something wasn't there, which was this tremendous feeling of compassion that Joe and I had for the downtrodden."

Nobody was more downtrodden than poor Clark Kent, who in that first issue was thoroughly humiliated by various bullies and also by his colleague Lois Lane. Superman's decision to walk among humans disguised as the humble Kent was

NEW TRIUMPH

Superman looks a little different in one of his first overseas incarnations, from Great Britain in August 1939.

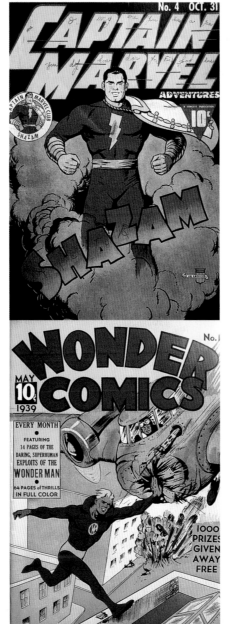

Cover of *Captain Marvel Adventures #4* (October 1941) by C. C. Beck. Cover of *Wonder Comics #1* (May 1939) drawn by Will Eisner.

part of a classical tradition that included heroes like Homer's Odysseus and Shakespeare's Henry V. That Kent is no more than a mask for Superman is shown clearly in the brief origin story, consuming less than a full page, that would be expanded and elaborated with each retelling over the years. In the original version, a nameless scientist on a nameless planet being "destroyed by old age" puts his infant son in a spaceship bound for Earth. The baby is found and taken to an orphanage, where his strength amazes doctors. Reaching maturity, he dons the Superman costume and takes a reporter's job as Clark Kent. No explanation is given for his human name, or for the way the authorities kept his powers secret for so many years.

Siegel and Shuster had the opportunity to improve on this sketchy scenario in just a few months, when they realized their dream of seeing Super-man appear in a nationally syndicated newspaper strip. A daily black-and-white strip made its debut on January 16, 1939, and a color Sunday page followed on November 5. Running continuously until May 1966, and then revived from 1977 to 1983, *Superman* became one of the most successful of the great adventure comic strips. *Superman* reached local newspapers via the McClure Syndicate, whose executive M. C. Gaines and his enthusiastic young assistant, Sheldon Mayer, had originally recommended the character for comic books. The same strip that had been rejected by almost every syndicate in the country was suddenly a hot property, and Gaines had the inside track. The McClure Syndicate was the country's oldest, and by 1941 it had placed Siegel and Shuster's strip in hundreds of newspapers with a readership estimated at more than 20 million. Such circulation far

MAY I USE YOUR CAPE?

As the first super hero, Superman is the acknowledged inspiration for hundreds of comic book characters. Some of them came too close for comfort, and in a couple of cases legal action resulted. The first issue of *Wonder Comics* (May 1939) featured "14 Pages of the Daring, Superhuman Exploits of the Wonder Man." This comic book was published by Victor Fox, a DC accountant who liked the look of the numbers Superman was getting, but the imitation he produced was a bit too blatant. DC sued and won in 1940, but Fox had already dropped Wonder Man, replacing him in the second issue with Yarko the Great. There was no third, but Fox later achieved a certain notoriety by pushing the limits of 1940s sex and violence with comics like *Phantom Lady* and *Rulah, Jungle Goddess*.

Captain Marvel, a far more serious rival, got his start in the February 1940 *Whiz Comics* from Fawcett Publications. A few years later, his *Captain Marvel Adventures* was the best-selling comic book in the country. Captain Marvel was a character of considerable charm, humor, and originality, but he nonetheless struck DC as suspiciously similar to Superman. A long-running legal action ensued: Fawcett won the first round, DC won the second on appeal, and Fawcett finally threw in the towel in 1953. Years later, DC would publish further Captain Marvel adventures under the title derived from the magic word that evoked his powers, *Shazam!*

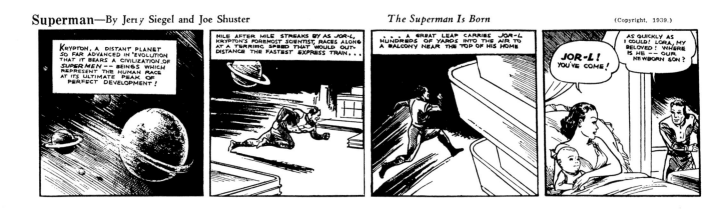

The first days of the *Superman* newspaper strip, starting on January 16, 1939,

Superman—By Jerry Siegel and Joe Shuster *A Strange Ship* (Copyright, 1939.)

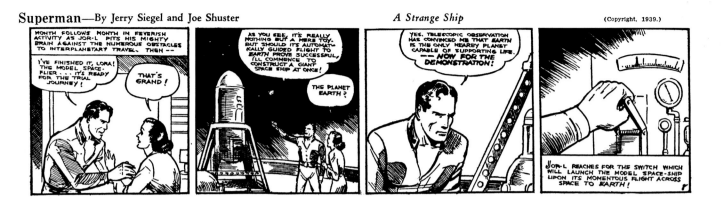

Superman—By Jerry Siegel and Joe Shuster *Destruction!* (Copyright, 1939.)

Superman—By Jerry Siegel and Joe Shuster *Speeding Towards Earth* (Copyright, 1939.)

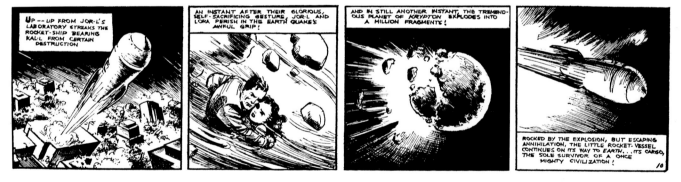

Superman—By Jerry Siegel and Joe Shuster *The Superman Is Here!* (Copyright, 1939.)

presented Siegel and Shuster's most complete account of the hero's origin.

Lil Danvers bucks the odds as the League plots Superman's death (April 1941).

The murderous Blonde Tigress undergoes some serious mood swings (May 1941).

One of the League's efforts to destroy Superman goes up in smoke (October 1941).

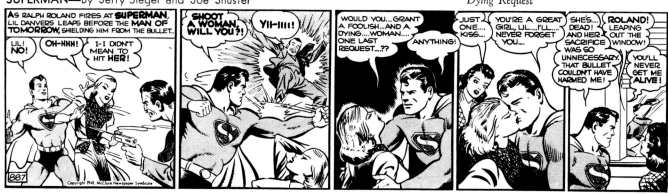

The Blonde Tigress goes soft at the wrong time, and the League loses (November 1941).

It just wasn't safe to be a bad guy in the early Superman strips.

surpassed that of *Action Comics* or any other comic book, and it can be argued that it was the newspaper strip that began Superman's existence as a franchise.

At National Comics, marketing Superman became a primary concern for publishers Harry Donenfeld and Jack Liebowitz. The company had assumed legal ownership of the character as a condition for buying the first thirteen-page story for $130. This bargain would eventually lead to considerable controversy and even litigation, but after years of rejections, there seems little doubt that Jerry Siegel had just wanted to give his brainchild a chance. A 1941 *Saturday Evening Post* article quoted Siegel as saying, "Well, at least this way we'll see him in print." As a result, Siegel and Shuster were obliged to negotiate for financial and creative participation in newspaper publication and all other spin-offs from the comic books. The duo received payments for writing and drawing the comic book pages and newspaper strips, while the licensing fees went to one of Donenfeld's interlocking corporations, Superman, Inc. By 1940 the publisher began to be identified as DC Comics, after a circular logo appearing on its covers. Officially the initials stood for "Detective Comics," but a family joke maintained that it might as well have been "Donenfeld Comics."

In an unusual arrangement, M. C. Gaines and the McClure syndicate allowed DC to handle the editorial work on the *Superman* strip. Meanwhile, editor Vin Sullivan left DC to help start another comic book company; he was replaced by Whitney Ellsworth, a dapper New Englander whose long tenure

as editorial director is credited with helping to define the style and subjects of the American comic book. A former cartoonist, Ellsworth had contributed comedy features and covers and done editorial work during the company's earliest days under Major Wheeler-Nicholson. Ellsworth's new job, he once said, included "editing stories, initiating new projects, checking art—everything but mopping the floor."

Among Ellsworth's most important tasks was determining a proper code of conduct for Superman. In the first newspaper adventure, Superman had deliberately torn the wings off a plane full of bad guys. The plane crashed in flames, its passengers presumably punished for attempting to do away with Lois Lane. Such melodramatics worried

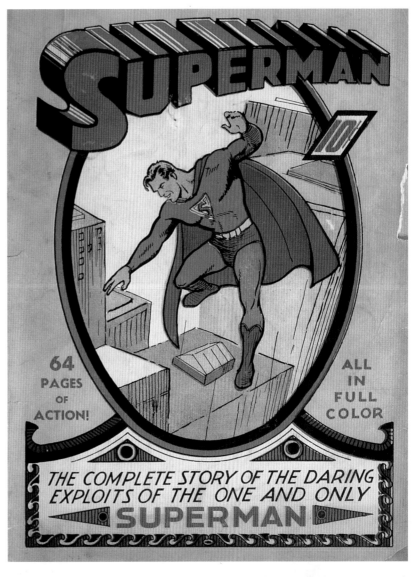

Joe Shuster's cover for the first comic book based on the exploits of a single original character (Summer 1939).

The publishers asked Siegel and Shuster to put this page explaining Superman's strength in *Superman #1*. The explanation would change over the years.

SCIENTIFIC EXPLANATION OF SUPERMAN'S AMAZING STRENGTH --!

SUPERMAN CAME TO EARTH FROM THE PLANET *KRYPTON,* WHOSE INHABITANTS HAD EVOLVED, AFTER MILLIONS OF YEARS, TO PHYSICAL PERFECTION!

THE SMALLER SIZE OF OUR PLANET, WITH ITS SLIGHTER GRAVITY PULL, ASSISTS **SUPERMAN'S** TREMENDOUS MUSCLES IN THE PERFORMANCE OF MIRACULOUS FEATS OF STRENGTH!

EVEN UPON OUR WORLD TODAY EXIST CREATURES POSSESSING **SUPER-STRENGTH!**

THE LOWLY ANT CAN SUPPORT WEIGHTS HUNDREDS OF TIMES ITS OWN.

THE GRASSHOPPER LEAPS WHAT TO MAN WOULD BE THE SPACE OF SEVERAL CITY BLOCKS!

IT IS NOT TOO FAR FETCHED TO PREDICT THAT SOME DAY OUR VERY OWN PLANET MAY BE PEOPLED ENTIRELY BY **SUPERMEN**!

background. His home planet got a name, Krypton, and so did his parents, Jor-L and Lora. Their infant son, soon to be rocketed to Earth, was called Kal-L, and everyone of his race had superpowers (although later stories would explain Superman's strength as a result of the differences between the environments of Earth and Krypton). On Earth, the infant Kal-L was still raised in an orphanage. The now familiar figures of the Kents, his foster parents, were yet to be imagined.

Of all the stories told in the early years of the daily strip, none had greater scope than the long sequence that began on March 10, 1941, and lasted until November 15. Sometimes given the overall title of "The League to Destroy Superman," this epic tale concerns a consortium of criminals, led by a sinister financier called Roland, who raise a million dollars as a reward for anyone who can kill our hero. The sinister scientists assembled for the job bear names like Sleez and Slag, but the most interesting among them is Lil Danvers, a big-game hunter known as the Blonde Tigress. Over the months the villains try heat, corrosive chemicals, a death ray, knives, "electro-darts," hypnotism, explosives, and electricity, but they succeed only in demonstrating Superman's increasing invulnerability. What's interesting to today's readers is that the early Superman sometimes ducks these menaces instead of just shrugging them off. He's most vulnerable, however, to the Blonde Tigress, gallantly helping her out of several tough spots while she confesses to herself, "I don't know why my heart is pounding so furiously at this moment. . . . All I do know is that I'm finding it increasingly

Harry Donenfeld: Superman was becoming a very valuable property, one that appealed to a young audience, and the publisher was anxious to avoid any repetition of the censorship problems associated with his early pulp magazines (such as the lurid *Spicy Detective*). It was left to Ellsworth to impose tight editorial controls on Jerry Siegel. Henceforth, Superman would be forbidden to use his powers to kill anyone, even a villain.

In the opening two weeks of the newspaper strip, Siegel and Shuster expanded on Superman's

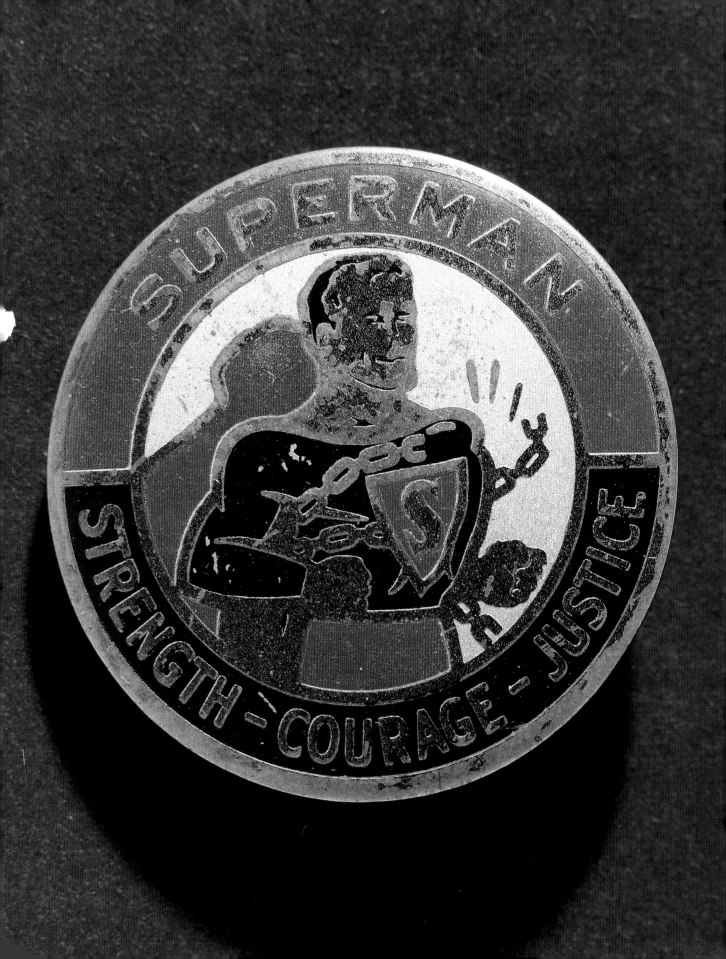

JACK ADLER

hard to hate the Man of Tomorrow!" Ultimately she performs a grand gesture, Hollywood-style, imprudently throwing herself between the Man of Steel and some hot lead fired by Roland. The bullet doesn't bounce off her chest the way it would have bounced off Superman's, and she dies with a farewell kiss while Lois Lane looks on wide-eyed.

• • •

Long before the newspapers were giving Superman's powers such a workout, he was demonstrating his economic strength by getting his own comic book, just a year after his debut in *Action Comics.* The first issue of *Superman,* dated Summer 1939, seems superficially to be no more than a collection of reprints from the early issues of *Action Comics,* but in fact it was painstakingly prepared. Interestingly enough, the editorial instructions offered to Siegel and Shuster came not from anyone working for the publisher, DC Comics, but from the representative of the McClure newspaper syndicate, M. C. Gaines. At this point, the tail seemed to be wagging the dog.

On March 27, 1939, Gaines wrote to Jerry Siegel, "We have decided that for the first six pages of the *Superman* book we would like you to take the first page of 'Superman' which appears in *Action Comics* #1, and by elaborating on this one page, using different ideas than those contained on this page, work up two introductory pages.

"On these two pages, you will of course leave out the scientific explanation of Clark Kent's amazing strength, as we want a separate page on that item to use further back in the book with the heading as follows: 'Scientific Explanation of Superman's Amazing Strength,' in which you will incorporate five or six various explanations, which we discussed while you were here in New York several days ago."

Gaines also requested "four pages of a thrilling episode which results in Superman becoming a reporter" (this was tacked onto the front of the story reprinted from *Action Comics* #1), "a two-page Superman fiction story with illustrations" (this prose piece was a technicality that enabled the publisher to receive second-class mailing privileges), and "photographs of yourself and Joe." In expanding the origin of Superman from one page to two, Siegel and Shuster first introduced "an elderly couple, the Kents," who find the infant Superman in his spaceship and then adopt and raise him. They die before he assumes the role of Superman. Mr. Kent's first name remained a mystery, but the original Mrs. Kent was called Mary, providing fodder for those who choose to see the entire saga as a Christian allegory. Later, the Kents would be permanently identified as Jonathan and Martha.

Gaines gave Siegel and Shuster about a week to provide all the new material he requested, "as we want to go to press with this *Superman* book as soon as possible, to get it on the newsstands not later than May 15th to offset any competition which we now have or may get in the next month or so and at the same time launch the new club Supermen of America in the *Superman* book."

Joe Shuster drew the cover of *Superman* #1, but between the work for the new comic book, the original *Action Comics,* and the ongoing newspaper strip, he was under increasing pressure. His solution was to establish a studio in Cleveland and to hire assistants to help with the art. An office was rented for $30 a month, with no telephone and no name on the door. Members of the growing staff, all paid from Shuster's earnings, included John Sikela, Paul Cassidy, Ed Dobrotka, Ira Yarbrough, and Wayne Boring. At this point, however, Joe Shuster's vision

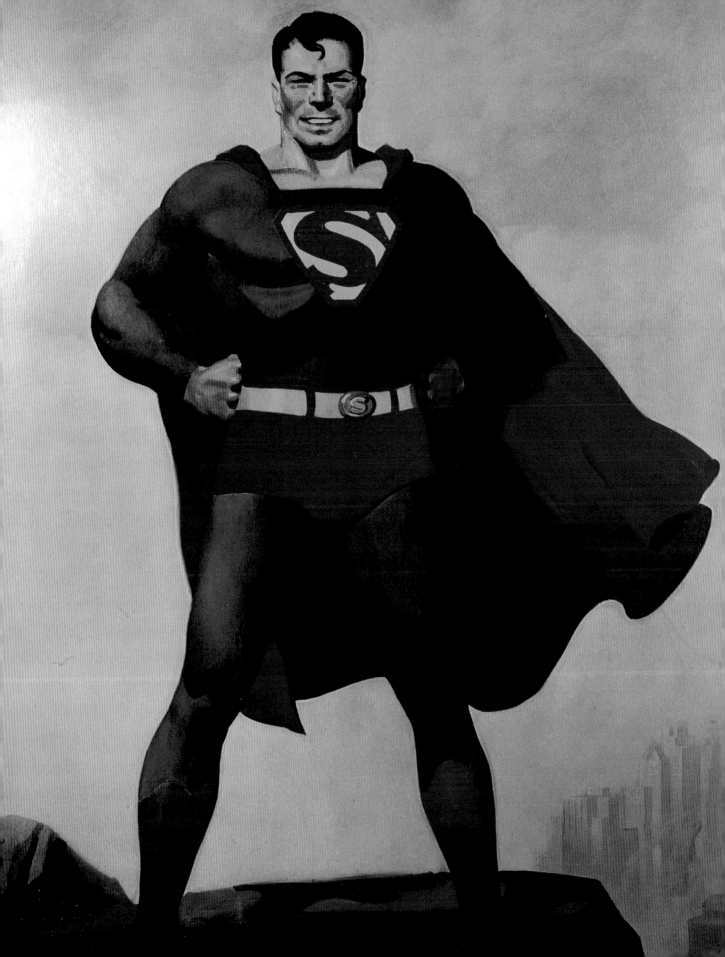

SUPERMEN of AMERICA

STRENGTH — COURAGE — JUSTICE

Headquarters: c/o ACTION COMICS, 480 Lexington Ave., New York City

This Certifies that:—

Name Melvin Patterson Age ... 10

Address 1210 South Adams ..

has been duly elected a MEMBER of this organization upon the pledge to do everything possible to increase his or her STRENGTH and COURAGE, to aid the cause of JUSTICE, to keep absolutely SECRET the SUPERMAN CODE, and to adhere to all the principles of good citizenship.

In Witness thereof I have this day set my

seal and signature as follows:

Reg. U. S. Pat. Office

Clark Kent.

(SUPERMAN)

No. **N** **966**

For the cost of a comic book, a kid could become a club member. The Supermen of America lasted more than a quarter of a century and had over a million members.

47

was still paramount. "A number of artists would make the sketches and they just weren't satisfactory, and Joe would go over them and almost redraw them," said Jerry Siegel. "Now readers may jump to the conclusion that Joe Shuster didn't draw anything—that other people worked on it—but the final result did have the spirit of Joe, and often he did quite a bit of work on it, and in many instances he insisted on inking the Superman heads and the heads of the leading characters. He got something almost mystical in his faces that I don't think anyone else has ever caught since."

Yet new images of Superman were proliferating, in such quantity that they were soon beyond Shuster's or Siegel's control. The hero began to be impersonated by mere mortals, actors who were hired with the understanding that their own names would be kept secret to foster the illusion that Superman really existed. Actor Ray Middleton was the smiling fellow who first donned Superman's tights for a personal appearance at the 1939 New York World's Fair. The same event also resulted in another comic book, *New York World's Fair Comics* (1939), which had ninety-six pages and sold for the extravagant sum of fifteen cents. Superman was shown with blond hair in his cameo on the cover, but sported his usual blue-black locks on the interior pages; also on the cover of the 1940 issue, he was shown posing for the first time with colleagues Batman and Robin. (Batman was created for *Detective Comics* #27 [May 1939] by artist Bob Kane with writer Bill Finger, after editor Vin Sullivan pointed out that super heroes were the coming thing. DC published dozens of new super hero stories, as did the dozens of new comics publishers that were springing up, but none achieved the stature and longevity of Batman and his kid sidekick Robin; they deserved to be featured beside Superman, even though they conspicuously lacked his superpowers.) The cover for *New York World's Fair Comics* #2 was drawn, not by Joe Shuster and his assistants or Bob Kane and his assistants, but by Jack Burnley, who had been hired by DC to handle an increasing workload. Scant months after their

creation, the characters were getting too big for any one person to control. *World's Fair Comics* turned into *World's Best Comics* (Spring 1941), which with its second issue became *World's Finest Comics* (Summer 1941); Superman and Batman continued to share the covers but appeared in separate stories inside.

Superman was now appearing regularly in three comic books and started making occasional guest appearances in a fourth title when he showed up in *All Star Comics* #7 (October–November 1941). This comic book was published by All American Comics, a sister company to DC put together by M. C. Gaines and Jack Liebowitz. *All Star Comics,* edited by Sheldon Mayer, featured many of the new super heroes published by All American and DC, including the Flash, Green Lantern, and the Spectre (created by Jerry Siegel for artist Bernard Baily). *All Star* also introduced the first great female super hero, Wonder Woman, and with its third issue inaugurated the Justice Society of America, a club for costumed characters. Superman and Batman, too big to need promotion in this title, were nonetheless honorary members and appeared in a few stories. A whole universe of fantastic heroes had evolved around the dynamic figure of Superman.

Firmly established as king of the comic books, Superman continued to expand his influence into other fields. The key figure in this growth industry was Robert Maxwell, a former pulp writer who had been put in charge of the DC subsidiary Superman, Inc. Maxwell started out by licensing the name and image of Superman to various manufacturers. Some made toys based on the character's exploits, while others simply attached his name and face to whatever items they were already producing.

The first Superman stuff began to roll off the assembly line in 1939. A membership button proclaiming its owner to be one of the Supermen of America was created for the comic book fans. Members (eventually there would be hundreds of thousands) could also enter contests whose prizes included Superman rings and sweatshirts. In 1940 a flood of Superman products was issued, including such items as puzzles, paint sets, paper dolls, games,

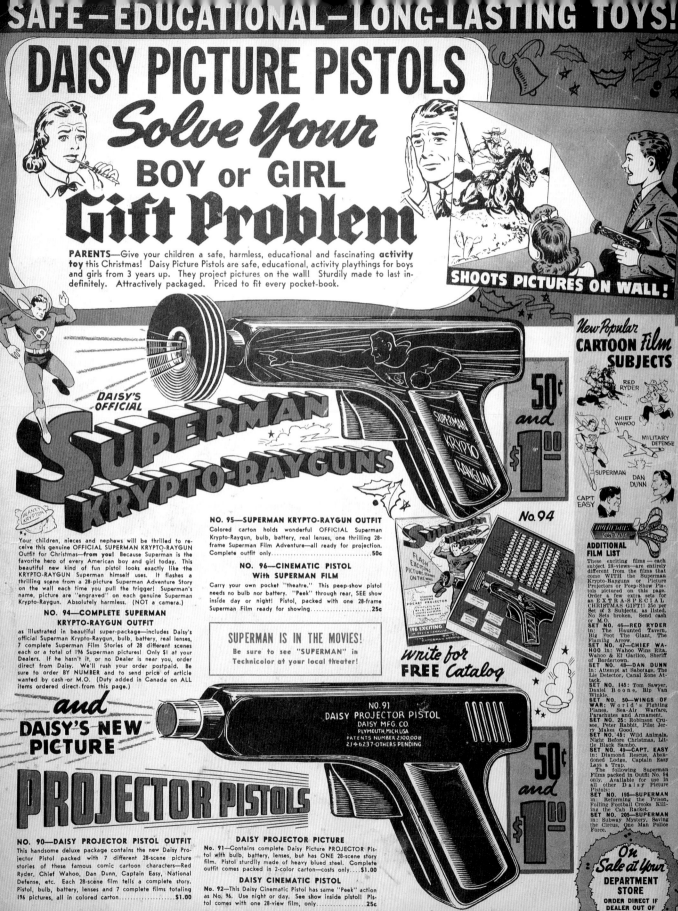

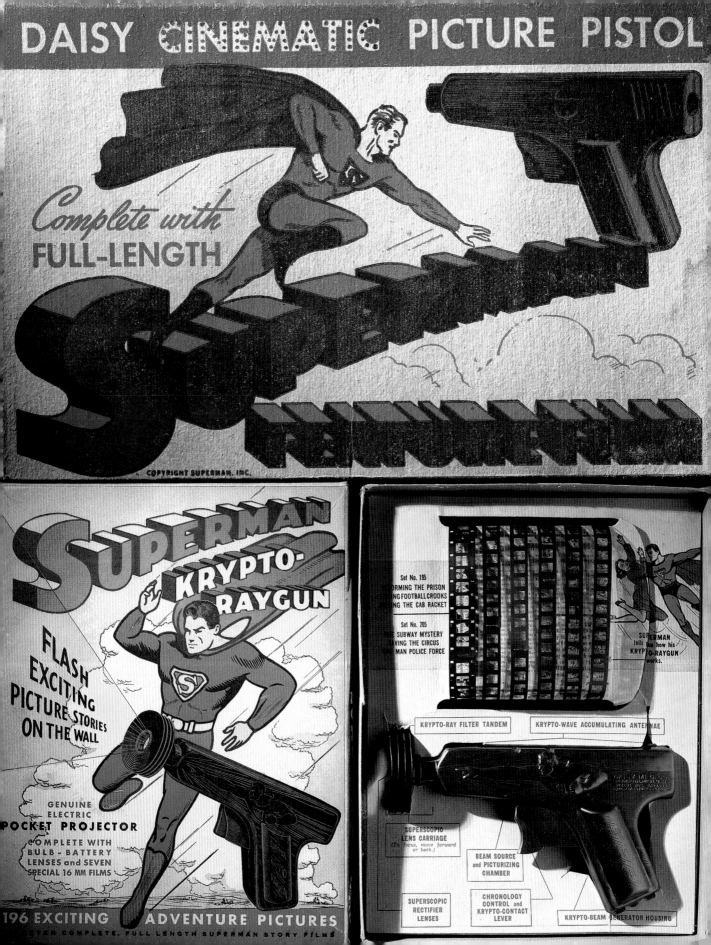

The tin Mechanical Superman Turnover Tank was made in Japan by Linemar, and featured a hero in a yellow costume.

Opposite: Made by the Syracuse Ornament Company, this pressed wood Superman from 1942 measures just under six inches.

• • •

greeting cards, coloring books, candy, and bubble gum (complete with trading cards). In an era before plastics, the 1940 Superman figures were made of wood or metal. Perhaps the year's most unusual item was Daisy Manufacturing's Official Superman Krypto-Raygun, a toy pistol loaded with film strip images that could be "shot" onto a nearby wall. And in those bygone days, batteries were included.

Kids could wear the image of Superman on playsuits, socks, shirts, moccasins, and underwear, while keeping their cash in a Superman billfold and dining on Superman bread. Licensing would eventually prove to be twice a treasure trove, because each time the Man of Steel was adapted by broadcasters or filmmakers, the ensuing publicity would create an upsurge in the market for other licensed products. It was the start of the process that media moguls of later decades would describe as "synergy."

Bob Maxwell was able to give Superman licensing its biggest shot in an already muscular arm by turning the comic book hero into a radio star. In 1940, television was little more than a gleam in an inventor's eye, and radio was the dominant form of home entertainment. Comedy, drama, and soap opera shared the airwaves with music and news, while children's programs predominated during the late afternoons and early evenings. *The Adventures of Superman,* one of the most popular and memorable of all such shows, flourished until 1951, when the era of major network radio programming was coming to an end in the face of new competition from TV.

Maxwell created the radio show in collaboration with press agent Allen Ducovny. They recorded a few pilot programs, which have never been broadcast. The pilots were good enough to attract a sponsor, H-O Oats hot cereal, but the

Opposite bottom: Superman battles a baby brontosaurus in this flip book, a prize from a Crackerjack box.

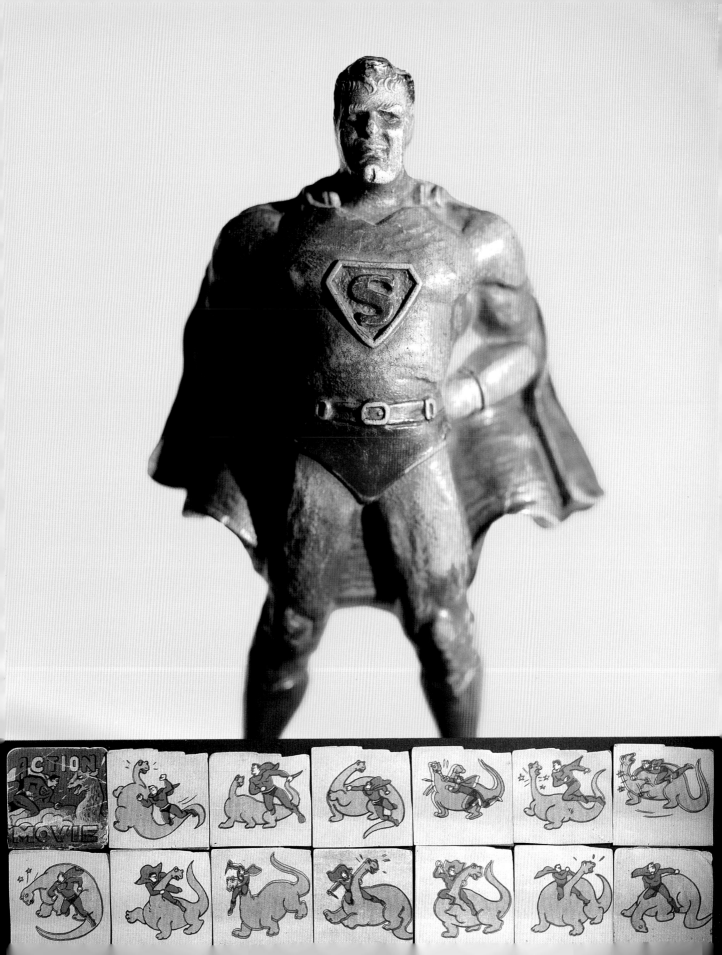

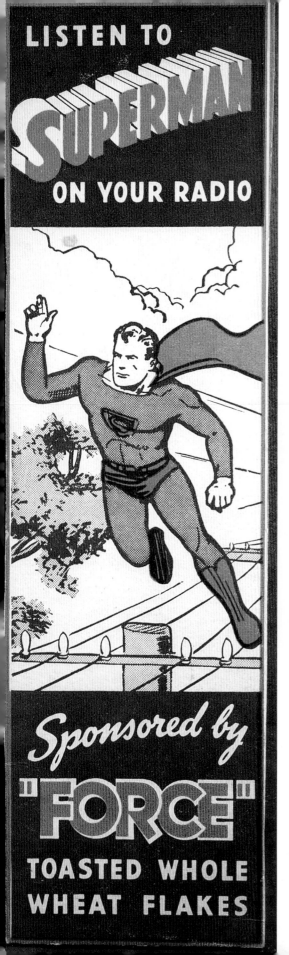

LISTEN TO SUPERMAN ON YOUR RADIO

Sponsored by **"FORCE" TOASTED WHOLE WHEAT FLAKES**

H-O's Force cereal was an early sponsor and put Superman on its package panels.

producers still couldn't get time on any of the major networks, so they syndicated the show via transcriptions made on fragile sixteen-inch disks. *The Adventures of Superman* premiered on February 12, 1940, and earned such high ratings that it was picked up in 1942 by the Mutual Network, which ran fifteen-minute segments each Monday, Wednesday, and Friday shortly before dinnertime. Adults were hearing the program too, and Superman was becoming a household word in millions of homes all over America.

The earliest shows, written by George Ludlam, recapitulated the familiar story of Superman's origin with some interesting variations. The initial

IN OUR LAST EPISODE

"Disguised as a press agent, Dr. Bly invited Lois to be a guest at Playland, a large amusement park outside Metropolis. And when the girl reporter arrived with Jimmy Olsen and young Dick Grayson, who is really Robin, the companion of Batman, the three were given a ride on the River of Horrors! But as their boat glided through a dark tunnel, a supposedly fake skeleton seized Lois and disappeared! Unable to make a police officer believe their fantastic story, Jimmy and Dick phoned Clark Kent and Batman. But when Kent arrived at the amusement park a few minutes later, the two boys were not there! As we continue now, Kent is pacing nervously as a tall, masked figure, wearing a bright blue mask and hood, approaches." This is only part of the typically breathless narration that opened the *Superman* radio show for September 10, 1945.

segment provided new information about conditions on the planet Krypton, while the next episode telescoped a lot of complicated backstory by proclaiming that the infant Superman had grown up during his spaceship trip from Krypton and arrived here as an adult. A couple of Earthlings he rescues from a traffic accident helpfully suggest that he find work as a reporter and take the name Clark Kent, which logically should have meant that his secret identity was never much of a secret from the beginning.

Close-up of a 1940 action figure, over a foot tall, made of wood with a cloth cape by the Ideal Novelty and Toy Company.

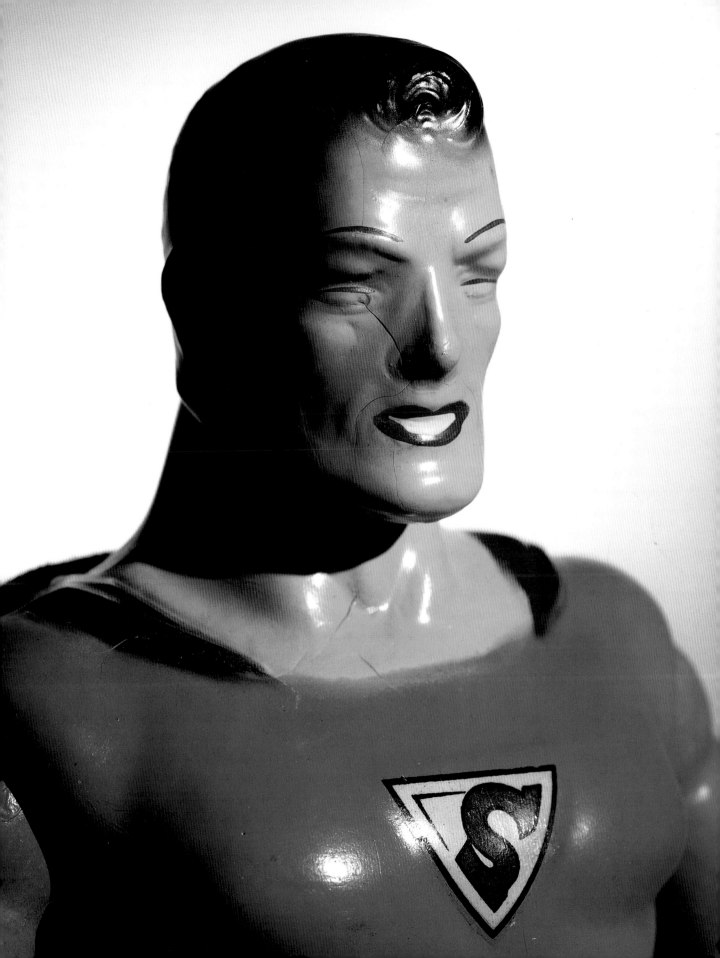

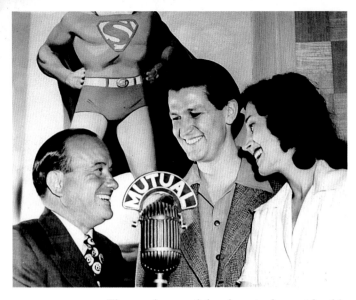

The producers of the show took considerable care to keep the name of the actor portraying Superman a secret. The anonymous star was Clayton "Bud" Collyer (born Clayton J. Heermance Jr.), a versatile actor who put himself through law school working on the air and ended up making so much money that he never practiced as an attorney. "They didn't know whether they wanted one man for each part, Clark Kent and Superman, or whether they wanted two. They didn't know how it should be played or anything," said Collyer. The actor solved the problem during the audition by using his tenor range for Kent and dropping down to a baritone for Superman, and Bob Maxwell offered him the role. "The whole idea embarrassed me and I said no," Collyer recalled, but he was finally persuaded to take the job, and later acknowledged that "it grew into a magnificent career within a career." Collyer, who was appearing on a number of other radio programs throughout the day, mastered the art of taking catnaps in the studio when he had a few minutes to spare, then jumping up refreshed and ready to go back to work.

The actors performed live with minimal preparation, their scripts held in their hands. "We did a quick read-through sitting around a table," said Collyer, "and then we did a dress rehearsal, and then we went on the air—about an hour and a half overall for cuts and writing changes and so forth." There were lots of jokes during rehearsals, which were intended to clear the air so the live broadcast could be done with appropriate seriousness, but Collyer was not above playing tricks on his colleagues during the actual performances, like removing their trousers or setting their scripts on fire.

The rest of the cast included some new characters, invented for the radio but soon to become permanent parts of the Superman legend in all media. One was Clark Kent's overbearing boss, editor Perry White (Julian Noa), and the other was ebullient copy boy Jimmy Olsen (Jackie Kelk), who was clearly intended to give young listeners a point of identification. Similar characters had popped up in the comics, but had not yet received a name or a personality. The role of Lois Lane was initially taken by Rollie Bester, wife of science fiction author and DC Comics writer Alfred Bester, but was played for most of the series by Joan Alexander. The key job of the narrator was handled for a couple of years by George Lowther, who also wrote scripts. When Lowther was promoted to director in 1942, he relinquished the narrator's microphone to Jackson Beck. Still active today, Beck possesses a voice with a distinctive gruff urgency that was perfectly suited for the show's memorable introduction: "Faster than a speeding bullet! More powerful than a locomotive! Able to leap tall buildings in a single bound! Look, up in the sky! It's a bird! It's a plane! It's Superman!"

The striking sound effect of Superman whizzing through the air over Metropolis was created by mixing together recordings of an artillery shell and a wind tunnel. A rarely discussed innovation of the broadcasts is that from the second show onward, narrators discussed Superman's moments aloft in terms of flying rather than merely powerful leaps. The radio show was the source for the elusive decision that Superman should actually be able to defy gravity. And it was during broadcasts starting in 1945 that Superman and Batman, years before their comic book collaborations, really became a functioning team. The impetus for the pairing was partly novelty, partly a desire to provide promotion for a possible Batman series (it

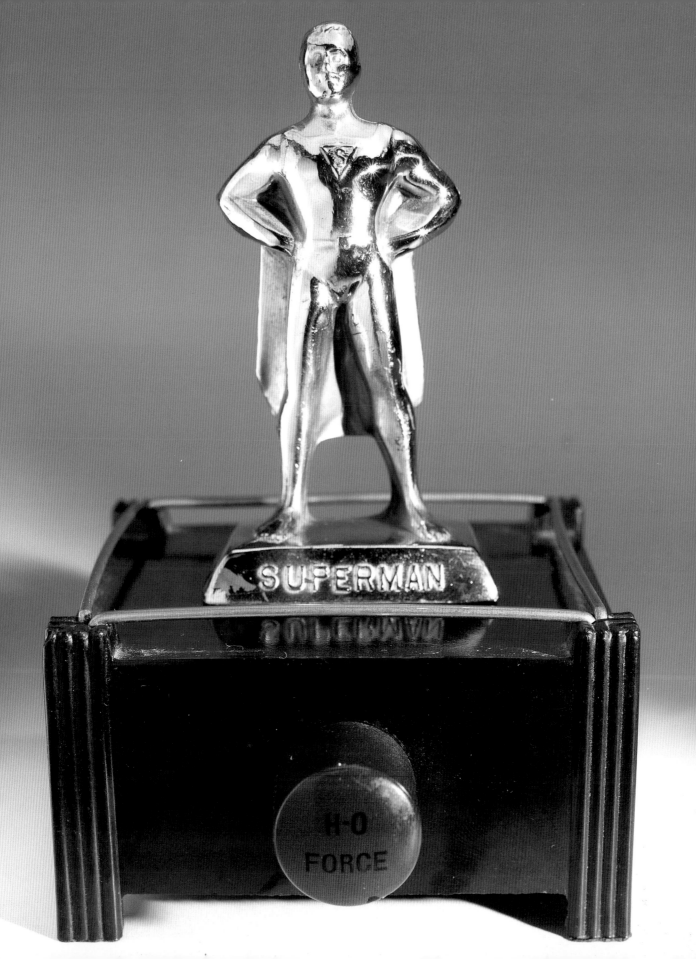

never materialized), but largely a desire to provide some time off for an overworked Bud Collyer. These episodes called for Superman to be occupied elsewhere, and the crime fighting would be handled by Batman (usually played by Matt Crowley) and Robin (usually played by Ronald Liss).

Another radio breakthrough was the 1943 introduction of kryptonite, the mineral from Superman's home planet that was hazardous to his health. Actually, Jerry Siegel and Joe Shuster had written and drawn a story about a suspiciously similar substance, called K-metal, in 1940. However, the story had never been published, apparently because it contained a scene in which Superman revealed his secret identity to Lois Lane—this would have robbed the series of a perennial plot device. Kryptonite would provide as many plots as the battle of wits between Clark and Lois did, and also provided an explanation for the star of the show's protracted absences.

Radio's most dramatic use of kryptonite came in 1945, when a wicked woman known as the Scarlet Widow got her hands on a chunk and proceeded to divide it among several other villains, including the Vulture and the Laugher. In a story line reminiscent of the newspaper strip sequence "The League to Destroy Superman," each arch-fiend took a turn attempting to ensure that the Man of Tomorrow would have no future. The days when the writers put Superman into a kryptonite coma gave Bud Collyer plenty of downtime, and the climax of the saga provided *The Adventures of Superman*'s most sensational segment, when Nazi scientist der Teufel (a.k.a. "the Devil") used kryptonite's radioactive power to create a superpowered villain called the Atom Man, specifically designed to destroy Superman. The battle between these two irresistible forces was the highlight of the series for many listeners. Others prefer the nationally acclaimed "Unity House" shows of 1946, which depicted Superman taking a strong stand against racial prejudice and even defying the Ku Klux Klan. This was a proud moment for the sponsor, Kellogg's Pep, and for Bud Collyer, who chose the

occasion to reveal his secret identity as the actor playing Superman. Increasingly busy as a television host, Collyer left the program in 1950, and was replaced for its final year by Michael Fitzmaurice. By then the show was airing on ABC three times a week, and each episode was half an hour long. For sheer quantity, the radio version of Superman clocked more hours of entertainment than any other adaptation to date, and also added more to the growing body of Superman lore.

• • •

In addition to his landmark radio work, Bud Collyer was the first person to portray Superman in motion pictures, once again lending his voice when the Man of Steel made his big-screen debut in animated cartoons. These short films, a real innovation at a time when most characters in the medium were anthropomorphic animals, remain among the most technically polished examples of the art form. They were science fiction spectaculars compressed into a mere seven minutes.

Launched in September 1941 with the release of the initial entry *Superman,* the cartoons were produced by Max Fleischer. The Fleischer studio, based in New York, was famous for its rambunctious, rough-and-ready presentation of characters like Betty Boop and Popeye (an acknowledged inspiration for Siegel and Shuster's Superman). The company had recently moved into a new phase by transplanting its staff to an enlarged modern facility in Florida, where it could create feature-length cartoons to compete with the tremendous success enjoyed by Walt Disney's prototype, *Snow White and the Seven Dwarfs* (1937). Ultimately, the move proved to be disastrous. Fleischer was financially overextended, and the studio's style proved inappropriate for the long form. Directed by Max Fleischer's brother Dave, the features *Gulliver's Travels* (1939) and *Mr. Bug Goes to Town* (1941) failed to bring in enough money, and in 1942 Fleischer's operation was absorbed by his distributor, Paramount. The one consolation for aficionados of animation is that Fleischer's expansion and subsequent experimentation provided the opportunity

These crude, chalk, fairground giveaways, made in various color combinations, appeared without authorization during the 1940s.

CLICK'S MOVIE SHORT OF THE MONTH

SUPERMAN

Two LITTLE GUYS invented Superman, put him into comic books as the muscle hero of all time, into 250 newspapers, on the radio. Now Jerry Siegel and Joe Shuster are scenarists, for Max and Dave Fleischer are making Paramount-released Superman movie shorts.

1 The First Superman Movie starts with the familiar (to 25,000,000 readers) tale of his origin on the Planet Krypton. Just before Krypton explodes, Superman's father sends him by rocket to Earth, where he disguises himself as Clark Kent, newspaper reporter.

2 Assigned to Investigate a mad scientist who threatens to destroy the city with his death ray, Lois Lane, Clark Kent's associate on the newspaper, is bound and gagged by the maniac who laughs fiendishly. Twenty miles away Kent is watching with his X-ray eyes.

3 Angry at the World, the mad scientist warms up his Electrothanasia-ray to show Lois what he can do. He vows revenge on the populace that laughed at his inventions, while the girl reporter in her aviation costume (she flies her own airplane) watches horror-struck.

4 An Experimental Bolt from the death ray machine wrecks a huge bridge (to make this scene Fleischer's animators studied newsreels of the wrecking of the Tacoma bridge) and frightens the whole population of the threatened city. This, of course, annoys Superman.

5 Clark Kent Changes his reporter's suit, takes off his glasses, and gets into his Superman costume (thousands of children have Superman costumes, but they can't go faster than a bullet or stop locomotives). The hero flies to save Lois, who as usual is in dire peril.

6 Snarling with Hate, the insane inventor, meanwhile, is aiming his death ray apparatus at the 100-story building that houses Clark Kent's and Lois' newspaper. The inventor is typical but even more menacing than the villains Superman is usually combatting.

7 Superman on His Way sees the death ray ripping at the newspaper tower. The building begins to topple, as Superman, cape flying, rushes through space to save it. Can he go fast enough? Will he be in time? Or will the building crash horrifyingly to the ground?

8 Hurtling Even Faster than the death ray, Superman reaches the swaying building, and with effortless ease pushes it upright again. Then he soars to the tower-top to steady the structure. The watching scientist sees him and fumes with rage. His foul plot is being foiled.

9 "I'll Kill Him!" he screams, stepping up the death ray to knock out the hero who, everyone knows, laughs at machine-gun bullets, shrapnel, and fire. Superman, dramatically, catches the death ray in his bare hands as though it were merely a bolt of common lightning.

10 Fighting the Death Ray, Superman twists it in his hands as he hurtles to the weird-looking house of the scientist. Expertly he ties the death ray machine in a knot, leaves it to kick itself to pieces. The madman raves until he is completely crazy. The noise is terrific.

11 As the Machine Explodes Superman rescues Lois and captures the mad scientist. Next day, Lois writes the story of the captive of the mad inventor by her hero, Superman, never dreaming he is really the mild-mannered reporter, Clark Kent, at the next desk.

26

Click magazine created this storyboard using frames from the first Fleischer Superman cartoon in 1941.

to turn the seventeen Superman shorts into a string of mini-masterpieces.

Animating Superman was Paramount's idea. "The average short cost nine or ten thousand dollars, some ran up to fifteen; they varied," Dave Fleischer said. "I couldn't figure how to make Superman look right without spending a lot of money. I told them they'd have to spend $90,000 on each one." Paramount agreed (probably to the astonishment of the Fleischer brothers), but the studio got its money's worth. Studio publicity proclaimed that almost a million drawings were used in the first film, which was far from the most sophisticated of the group. Clark Kent and Lois Lane were ill-defined, the antics of the black bird perched on the mad scientist's shoulder were pure slapstick, the effect of the villain's "electrothanasia ray" was to make real estate get all rubbery, and the image of Superman deflecting the ray with fisticuffs

defied elementary logic. The film was impressive enough to win an Academy Award nomination anyway, but the follow-ups were considerably more accomplished. Dave Fleischer was always credited as the director, although disgruntled employees have claimed that he was merely a figurehead and that the head animators did most of the work.

Thanks to their big budgets, the Superman shorts looked like features, complete with tracking shots and a stunning variety of camera angles, each of which necessitated a new background. Artists duplicated real illumination, molding the characters with light and dark, and providing them with dramatic shadows. The films moved at an accelerating pace, with cuts coming faster and faster toward the climaxes, propelled by Sammy Timberg's dynamic musical scores. Special effects involving fires, rays, and explosions seemed to set the screen ablaze.

Rare layout drawing (top) and animation cel (bottom) from an unreleased 1940 Fleischer test reel, prepared a year before the first cartoon was released.

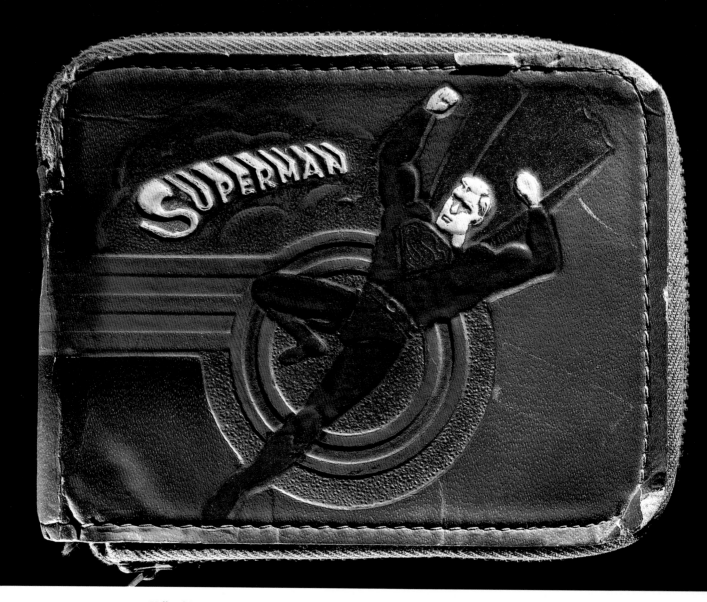

"Official Superman Billfold" from Hidecraft (1947). Pencil box from Hassenfeld Brothers (1940).

Jerry Siegel's Robotman looked his best after he fell into the hands of artist Jimmy Thompson. From *Star Spangled Comics* #72 (September 1947).

Everything was in place by the time the second cartoon, *The Mechanical Monsters,* was released near the end of 1941. Arguably the best film of the bunch, it featured Superman battling an army of gigantic, flame-spewing, flying robots in a series of sensational scenes. Later special effects extravaganzas include *The Bulleteers,* in which an airborne torpedo smashes through the skyscrapers of Metropolis, and *The Magnetic Telescope,* in which an astronomer's harebrained invention sends an asteroid hurtling earthward. When not struggling with mad scientists, Superman took on ferocious forces of nature like gorillas (*Terror on the Midway*) or dinosaurs (*The Arctic Giant*).

After the collapse of the Fleischer studio, Paramount formed Famous Studios and continued the series by having Superman fight in World War II. The first offering was the xenophobically titled *Japoteurs* (1942), and four of the remaining seven cartoons had similar themes. Budgets also seemed to have been trimmed, although the new studio, which employed several Fleischer veterans, was still capable of producing such vivid fantasies as *The Mummy Strikes* and *Underground World* just before the Superman series ended in 1943. Jerry Siegel was very pleased with the cartoons. "They were great," he said. "That was full animation, and the early cartoons adhered very closely to what we were doing in the comics."

• • •

Although creators Jerry Siegel and Joe Shuster were generally out of the loop when it came to media adaptations of Superman, Shuster did stop by the Fleischer animation studio while visiting Miami. He reported that he spent "a couple of days" drawing model sheets of Lois Lane, Clark Kent, and Superman. More surprising than his participation in the films was that the once impoverished artist was now able to afford a Florida vacation. He and Siegel had come a long way in a short time, having negotiated several increases in their page rates. They were also getting a percentage of the proceeds from all subsidiary rights

The limitless abilities of Jerry Siegel's creepy character the Spectre included the power to loom large. Cover by Bernard Baily for *More Fun Comics* #57 (July 1940).

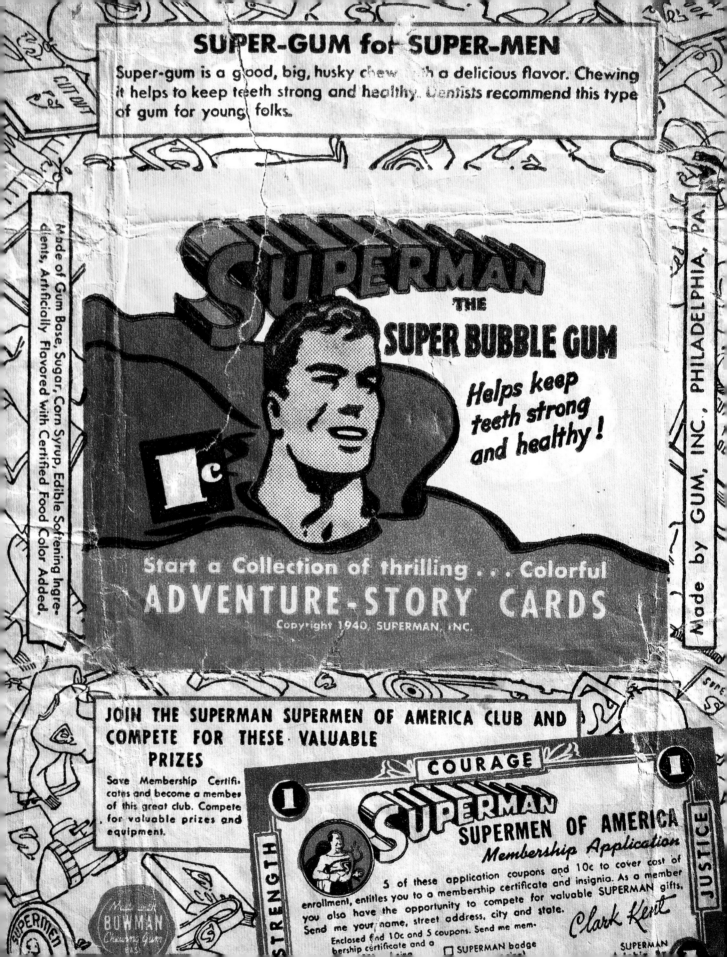

With Superman seemingly sealed in crystal, the Ultra-Humanite exults in *Action Comics* #14 (July 1939).

licensed by Superman, Inc. Contemporary published reports estimated their joint annual income at over $100,000, but Siegel insisted that they never made more than $30,000 apiece. Adjusted for inflation, the lower figure is the equivalent of $315,000 today, indicating that Siegel and Shuster were doing very well.

Shuster moved his entire family, including parents and siblings, into a ten-room house and concentrated on building himself up with a regimen of weight lifting and a diet of steaks and milk. He continued to work in the Cleveland office with his art staff, while Jerry Siegel usually wrote at home. Siegel and his new wife, Bella, had bought a house, where he turned out his Superman scripts to the accompaniment of recordings by the Benny Goodman jazz band. Shuster, already suffering from vision problems that would grow worse every year, had his hands full with Superman, but Siegel found time to create new super heroes. The Spectre was drawn by Bernard Baily and first appeared in *More Fun Comics* #52 (February 1940). A policeman granted supernatural powers to avenge his own murder, the Spectre was unrelievedly grim. There was also something slightly morbid about Robotman, a scientist so horribly injured that his brain was installed in a mechanical man. Originally drawn by Paul Cassidy, he got his start in *Star Spangled Comics* #7 (April 1942). Perhaps these characters represented some sense of loss that Siegel experienced along with his newfound sense of power; by 1941 he was already looking back into the youth of Superman and making plans for something to be called Superboy. The feature would focus on an adolescent's practical jokes, and Siegel said, "It will be about Superman before he developed a social conscience."

The adult Superman's social conscience was also less in evidence by 1941; that particular well of inspiration appeared to have run dry, or perhaps the change was the result of DC's editorial policy. Shuster said that as time went by the partners were more "restricted" in terms of their material, and by 1941 Siegel was submitting his scripts for the

approval of editorial director Whitney Ellsworth before they were turned over to the artists. With the number of DC's characters and comic books ever on the increase, the company hired a managing editor, Mort Weisinger. A science fiction fan who had corresponded with Jerry Siegel when they were teenagers, Weisinger grew up to become editor of the pulps *Thrilling Wonder Stories* and *Startling Stories,* but he barely got started at DC before he was drafted; pulp colleague Jack Schiff replaced him. By the time World War II was over, DC had expanded so much that the services of both men were required. "I thought that my experience in the pulps would help if we could use that in the comics," said Schiff, who actively worked to contribute plot ideas. "We managed to get tight stories."

• • •

A good hero required a worthy opponent, and to some extent the history of Superman became the story of his villains. As the *New York Times* put it during Superman's first decade, "the gimmick is to create characters that are competition." The earliest super villains, the ones who returned again and again to provide overpowering challenges for the Man of Steel, were mad scientists. First of the breed was the Ultra-Humanite. This hairless "mental giant," whose name was a synonym for "Superman," seems to have been modeled by Siegel and Shuster on the original, evil Superman they had created back in 1933. In his first appearance, in *Action Comics* #13 (June 1939), the Ultra-Humanite describes himself as "the head of a vast ring of evil enterprises" and is content to attack Superman with

The gum that helped "keep teeth strong" is long gone, but the 1940 cards produced by Gum, Inc., are still in collections today.

If you can't beat him, you can wear him down: two pests team up to give a hero a headache, in a story that exemplifies its era, from *Superman* #40 (May–June 1946). Writer: Alvin Schwartz. Artist: Ira Yarbrough.

Propelled on a pogo stick, the Toyman makes his debut dodging Superman on the cover of *Action Comics #64* (September 1943). Art by Ed Dobrotka.

mundane devices like electricity and a buzz saw. But by the next month the villain has developed the power of invisibility, and in the issues that followed, his inventions included early versions of cellular phones, holograms, and biological weapons. Accidentally killed by one of his own futuristic weapons, he is briefly resurrected and instructs his assistants to transplant his twisted brain into the head of glamorous movie star Dolores Winters. Now a transvestite terror, the Ultra-Humanite presses forward with rays and robots but ultimately leaps into a volcano when cornered by Superman in *Action Comics* #21 (February 1940).

Lex Luthor, who turned out to be the Ultra-Humanite's longer-lived successor, made his debut just two months later in *Action Comics* #23. Originally equipped with a full head of red hair, by 1941 Luthor was conforming to Siegel and Shuster's hairless-mastermind stereotype. From the start he had a planetary agenda that put the Ultra-Humanite's attacks on Metropolis to shame. In his original appearance, Luthor is shown fomenting a war in Europe as part of his plan for world domination; he makes his headquarters in a city in the sky supported by a gigantic dirigible. *Superman* #4 (Spring 1940), his next appearance, shows Luthor hiding out in an undersea city, assaulting the world with earthquakes, and challenging Superman to a contest of strength versus science. By 1942, he is using electricity to give himself powers almost equal to his archenemy's; small wonder, then, that he is sometimes called "the super scientist." Sentenced to die for his crimes, he is merely invigorated by the power of the electric chair and even achieves gigantic size during the course of one adventure. Thwarted by Superman at every turn, Luthor has transferred his base of operations to outer space by late 1942, and by 1945 is using alien technology to create rays that can do anything from melting steel to making people too lazy to resist him. A character of limitless ambition, Luthor has been and remains Superman's most famous foe.

Indeed, Luthor was such a magnificent menace that other villains who tried for viciousness tended

This scene of postwar domestic bliss, from *Superman #36* (September–October 1945) creates the erroneous impression that Superman and Lois Lane may have set up housekeeping. Pencils: Wayne Boring. Inks: Stan Kaye.

to fade into insignificance. The Archer, credited with being Superman's first costumed adversary, may have been a ruthless killer, but he disappeared for forty-one years after making one appearance in *Superman* #13 (November–December 1941). The bearded and bespectacled Puzzler was a homicidal villain obsessed with tricks and games, but his gimmicks weren't enough to keep him around for long. He showed up in June 1942 and was gone by January 1943, no doubt baffled to realize that he was last seen making a mysterious escape from Superman but that nobody was interested enough to bring him back.

Wardrobe and stunts weren't enough to make first-rate enemies for Superman, and he could hardly be intimidated by mere brute strength. "As the strip went on we made him more and more powerful," Jerry Siegel admitted, and the counteractive kryptonite didn't show up in the comics until 1949. There was actually no way to intimidate Superman with violence. What was required was attitude.

A key ingredient in the success of Superman during what is now called the Golden Age of comic books was a sense of humor. "There was a spirit of fun in the thing," said Jerry Siegel. "And as a matter of fact, Joe and I, when we first started going into comics, had intended to do a comedy strip. So we were very comedy oriented, and that's why *Superman* did have this comic flair to it." Superman couldn't be defeated, but he could be deflated, and many of the most memorable enemies of his early years were clowns.

Famous for her fish stories, Susie has a whale of a tale to tell on the cover of *Action Comics* #68 (January 1944). Pencils: Jack Burnley. Inks: Ed Dobrotka.

SUPERMAN'S NAUGHTIEST NEMESIS

Of all the unusual antagonists faced by Superman during his early comic book adventures, none was more improbable or more annoying than freckle-faced, pigtailed, eight-year-old Susie Tompkins. The niece of Lois Lane, Susie was billed as "the girl who loves to tell whoppers," and she literally gave Superman nightmares the first time they met, in *Action Comics* #59 (April 1943). While baby-sitting, he fell asleep and dreamed he was forced to serve as her fairy godmother. In further adventures she continually created havoc for Superman with her tall tales. In 1946 she even enlisted the aid of that mischievous sprite Mr. Mxyzptlk to turn her wildest imaginings into bizarre reality. Susie's adventures continued until 1955, when she retired after accidentally setting off a time machine that whisked her back to the days of the Arabian Nights. To retrieve the device and rescue her, Superman was forced to assume the guise of her genie and fulfill her every desire. When it came to making Superman play the fool, Susie Tompkins had no peer.

The earliest opponent to really play for laughs was the Prankster. A corny practical joker who considered himself "the funniest man in the world," the Prankster had a bulbous body, a scrawny neck, and a goofy, gap-toothed grin. Showing up in *Action Comics* #51 (August 1942), he began forcing his way into banks to give away money, but it was only a trick to prepare the way for the illegal withdrawal of larger sums. In his next outing he announced his reformation and won wealthy patrons, but only to gain access to their cash. When confronted by an angry Superman, the Prankster deftly ducked and caused the Man of Steel to punch himself in the jaw. By the time of *Action Comics* #95 (April 1946), the Prankster was so good at humiliating Superman that he drove the Man of Steel (at least temporarily) into retirement. Time and again, the Prankster's needling hurt Superman more than a dozen death rays.

The Toyman's childish crimes sometimes had a similar effect. Myopic and middle-aged, with unfashionably long hair, the Toyman committed his first robbery with the aid of ingenious wooden soldiers in *Action Comics* #64 (September 1943). When captured by Superman, he promised to strike back: "How the world will laugh when Superman is defeated by a toy!" He later pulled off robberies with the help of toy policemen or even toy Supermen, and in 1949 demonstrated a more practical side by constructing an early computer called a "super brain." The Toyman and the

Prankster teamed up with Lex Luthor in a memorable story illustrated by Wayne Boring for *Superman* #88 (March 1954), but the trio's defeat seemed to devastate the two comedians, who dropped out of comics altogether.

All but forgotten today, J. Wilbur Wolfingham was another funny foe whose numerous encounters with Superman spanned a decade. A con man sporting a cigar and a monocle, Wolfingham was clearly inspired by the irascible entertainer W. C. Fields, a point made clear by the plot of his first adventure in *Superman* #26 (January–February 1944), when he defrauded a group of film comedians. Wolfingham was often outsmarted rather than outfought by Superman, who frequently arranged for the swindler's schemes to rebound to the benefit of their intended victims.

No adversary was more amusing than the little imp whom Jerry Siegel originally called Mr. Mxyztplk. Only Lex Luthor has proven to be a more enduring villain. First drawn for the comic books by Ira Yarbrough, Mr. Mxyztplk caught the eye of DC's editorial director Whitney Ellsworth. He jumped the gun and wrote the character into a newspaper sequence, where Mxyztplk made his debut in February 1944. The character then showed up in *Superman* #30 (September–October 1944). Such a mixed-up debut was typical for Mxyztplk, a minuscule man from another dimension whose goal was driving people, especially Superman, crazy. A court jester in his own world, he had magical powers in ours and could be exorcised only if tricked into pronouncing his own name backward. Inspired by the Warner Bros. cartoon character Bugs Bunny, Mxyztplk described himself as "just as mean as mean can be" and delighted in making Superman feel like a buffoon on the order of Elmer Fudd. He even fooled DC's editors, who later misspelled his name as Mxyzptlk, and then just left it that way. He was Jerry Siegel's ultimate comedy character, and perhaps his last important contribution to the foundation of Superman lore, for the creation was growing away from his creators.

The maddening Mr. Mxyztplk explains his role in the scheme of things to the Man of Steel in *Superman* #30 (September–October 1944). Script: Jerry Siegel. Art: Ira Yarbrough.

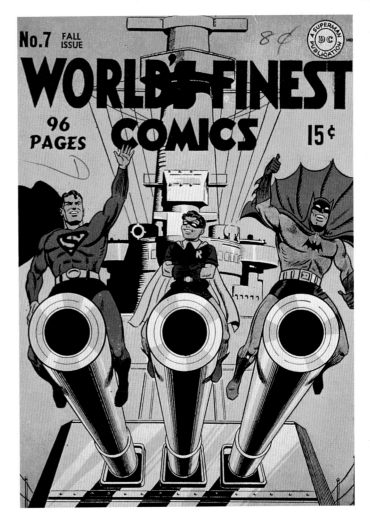

Joe Shuster's vision was growing steadily worse. He was contributing less to the artwork coming out of the Cleveland studio, while other artists like Wayne Boring were now working directly for DC, usually under the supervision of editor Jack Schiff. New writers were also making their mark. In fact the second Mr. Mxyztplk story was written by Don Cameron, in part because Jerry Siegel had been drafted in 1943. Siegel was enough of a celebrity that he was sworn into the army in a special ceremony during Cleveland's Festival of Freedom on the Fourth of July. Ordered to report to the service newspaper *Stars and Stripes,* Siegel still found time to write some Superman stories, but was also assigned a lot of time peeling potatoes to instill him with some sense of army discipline. Shuster was exempted from the draft because of poor eyesight, and in the comics Clark Kent received the same exemption when his X-ray vision caused him to misread an eye chart.

Joining Don Cameron as another new writer on *Superman* was Alvin Schwartz, who started out in the comic books but was soon paired with Wayne Boring on the newspaper strip. Schwartz's most memorable moment came when he innocently got Superman involved with a cyclotron, a scientific device he recalled from an old magazine article. Unbeknownst to Schwartz, the cyclotron was a key element in the ongoing creation of the atomic bomb, and suddenly Superman was under investigation by the War Department. Some papers mysteriously stopped running the strip, but the affair ended without many repercussions. A secret document prepared by Lt. Colonel John Lansdale Jr. on April 21, 1945, concluded, "It is impossible to censor comic strips as the Office of Censorship does not have the personnel for such a task. Also, to attempt to do so would call a great deal of attention to secret matters." And Lansdale had another point to make to the engineers at work at Oak Ridge, Tennessee: "It is further believed that the 'funny page' characterization of a cyclotron will considerably deemphasize any serious consideration of the apparatus by many people."

A different sort of crisis arose a few years later when Don Cameron wrote the scripts for a new comic book series about Superboy, which first appeared in *More Fun Comics* #101 (January–February 1945). The initial Superboy stories, only a few pages long, featured a small, helpful child, already dressed in the familiar costume. Within a year, the character made a transition to adolescence and was featured in a series deeply rooted in the idyllic town of Smallville and the home of his foster parents, the Kents. As Superboy evolved, his exploits were transferred in 1946 to *Adventure Comics,* where he became the leading character and appeared on the covers. Superboy was a success, and his own comic book would start in March–April 1949. One person wasn't a fan, however, and that was Jerry Siegel.

Your purchase of War Stamps and Bonds will help

STAMP OUT the JAPANAZIS!

Best personal wishes from Jerry Siegel & Joe Shuster

Small store signs like this one helped encourage the sale of stamps and bonds during World War II.

In April 1947, Siegel and Shuster sued DC, hoping to win $5 million and regain the rights to Superman. Ever since Superman had become a hit, they had chafed at the idea that their publisher claimed ownership of the character and was taking the lion's share of the proceeds. Furthermore, their income had begun to drop after the war. Although Siegel and Shuster may have viewed this decline with suspicion, it's likely that Superman (along with many other super heroes closely associated with the war effort) had gone into a temporary decline with the coming of peace in 1945. Other comic book genres, like crime and romance, were in the ascendancy. Siegel, who seems to have been the driving force behind the lawsuit, viewed DC's other super heroes as competition that cut into his income, and he was especially resentful of Superboy. Siegel's initial idea of the character as a trouble-

maker had not found favor with DC, and yet the company had published a different version and even put Siegel's byline on it.

Initially, Siegel and Shuster found an ally in M. C. Gaines, the publishing executive who had originally recommended Superman to DC. Gaines had been a partner in All American, DC's sister company, home to heroes like Wonder Woman and the Flash. Eventually, personality conflicts had led him to sell out his interest, and the company was absorbed into DC. Gaines then started EC Comics, which would later (under the leadership of his son William) introduce such influential titles as *Tales from the Crypt* and *MAD*. In 1955, years after the Siegel and Shuster lawsuit, the younger Gaines offered his recollections. "As I get the story, a couple of sharp lawyers got ahold of these boys and got them malcontented," Bill Gaines said. "After my

Chapter titles like "The Skeleton Ship" and "Fire at Sea" enlivened the maritime mystery in the first Superman novel.

SUPERMAN BY THE BOOK

Superman moved into yet another medium with the publication of George Lowther's 1942 novel *The Adventures of Superman*. Lowther had worked as narrator and writer on the radio series of the same name, and he had become its director that same year. He was eminently qualified to put the radio version of Superman's background into the early pages of the book, but he contradicted it instead, expounding at length on Superman's childhood as the adopted son of the Kents. He also gave them names, Sarah and Eben, which were later changed in the comic, and altered the names of Superman's Kryptonian parents to Jor-el and Lara, while providing new details about life on the dying planet of Krypton. The bulk of his narrative pitted Superman against apparent hauntings, which were merely a mask for Nazi spies. The story is perhaps less memorable than a handful of color paintings produced as illustrations by Joe Shuster's Cleveland studio. Although primarily intended for a juvenile audience, the book marked the first time a character created for comic books was the protagonist of a novel.

SUPERBOY

THOUSANDS OF FOLLOWERS OF THE GREAT **SUPERMAN** HAVE ASKED THE ANSWERS TO THESE QUESTIONS: " WHAT IS THE STORY OF **SUPERMAN'S** ORIGIN ?"-- AND " WHAT WAS **SUPERMAN** LIKE BEFORE HE GREW TO MAN'S ESTATE -- WAS HE JUST AN ORDINARY BOY, OR WAS HE A "**SUPERBOY** ? "

IN THIS STORY YOU WILL FIND THE ANSWERS TO THOSE QUESTIONS --AND, WE BELIEVE, YOU WILL LOOK FORWARD TO THE FURTHER ADVENTURES OF THE YOUTH WHO WAS DESTINED TO BECOME THE IDOL OF MILLIONS AS THE GREAT **SUPERMAN!** FOR THESE STORIES WILL DEAL WITH...

SUPERBOY!

father had broken with the DC bunch, they came down and gave a sob story to my father. So my father got righteous indignation and started to aid and abet their lawsuit against DC." The elder Gaines began to feel that Siegel and Shuster were misrepresenting some of the facts in the case, "at which point," his son remembered, "he dropped them like hot potatoes and that was the end of that."

While the suit was pending, Jerry Siegel met Joanne Carter for the first time in over ten years. The schoolgirl who had modeled for Lois Lane had kept in touch with Joe Shuster through the mail, and he escorted her to a costume ball given by the National Cartoonists Society when she visited New York. "It was at the New York Plaza, and all the great comic strip artists were there," she recalled. "Jerry and I were reunited at that time. He

Don Cameron wrote the script and Joe Shuster apparently did the unsigned art for the first appearance of Superboy in *More Fun Comics* #101 (January–February 1945).

stayed in New York, and a few months later we were married." There's no record of how Joe Shuster responded to this sequence of events, but there was another problem to consider: at the time, Jerry Siegel was married to another woman.

Siegel's first wife, Bella, sued for divorce on July 14, 1948, and a decree was granted on October 7. The speed of that divorce annoyed Cleveland Judge Samuel Silbert, who had ruled that divorces in his court should be held up for six months to prevent the tendency to "jump in and out of marriage." Nonetheless, the October 15 issue of the *Cleveland Plain Dealer* proclaimed that on the previous day Siegel had married "Miss Jolan Kovacs, a model known professionally as Joanne Carter." Later, the newspaper reported that Siegel had asked the license bureau to keep the wedding a secret, so that it could be exclusively announced by Walter Winchell, the powerful New York columnist.

A few months earlier, the lawsuit with DC had been decided. In May the court had decreed, according to *Newsweek,* that Siegel and Shuster "had no property rights in Superman since they had assigned all rights to the publisher at the start of Superman's and their own career ten years earlier." A settlement was arranged in which the pair received $100,000 for signing a quitclaim to both Superman and Superboy. A new Siegel and Shuster character, Funnyman, was announced with much fanfare, but his comic book, published by Magazine Enterprises, lasted only six issues. In a shockingly short time, the partners found themselves just about out of the comics business, with most of their money eaten up by legal fees and their bylines removed from the Superman comic books and newspaper strips. A final reconciliation with DC would not take place for more than a quarter of a century.

Lana gets stood up at the prom on the cover of *Superboy* #34 (July 1954). Art: Win Mortimer.

Superman proceeded to get a face-lift at DC. Although many artists had ghosted Superman, the work had been done under Joe Shuster's name, and the art style was based on his bold, vigorous cartooning. By 1948, Wayne Boring had given the Man of Steel a new look, on view in stories like the tenth-anniversary retelling of "The Origin of Superman" in *Superman* #53 (July–August 1948). By now the idea of Ma and Pa Kent raising Clark and instilling him with basic virtues was in place, and Superman was drawn in a more detailed, realistic style of illustration. He also looked bigger and stronger. "Until then Superman had always seemed squat," Boring said. "He was six heads high, a bit shorter than normal. I made him taller—nine heads high—but kept his massive chest."

Also contributing to the new sense of Superman as a more serious, believable character was the first sustained appearance by an actor in the part. Previously Superman had been only a radio voice or an animated cartoon, but in 1948 he became the hero of a live-action movie serial, unreeling one chapter a week at Saturday matinees for kids. In keeping with tradition, nobody received credit for playing Superman, but it didn't take a detective to realize that it was the same performer who was listed as portraying Clark Kent, and that his name was Kirk Alyn. A former dancer who had appeared on Broadway with stars like Ethel Merman and Ginger Rogers, Alyn was a bit dismayed when he went for an audition in producer Sam Katzman's office and was told to strip to his underwear. "I said, 'Wait a minute! What kind of interview is this?'" Alyn recalled, but he was finally convinced that his build would determine his suitability for the role. "I was working with barbells, so I was in good physical shape."

Sam Katzman, who had made dozens of low-budget movies for Columbia, was the logical producer for the 1948 serial *Superman*. His penny-pinching methods might not have produced the best possible results from an artistic perspective, but he rarely failed to turn a profit, and *Superman*

became the biggest moneymaker in the long history of serials. Director Spencer Bennet rarely filmed more than one take, and special effects to show Superman flying were achieved with the aid of some fairly crude animation. Such cost-cutting methods were considered good enough for the juvenile audience who flocked to see each new chapter, encouraged by constant plugs on the *Superman* radio show. What they saw was a hackneyed but serviceable story about the hero's struggles with someone called the Spider Lady for control of the dreaded Reducer Ray, with most of the suspense provided courtesy of kryptonite.

The most attractive aspects of the serial were provided by Alyn's earnest performance and the perky personality of his Lois Lane, Noel Neill. "I tried to look like her," said Neill, "but that's about all we did for any in-depth study. We didn't have time. We did a lot of exteriors and a lot of chases, and it was almost like a western with the hero in long underwear."

The inevitable follow-up to such a big success was *Atom Man vs. Superman* (1950), a fifteen-part serial, in which the title villain was not the radio character, but rather comic book bad guy Lex Luthor (Lyle Talbot). Wearing an uncomfortable plastic bald cap, Talbot made an impressively stern Luthor as he fiddled with a laboratory full of futuristic equipment. "Oh, all the dials we had in that one set there! Those were just things that they'd gotten from the phone company or somewhere, and they put them on the wall with a lot of lights behind them," Talbot said. "You had a sense of humor, and you'd laugh about certain things, but our approach was never to kid it. This had to be for real."

More elaborately plotted than its predecessor,

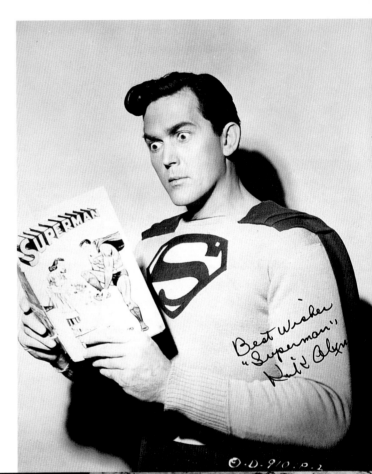

Kirk Alyn, the first cinema Superman, is wide-eyed with wonder as he beholds *Superman #51* (March-April 1948).

Tommy Bond as Jimmy Olsen, Noel Neill as Lois Lane, and Kirk Alyn as Clark Kent are on the rocks in the serial *Superman* (1948).

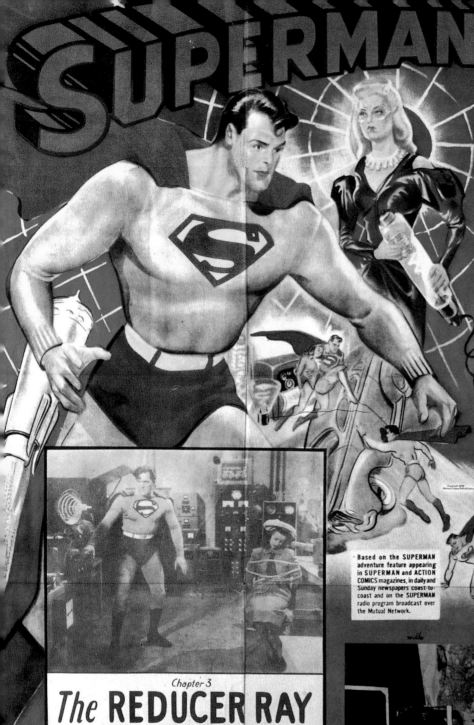

This poster, with a different photo insert for each of the fifteen chapters, helped draw record crowds to the first *Superman* serial.

Atom Man vs. Superman came complete with fires, floods, and flying saucers. Because the budget would cover only stock footage and animation, the result fell shorter of its aspirations than the more modest *Superman.* In any case, serials were on their way out by 1950 (so, for that matter, was radio drama), and television was the coming thing. Whitney Ellsworth, DC's editorial director, who had served as a consultant on the serials, was spending more and more time in Hollywood, working on a film that was also a pilot for a TV series. Ellsworth's defection meant that he was no longer available to supervise Superman's editor Mort Weisinger, who now assumed complete control over the Man of Steel's comic book career. As things turned out, the controversial Weisinger would guide Superman's destiny for the next twenty years.

Based on the SUPERMAN adventure feature appearing in SUPERMAN and ACTION COMICS magazines, in daily and Sunday newspapers coast-to-coast and on the SUPERMAN radio program broadcast over the Mutual Network.

Chapter 3
The REDUCER RAY
A COLUMBIA SERIAL
Directed by SPENCER BENNET and TH

Lyle Talbot as Lex Luthor reads the headlines to his henchmen on this lobby card from the second Superman serial.

Opposite: This classic tale from *Action Comics* #47 (April 1942) ranges from social satire to epic adventure, pitting a Superman the cops don't trust against a Luthor who has acquired super-powers and even fangs. Script: Jerry Siegel. Art: John Sikela.

SUPERMAN
MEETS
ATOM MAN
Chapter 4

A COLUMBIA SE

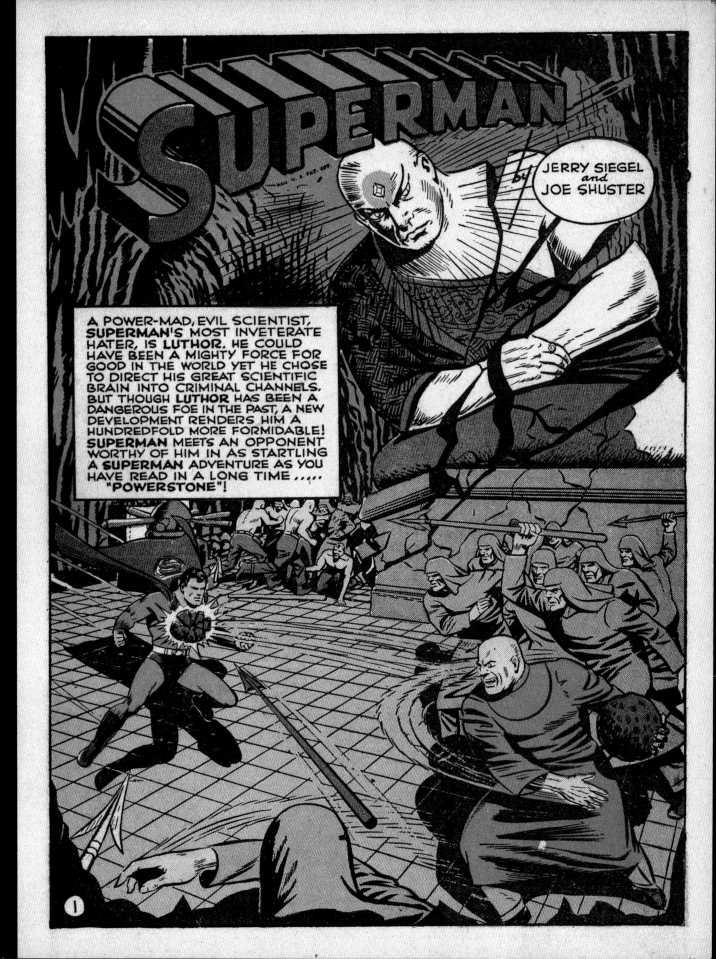

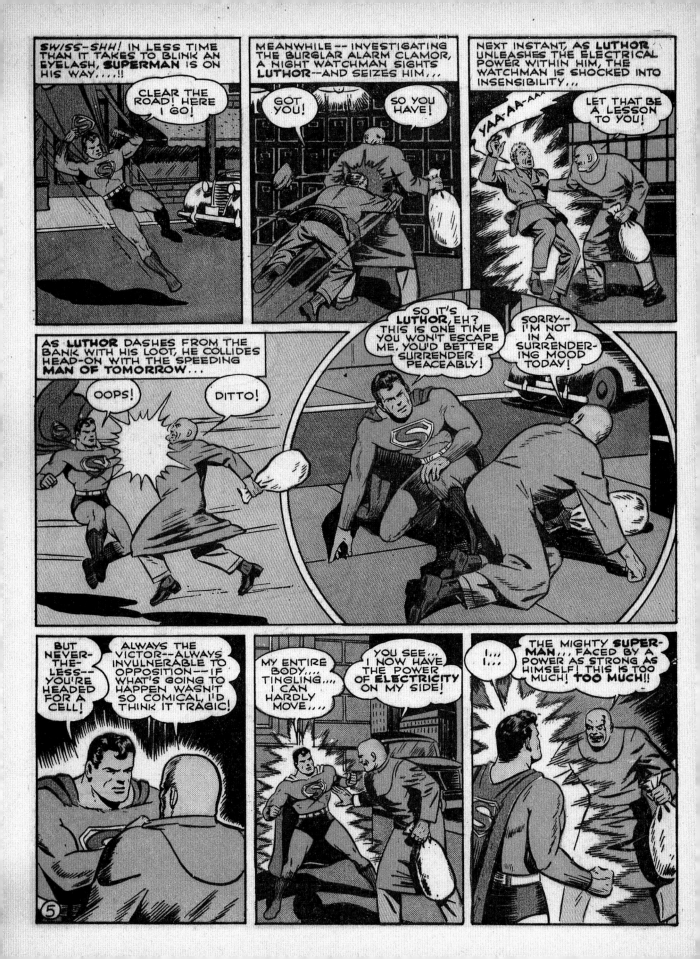

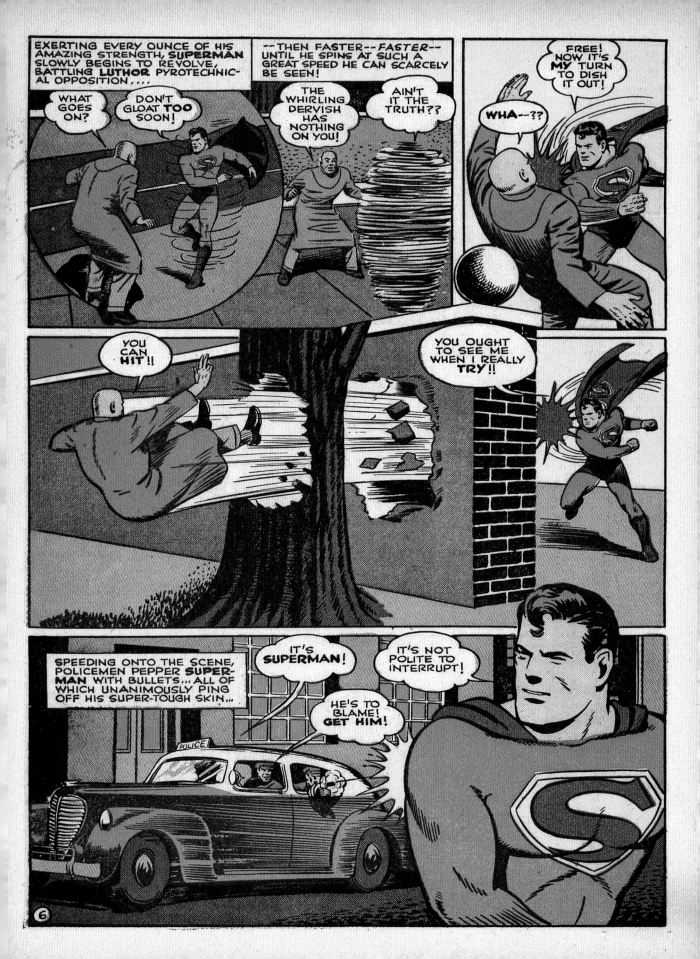

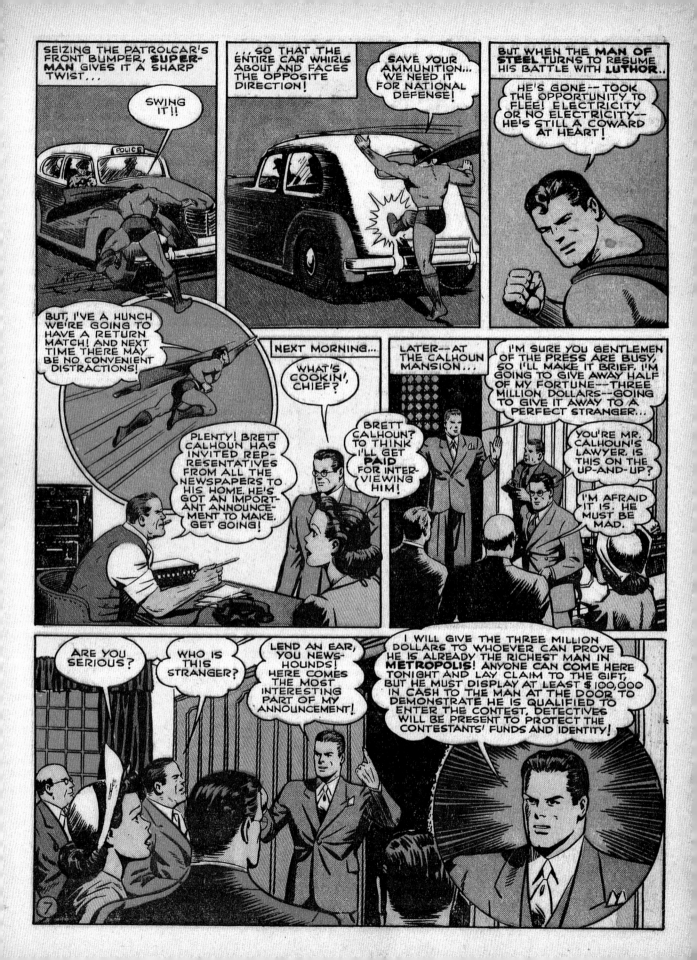

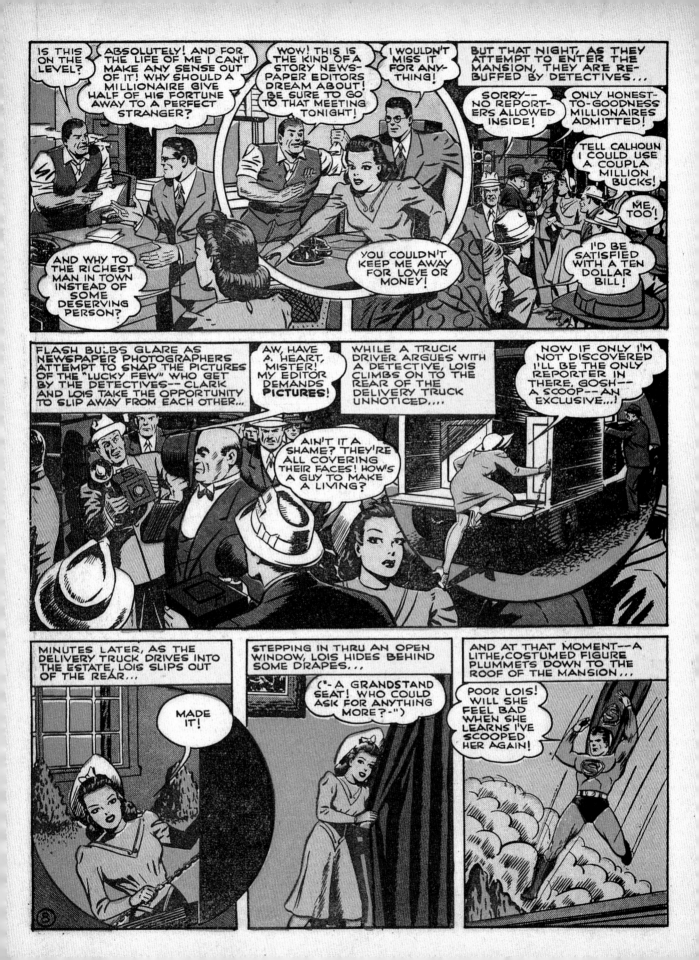

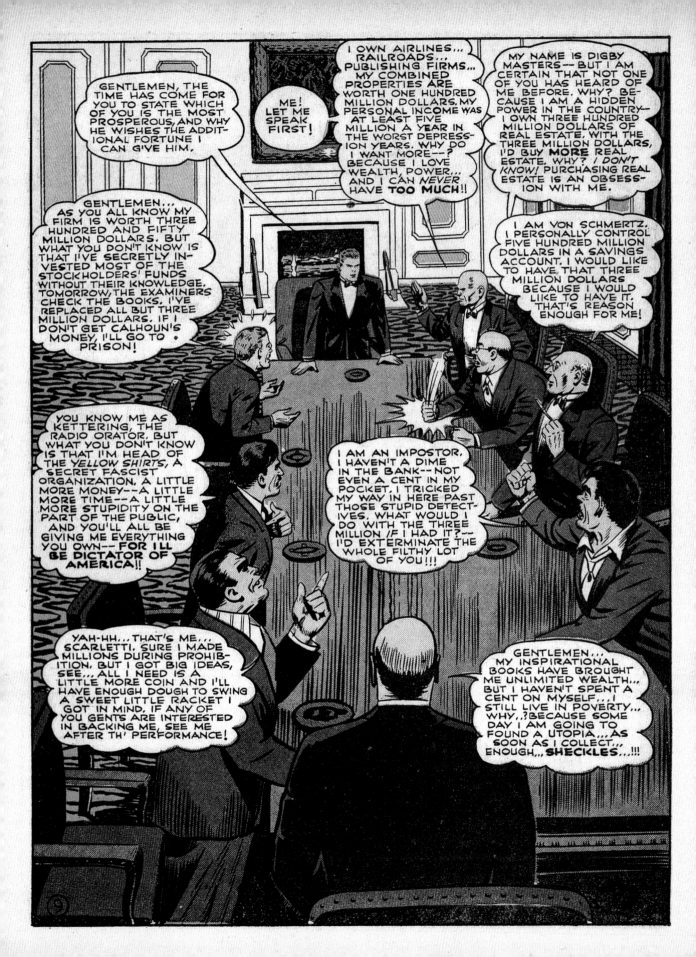

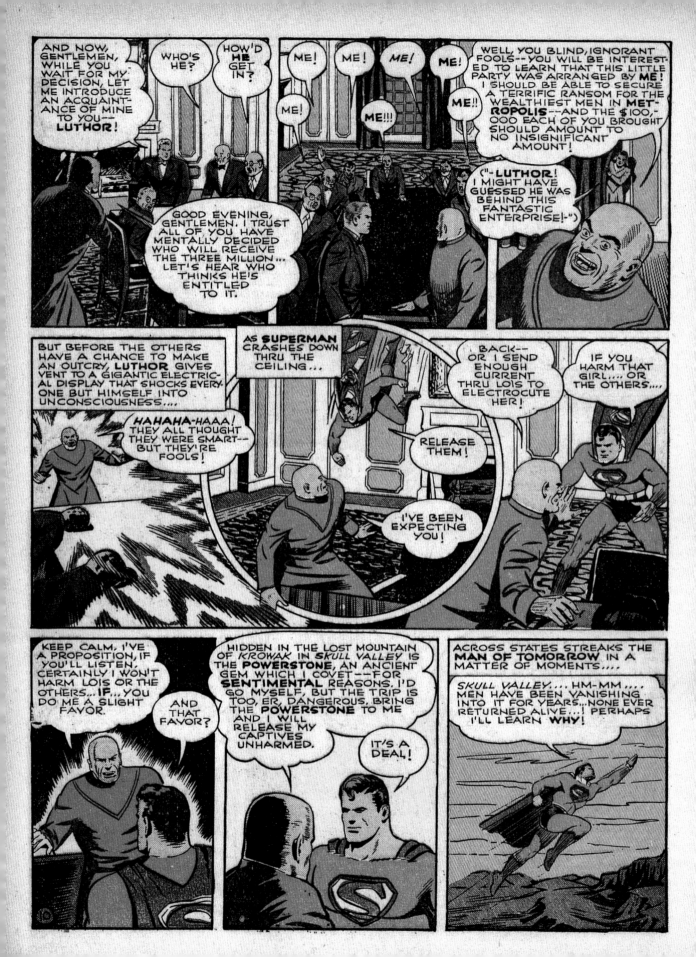

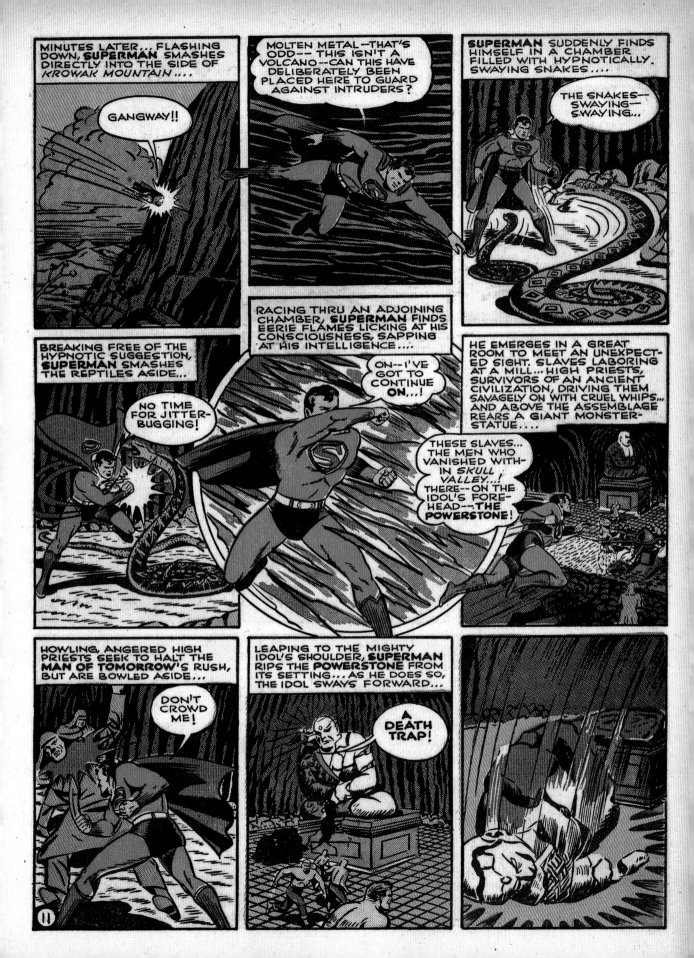

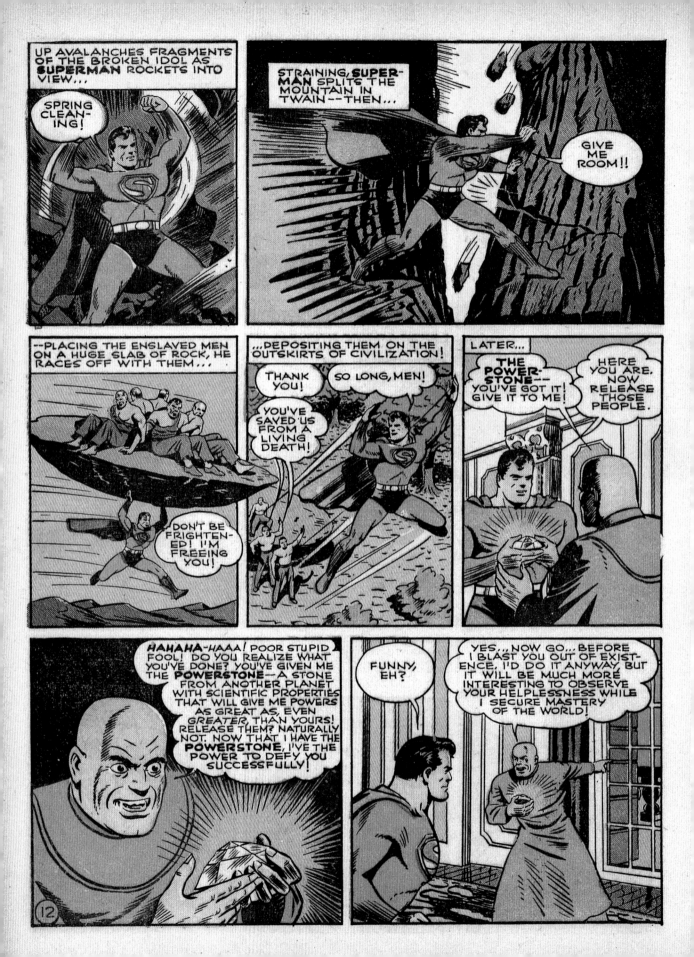

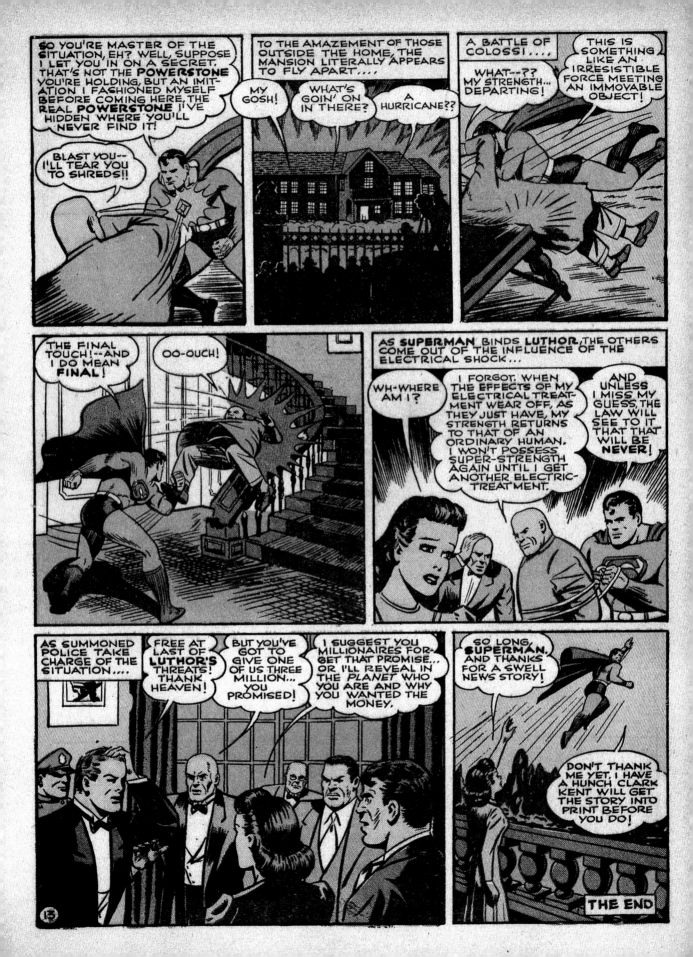

TRANSFORMATION

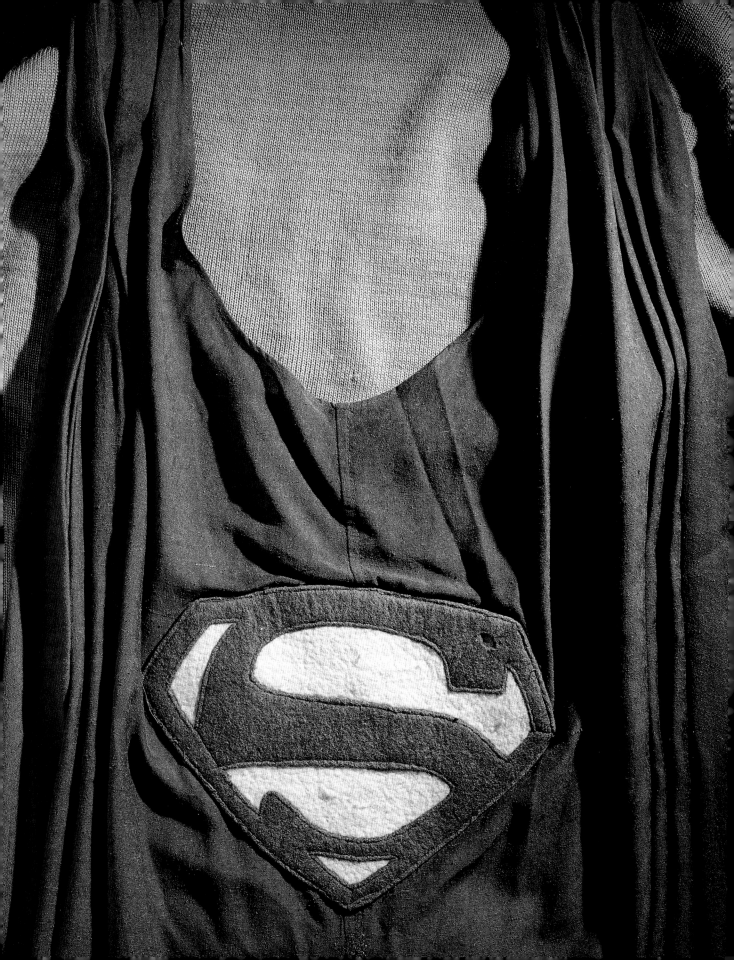

George Reeves and longtime companion Toni Mannix laugh it up with producer and editor Whitney Ellsworth.

Production on Superman's first television series began in 1951, only a few months after the release of his second motion picture serial and while his radio program was still on the air. But the TV show seems to mark Superman's entry into the modern world. With its 104 episodes regularly broadcast for more than forty years, this show has become the earliest version of the Man of Steel that is familiar to a general audience. Despite its low budget, erratic production schedule, and difficult working conditions, *The Adventures of Superman* has survived as a television classic.

Superman's publishers decided to take charge of creating the show themselves. "I sent Robert Maxwell out to organize the film company," recalled DC's Jack Liebowitz, relying on the man who had been so successful with both product licensing and radio. Proceeding with extreme caution, Maxwell wrote the pilot script himself under an alias, worked with a more experienced producer (Barney Sarecky), and arranged that the pilot film would be long enough to earn back its cost by playing in movie theaters as a feature. The result, *Superman and the Mole Men,* ran about an hour and was later shown as the only two-parter of the thirty-minute series, under the title "The Unknown People." By either name, the show—a plea for tolerance on behalf of a subterranean race of little people whose world is disturbed by an oil rig—is preachy, rather dull, and unconvincing in its fantasy elements (for a brief flying scene, the crude animation from the serials is employed again). Yet it served its purpose by demonstrating that an inexpensive show was feasible and by casting the right actor to play Superman. His name was George Reeves, and he still has fans who believe that the affable dignity and earnest conviction of his interpretation have yet to be surpassed. "George had a classic profile and a strong jaw—and he was a good actor," said series director Thomas Carr. "Some of the potential stars we tested had one or the other, but George had both." Reeves eschewed stereotypical bumbling as Clark Kent, which worked

Noel Neill and George Reeves take a coffee break on the set of *The Adventures of Superman.*

Lucille Ball gets a grip on the Biceps from Krypton in this scene from *I Love Lucy*.

WHO LOVES LUCY?

It's a measure of the mark George Reeves had made on the popular culture of the 1950s that he was invited to appear on the decade's most popular situation comedy, *I Love Lucy*. Such guest shots were generally reserved for Hollywood icons like John Wayne, Rock Hudson, or Harpo Marx, but in 1956 Reeves joined their illustrious company—or rather Superman did. The days were long gone when actors were expected to play Superman anonymously, but Reeves went unbilled in *I Love Lucy*'s credits and was always referred to as "Superman" in the script by Madelyn Pugh and three Bobs: Carroll, Schiller, and Weiskopf. Yet the character in the story is clearly in show biz, a friend of bandleader Ricky Ricardo (Desi Arnaz) who can't make it to Little Ricky's birthday party. It seems he has a flight to catch, but as wife Lucy (Lucille Ball) asks indignantly, "If he's Superman, what does he need a plane for?"

Lucy decides to replace the missing guest, and dons a ridiculous outfit consisting of tights, boots, cape, football helmet, and plaid boxer shorts. Of course Superman does show up after all, just in time to rescue the redhead, who's trapped in the rain, covered with pigeons, on a ledge outside her third-floor apartment. "Do you mean to say you've been married to her for fifteen years?" the rescuer demands of Ricky. "And they call me Superman!"

I Love Lucy, which along with *The Adventures of Superman* is one of the few shows of that time still popular today, owes its longevity, in part, to its preservation on film via the three-camera technique invented by Oscar-winning cinematographer Karl Freund to preserve live performances. A generation earlier, in Germany, Freund had photographed *Metropolis*, the silent film that helped inspire Superman.

particularly well because Kent had to carry most stories; Superman's stunts were often saved for the climax of each episode.

Maxwell got the green light to make twenty-six episodes of *The Adventures of Superman* in 1951, with Phyllis Coates returning from the pilot to play a no-nonsense Lois Lane. She was a good match for Reeves's capable Clark Kent. These early episodes, filmed in black and white, have adherents who praise them for their dark, dramatic tone. The villains meant business and death was not uncommon—although a certain amount of comedy relief was provided by the exuberant Jimmy Olsen (Jack Larson) and the irascible Perry White (John Hamilton). The early episodes were hard on Reeves, who suffered some injuries while performing stunts like flying or crashing through walls.

The program was not broadcast until 1953, when Kellogg's cereals agreed to sponsor *Superman* in syndication. Another set of twenty-six shows was ordered, but by then Robert Maxwell was gone—

Owning this lithographed lunchbox from 1956 was like finding a sandwich in your comic book.

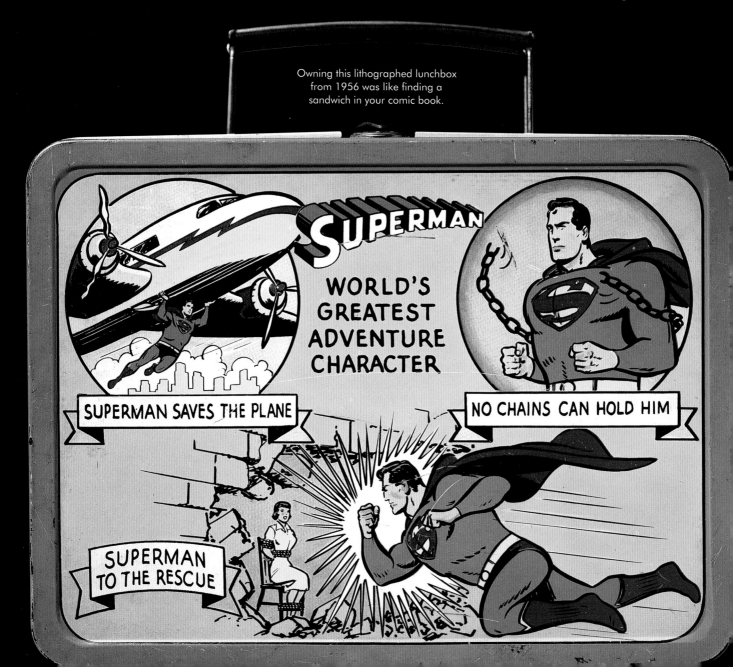

"by mutual consent," according to Jack Liebowitz. Some commentators have suggested that Maxwell left because DC and Kellogg's wanted a lighter, more juvenile program, but Liebowitz has insisted that the problem was the producer's tendency to exceed his budgets. Maxwell went on to a career that included the TV version of *Lassie.* "I sent out Whitney Ellsworth and Mort Weisinger to organize the film company," Liebowitz said. "I always wanted to do the films myself. I didn't want to send them out to subcontractors."

Ellsworth, then DC's editorial director, took the train west to become a Hollywood producer and essentially left comics behind. That made Mort Weisinger Superman's virtually unsupervised supervisor at DC. Liebowitz had great faith in Weisinger, calling him "a great creative mind." In his capacity as story editor for the television series, Mort Weisinger would spend a few high-pressure weeks with Ellsworth at the start of every season. "Together we knew as much about Superman as it was possible to know," Ellsworth said. "So in advance of production we'd lock ourselves in a room and work on stories. By the time we were ready to hand out writing assignments we were able to give the writers outlines of what we wanted—not just so-called premises but complete step-by-step story lines in almost every case." This editorial method, also used in the comics, theoretically made life easier for writers, but some felt pressured and frustrated by the limitations placed on their creativity.

Actors on *The Adventures of Superman* also felt the constraints of Ellsworth's systematic approach. To save money, the many scenes set in the offices of the *Daily Planet* would all be shot together, even if they took place in different episodes. "Nobody knew what we were doing or what scripts we were in," said Jack Larson. The veteran John Hamilton took to reading his lines off papers scattered on Perry White's desk. One cast member who didn't mind much was George Reeves, who may not have had superpowers but reportedly possessed a photographic memory. Despite the confusion, the show was kept afloat by the chemistry among the cast members, sparked when the ebullient Noel Neill came in as Lois Lane for the Ellsworth episodes. Having done the serials, she was the logical choice when Phyllis Coates (who didn't know whether more *Superman* shows would be filmed) took another job after the first season. In fact, the entire troupe was kept up in the air, as production was shut down and then resumed time and again. "DC Comics would let us know if we were going to do any more," said Neill. "The cast wouldn't see one another for a year and a half, then we'd get the call." Groups of 13 episodes were made during brief flurries of intense activity in

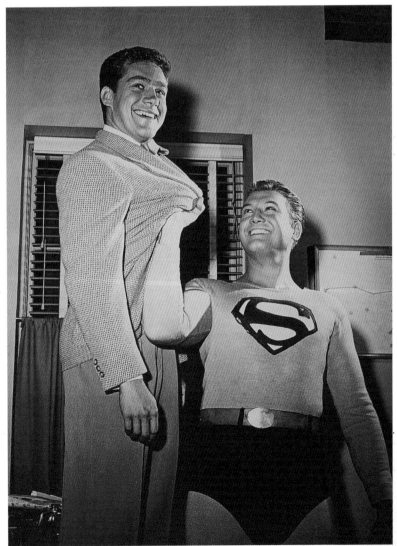

Jimmy Olsen was elevated to stardom by Jack Larson's amusing portrayal, with George Reeves as Superman providing support.

PILOT TO COPILOT

Every dog begins to look like its owner: the first Superboy (John Rockwell) and the one and only Superpup (Billy Curtis).

In light of the popularity of *The Adventures of Superman,* producer Whitney Ellsworth naturally proceeded to search for a follow-up. In keeping with television tradition, Ellsworth made a pilot film, and when that one didn't sell, he went on to make another. Lightning didn't strike twice, but one of the pilots is an amazing piece of work that might well become a cult favorite if more people get a chance to look at it.

The Adventures of Superpup was Ellsworth's brainstorm, and he apparently had no idea how eccentric it would appear to the casual observer. Nonetheless, there was a touch of genius in it. The idea, essentially, was to produce the equivalent of a cartoon without expensive and time-consuming animation; Ellsworth's solution was to dress little performers in stylized animal costumes, dress said animals in human clothing, and then set them loose on the old sets from *The Adventures of Superman* to perform a super hero spoof. It's worth recalling that Ellsworth, most often remembered as an executive, started out drawing humorous cartoons, and since he was also a dog lover, it's just possible that *Superpup* represented his most heartfelt creative act.

Produced in 1957, *The Adventures of Superpup* neither found a sponsor nor ever got on the air. It was filmed in color, but only a black-and-white print was made, evidence supporting the contention that DC was not entirely committed to Ellsworth's project. After all, the *Superman* episodes were continuing to make money in syndication, and another program could have been viewed as a pointless expense. There may also have been doubts about mocking the company's flagship character with a show about a silly-looking mutt named Bark Bent who works for editor Terry Bite on a paper in Pupopolis. Maybe kids would have enjoyed it, but in any case it's a film worthy to stand next to Ed Wood's contemporaneous *Plan 9 from Outer Space* for sheer eye-popping oddity.

The Adventures of Superboy was Ellsworth's next pilot. Made in 1961, it logically attempted to extend the Superman series with the same spin-off that had worked so well in the comic books. Although Ellsworth produced the half-hour film and cowrote its script, the result is halfhearted. The story is a tad didactic as Superboy catches some crooks while restoring a son's faith in his father, and John Rockwell doesn't set the screen ablaze in the title role. Then again, *Superman and the Mole Men* didn't really reveal what George Reeves could do. The twelve additional Superboy scripts Ellsworth had prepared went unfilmed, and the impression remains that Ellsworth, really a comic book man, might not have been quite as good a producer as Robert Maxwell, who had set up the original *Superman* TV show and kept the radio version running for over a decade. Or maybe Ellsworth just wasn't as lucky.

1954, 1955, 1956, and 1957. There were 104 in all, the final 52 foresightedly filmed in color. One startling result of the switch to color was that Noel Neill's hair, which had previously looked as dark as Lois Lane's, suddenly showed up in her natural shade of red.

The one constant was George Reeves, who sometimes seemed to be carrying the entire series on his padded shoulders. When he wasn't filming, he made numerous personal appearances for groups of children. He was very conscious of his responsibility to his audience, as he explained in a 1954 interview: "In *Superman,* we're all concerned with giving the kids the right kind of show. We don't go for too much violence. Once, for a big fight scene, we had several of the top wrestlers in town do the big brawl. It was considered too rough by the sponsors and producer, so it was toned down. Our writers and the sponsors have children, and they are all very careful about doing things on the show that will have no adverse effect on the young audience. We even try, in our scripts, to give gentle messages of tolerance and to stress that a man's color and race and religious beliefs should be respected." When his remarks were not intended for public consumption, Reeves was less sentimental about kids, who sometimes tested his invulnerability with swift kicks. In Detroit, a boy showed up with a loaded gun, and Reeves had to talk him out of shooting it by explaining that bullets fired at Superman might bounce off and injure someone else.

A fanciful Mexican lobby card for the TV pilot and feature film known in the United States as *Superman and the Mole Men* (1951).

Magazine
Sports · TV
Closeup

New York Post

©1959 New York Post Corporation
Re-entered as 2nd class matter Nov. 22, 1949, at the Post Office at New York under Act of March, 3, 1879.

TWO SECTIONS
88 PAGES
NEW YORK, TUESDAY, JUNE 16, 1959
Volume 158
No. 165
10 Cents

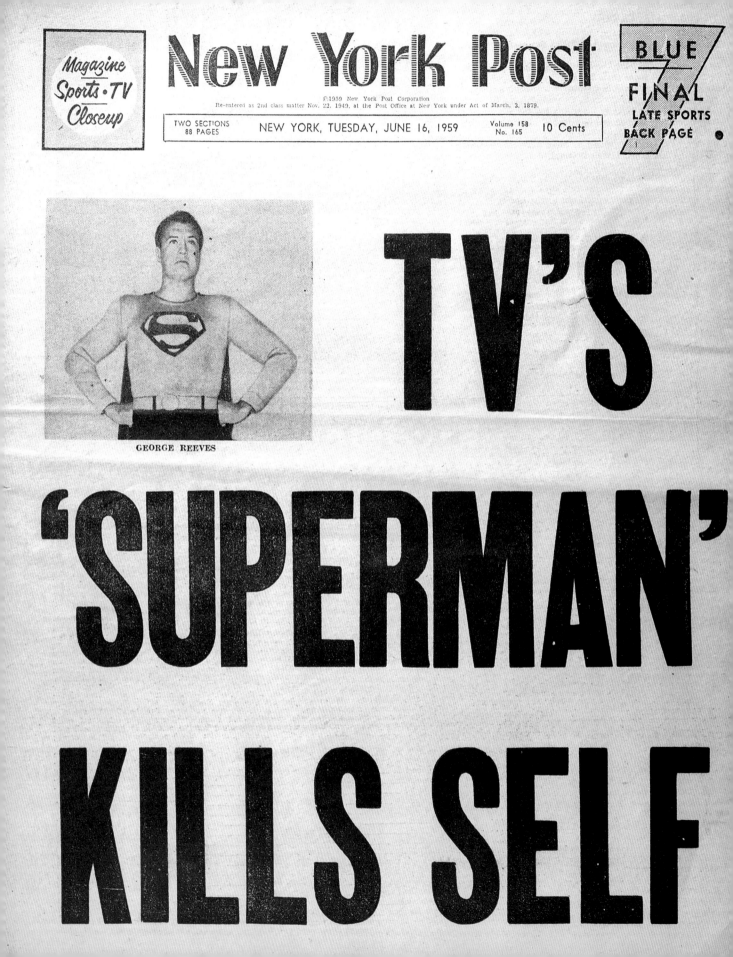

GEORGE REEVES

TV'S 'SUPERMAN' KILLS SELF

On June 16, 1959, Reeves was found dead of a gunshot wound. The official verdict was suicide, but some of his associates suspected foul play. By all accounts an affable man, Reeves had apparently grown disillusioned that his career, interrupted by service in World War II, had turned him into a children's entertainer. He regretted missed opportunities and feared that he had been typecast. Yet he had begun to direct episodes of *Superman* and was engaged to be married at the time of his death. Wild speculations continue to appear in print (the most persistent rumor is that Reeves died after stepping out of a skyscraper window, attempting to fly), but his death remains a mystery. And in spite of his appearance in such prestige films as *Gone with the Wind, So Proudly We Hail,* and *From Here to Eternity,* it was as Superman that George Reeves achieved his measure of immortality. "Superman is a legend," said Noel Neill. "We had no idea that we were involved with anything that would go on and on, and I'm sure it will still be going on long after we're all gone."

The tremendous popularity of the television show had a predictable effect on the manufacture and sale of new Superman merchandise, but it also led to some unexpected activity in comic books. There were already three comics featuring the Man of Steel (*Action Comics, Superman,* and *World's Finest Comics*), not to mention Superboy's venues (*Adventure Comics* and *Superboy*). Now Jack Larson's funny and enthusiastic TV performances inspired a publication called *Superman's Pal Jimmy Olsen.* It enjoyed a successful run of twenty years. The first issue, dated September–October 1954, introduced Jimmy as a master of disguise, "the Boy of 100 Faces," but however much ingenuity the lad supplied, he usually ended up in a mess that only Superman could straighten out. In the years that followed, the adolescent Jimmy was perpetually embarrassed by weird bodily transformations that turned him into everything from a werewolf to a human porcupine. He eventually transcended such humiliations by acquiring the power to turn himself, for short periods of time,

This uncannily detailed life mask of George Reeves was made for use on the television series, long before the star's tragic death.

The cub reporter is a teenage werewolf in
Superman's Pal Jimmy Olsen #52 (April 1961).
Art by Curt Swan and Stan Kaye.

This box contained a tank to be overturned, and a
lithographed metallic figure of Superman (opposite)
with an indecipherable, alien expression.

into a slightly silly super hero called Elastic Lad.

Superman's Pal Jimmy Olsen provided practice for an artist named Curt Swan, who was already a fixture at DC. "I was thrown so many different titles, I felt like the backup person," Swan recalled. Things began to change for him in 1953, when editor Mort Weisinger gave him work on a one-shot Superman comic done in the briefly fashionable 3-D format. "From then on, from time to time, he would throw a Superman script my way." *Jimmy Olsen* turned into a steady assignment and proved to be a stepping-stone in Swan's gradual progress toward becoming the key Superman artist for a generation.

Weisinger's next move in expanding the Superman line was *Superman's Girlfriend Lois Lane,* which began its first issue in March–April 1958. The entire issue was drawn with verve and polish by Kurt Schaffenberger. In three stories he depicted Lois masquerading as a sexy actress, tempting Superman with her technique as "Lois Lane, Super-Chef," and (in the cover story) casting spells as the withered "Witch of Metropolis." It was a catalog of stereotypes—from hussy to helpmate to hag—but Lois Lane's irritable love-hate relationship with Superman had plenty of drama, and the series lasted sixteen years. The surprising

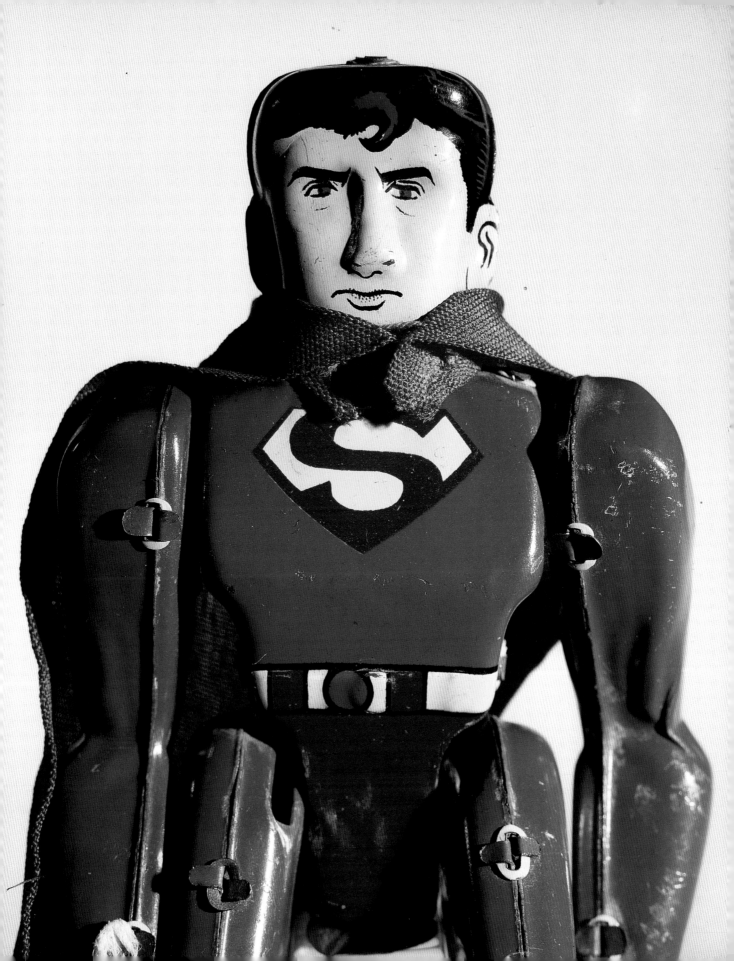

By his own reckoning, Curt Swan drew more Superman comics than any other artist.

success of *Jimmy* and *Lois* helped consolidate Mort Weisinger's position at DC. "The management protested that the characters weren't strong enough and they'd never go. But I had a gut feeling," said Weisinger, "and I had talked to kids." One of the ways the editor kept in touch with his young audience was through a letters column, "Metropolis Mailbag," introduced in 1958. Although not entirely unprecedented in comics, this was a first for the *Superman* series.

New concepts and characters were constantly introduced in Weisinger's comics during this period. Every idea that worked in one title ended up percolating through all the others. Many of these concepts are still remembered, and some are still in

A guy and a gal go flying on the first cover for *Superman's Girl Friend Lois Lane*. Art by Curt Swan and Stan Kaye.

Brainiac, the alien who inadvertently restored some of Superman's heritage in *Action Comics #242* (July 1958), later turned out to be a computer. Pencils: Curt Swan. Inks: Stan Kaye.

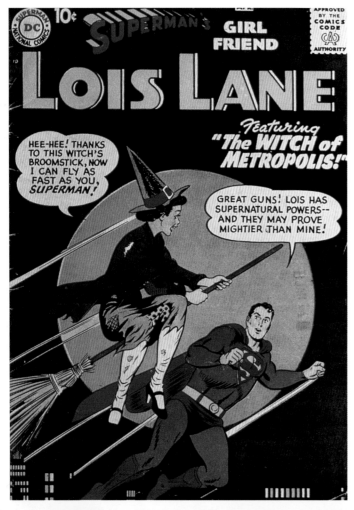

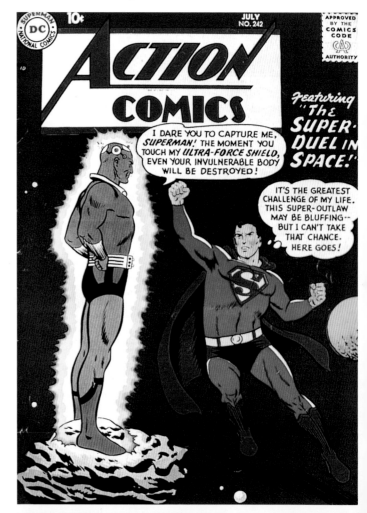

use today. "I would bring out a new element every six months," said Weisinger, "to keep the enraptured kids who were our audience involved." This was the start of the idea of an interlocking universe composed of many comic books; rather than offering independent stories that were accessible to the casual reader, the Superman comics were most enjoyable for the committed fans. Weisinger's goal, he said, was "to prevent Superman from being just a fad."

There is still controversy surrounding the question of who was most responsible for the Superman renaissance that began around 1958. Certainly an immense amount of credit is due to writer Otto Binder, who had years of experience working on scripts for Superman's most successful rival,

Captain Marvel. Binder's humorous approach, and his earlier experience creating variations on a theme for comics like *The Marvel Family* (1945 through 1954), clearly had a significant effect on Weisinger's line of Superman comics, which was becoming something close to a company within a company.

A small army of artists were hunched over their drawing boards working on *Superman*, but many of the significant stories were still ending up in the hands of old master Wayne Boring. A case in point was "The Super-Key to Fort Superman" from *Action Comics* #241 (June 1958). This tale, celebrating Superman's twentieth year of publication, introduced his Fortress of Solitude, an Arctic hideout where the hero could store souvenirs,

Lois and Lana's romantic rivalry apparently leads to brutal murder in *Superman* #150 (January 1962), but the victims are actually robots. Art: Kurt Schaffenberger.

conduct experiments, and contemplate his past. The Fortress took on even more importance in the next issue of *Action Comics,* when it became home to the marvelous microscopic city of Kandor. An interplanetary villain named Brainiac was introduced; his misdeeds included shrinking cities and bottling them. One such bottle contained Kandor, which Superman rescued and cherished as the last remaining vestige of Kryptonian civilization. A miniaturized Superman could visit there, deprived of his powers but happy in his natural environment. In a series of stories written by Edmond Hamilton and drawn by Curt Swan, Superman even teamed with Jimmy Olsen inside the bottle city to become Nightwing and Flamebird, Kandor's equivalent of Gotham City's Batman and Robin. Showing Superman so much at home in the bottle emphasized the extent to which he was as much an alien as an American.

To prevent Superman from feeling alone in our world, steps were taken to provide him with companions of his own kind. In *Adventure Comics* #210 (March 1955), Superboy had acquired a pet called Krypto the Super-Dog. Superman's father had sent the super pooch into space as a test before shooting off his only son, the story went, and Krypto had eventually drifted down to Earth. He had a crimson cape like his master, and even ended up with a Doghouse of Solitude. A more serious addition to the team came with the debut of Supergirl. A prototype had appeared in 1958, conjured up by Jimmy Olsen's imprudent magic spell, but the real deal arrived a year later in *Action Comics* #252 (May 1959). She was Kara, a refugee in a rocket who came from a Kryptonian city floating in space. The number of survivors who were suddenly showing up might have seemed ludicrous to older readers, but youngsters (and especially girls) were enthralled. Supergirl promptly got her own series, written by Leo Dorfman, to back up the Superman stories in *Action Comics.* Weisinger's plan of keeping things jumping continued to pay off, and the Superman comic books were again the industry's best-sellers.

Now Supergirl needed a pet, and she got one in *Action Comics* #261 (February 1960) with Streaky the Super-Cat. Just the usual orange terrestrial kitty before exposure to a new variety of kryptonite, Streaky acquired the obligatory cape along with a tendency to fly through the sky. There was also Beppo the Super-Monkey, another Kryptonian lab animal shot into space, who showed up in *Superboy* #76 (October 1959). The most dramatic addition to the increasingly implausible menagerie was Supergirl's resplendent white stallion, Comet the Super-Horse. His origin story in

Curt Swan's favorite stories featured Superman and Jimmy Olsen as costumed crime fighters in the bottle city. Script: Edmond Hamilton. Pencils: Curt Swan. Inks: George Klein.

Cover of *Superman #76*
by Win Mortimer.

PUSH BUTTON PUPPETS

SUPERMAN and SUPERGIRL

COPYRIGHT © NATIONAL PERIODICAL PUBLICATIONS, INC., 1966

REG. U. S. PAT. OFF.

TRY US IN THE BOX

KOHNER

Adventure Comics #252 (September 1958), the red stuff might split Superman into two people, drive him insane, let him breathe fire, or give him the head of an ant. The effect usually wore off in a few days, but by then the fans had another startling story. Eventually the varieties of kryptonite came to include gold, white, and blue, each with its own peculiar properties.

One critic of this kind of gimmickry was artist Curt Swan, but that was the least of the problems he had with editor Weisinger. "He could be very obnoxious," said Swan, who developed blinding headaches as the result of the strain in their relationship and even quit comics to get some relief. Swan eventually returned and found he could handle Weisinger by standing up to him instead of swallowing his anger. Others, like writer Otto Binder, took an easier way out. One of the principal architects of the new Superman introduced starting in 1958, Binder got so fed up with Weisinger that

he left the field for good in 1960. Writer Alvin Schwartz insisted that Weisinger took credit for the ideas of others and reported that another writer, Don Cameron, became so annoyed that he tried to throw the editor out of a window.

One writer who didn't fight back was Jerry Siegel. Superman's co-creator had fallen on hard times, and his wife, Joanne, interceded with Weisinger in the hope of finding work for her husband. Working without credit and at standard rates, Siegel contributed some of his most interesting stories for the editor he later commended for an "insistence on freshness and originality." Weisinger in turn called Siegel "the most competent of all the Superman writers." Yet it is Curt Swan's recollection of the editor that "many times I'd come in to pick up a cover and he'd be berating Jerry." Possibly Weisinger was trying to elicit the "emotional" quality he praised in Siegel's work, which found expression in memorable narratives like "The Death

These extremely rare "push button puppets" from 1966 represent one of the few examples of a toy based on Supergirl.

If there could be a Superboy, there could be a Superbaby, and he was the ideal character to introduce the Super-Monkey. This October 1959 cover is by Curt Swan and Stan Kaye.

A Pegasus without wings, Comet streaks across the cover of *Action Comics* #293 (October 1962), courtesy of Curt Swan's pencils and George Klein's inks.

It's raining cats and dogs as Streaky and Krypto drop from the sky on the cover of *Action Comics* #266 (July 1960). Pencils: Curt Swan. Inks: Stan Kaye.

Superman and Jimmy Olsen check the shelf life of too many types of kryptonite in *Action Comics* #310 (March 1964). Cover by Curt Swan and George Klein.

A parade of civilians and super heroes pay their last respects, in a possible future shown in *Superman* #149 (November 1961). Script: Jerry Siegel. Pencils: Curt Swan. Inks: Stan Kaye.

of Superman" from *Superman* #149 (November 1961). One of a group of "imaginary stories" in which writers explored alternate realities that might have radically changed or even ended the series, the book-length tale, illustrated by Curt Swan, depicted Lex Luthor's elaborate plot to kill Superman with kryptonite. Luthor was banished to a recently introduced limbo called the Phantom Zone (probably inspired by scenes from the 1949 movie serial) for his crime, but there was no happy ending to this story, which concluded with a tearful Supergirl patrolling the skies over Metropolis with the faithful dog Krypto by her side.

Siegel also made notable contributions to a new series, which began inconspicuously in *Adventure Comics* #247 (April 1958). Written by Otto Binder and drawn by Al Plastino, "The Legion of Super-Heroes" showed Superboy traveling to the future to join a club full of kids with amazing powers. Somehow the idea struck a chord, and when the Legion returned for further adventures, Siegel was the dominant writer, with illustrations by Curt Swan, Jim Mooney, and George Papp. Eventually John Forte became the regular artist, and his plain, direct representation of potentially absurd characters like Bouncing Boy and Lightning Lad helped give the series its charm. By 1962 the Legion (with Superboy) was appearing in every issue of *Adventure Comics,* but before much longer Siegel was gone from DC, launching another unsuccessful lawsuit in the hope of getting the rights to Superman.

Pulp veteran Edmond Hamilton took over the Legion scripts, and eventually Curt Swan took up the pencils. Swan was already doing the covers for most of the Superman line, not to mention an increasing number of the interior stories. Gradually his version of Superman superseded that of Wayne Boring, whose nearly thirty years of work on Superman came to an end in 1967. "I made certain changes from Wayne Boring's concept that Mort liked. Some of them he suggested. Boring had a very stylized presentation of people in general and Superman in particular. Mort felt that the jaw was

too large, for example," Swan said. At the same time he admired his predecessor's approach: "It was kind of cartoony, but I thought it was very good." The trend away from simple cartooning to progressively more detailed and realistic illustration led Superman from Joe Shuster to Wayne Boring to Curt Swan, and eventually beyond. Swan admitted that he had to exaggerate the character's musculature to get the right effect, yet his was a convincingly human Man of Steel that still has its advocates as the ultimate depiction.

One oddity caused by red kryptonite was these twin Supermen, red and blue, from *Superman* #162 (July 1963). Script: Leo Dorfman. Pencils: Curt Swan. Inks: George Klein.

Everybody loves a lover in *Action Comics* #255 (August 1959). Pencils: Curt Swan. Inks: Stan Kaye.

EVERYTHING YOU KNOW IS WRONG

When people inadvertently call something "bizarro" while searching for the word *bizarre*, you can tell that they've been exposed to the oddest aspect of the Superman myth. Bizarro was a creature who first appeared in *Superboy* #68 (October 1958), the imperfect result of a ray intended to create a duplicate Superboy. A "Thing of Steel," and intellectually defective as well, Bizarro was a variant of the Frankenstein monster, complete with pathos. "Me want to make friends, but people against me," he moaned. He was more clumsy than dangerous, so it came as something of a shock when Superboy callously destroyed the foolish, forlorn Bizarro while reassuring readers that the poor fellow was never really alive in the first place. Writer Otto Binder had miscalculated the character's appeal to youngsters (who perhaps felt misunderstood themselves), so a new Bizarro was created by Lex Luthor in *Action Comics* #254 (July 1959). Stories during the next few months included "The Bride of Bizarro" and "The Son of Bizarro," and before long there was an entire race of Bizarros, happily inhabiting a square planet called Htrae ("Earth" spelled backward). The backward Bizarros ate "cold dogs," went to sleep when they heard alarm clocks, and generally did everything in contravention to the rules of human society. They even had their own special kryptonite, colored blue, and synthesized by Superman to keep them in line. The humor was occasionally forced, but the idea of challenging conventional wisdom made the Bizarros rebels as well as fools. Inevitably, kids found them irresistible.

• • •

An even more human version of Superman made its debut on March 29, 1966, when the character became the hero of a Broadway musical. For the first time, an actor was playing the original super hero in a dramatic presentation in front of a live audience. Superman (Bob Holiday) flew on stage with a wire, like Peter Pan, but in the spirit of satire, the wire was clearly visible to the audience. *It's a Bird, It's a Plane, It's Superman* was produced and directed by master showman Harold Prince, and written by the team of Robert Benton and David Newman, who later achieved acclaim for their film scripts *Bonnie and Clyde* (1967) and *Superman* (1978). The songs were by Charles Strouse and Lee Adams, who had scored a big hit with *Bye Bye Birdie.*

Despite this impressive lineup and good reviews from most of the New York critics, the show never quite got off the ground and lost money when it closed after 128 performances. None of the numbers Strouse and Adams created for Clark Kent and company were really memorable. Another problem with the show was indicated by the fact that top billing went to Jack Cassidy, who had an amusing but basically nonessential role as an unscrupulous newspaperman. The show worked best in stunts like giving Superman a dancing phone booth to change in, or filling the stage with big boxes to duplicate the panels of a comic book. The basic problem, however, may have been that the musical took years to mount and ended up in competition with a wildly popular *Batman* television program that had made its debut just a few months earlier. As Harold Prince said, "the show lost its uniqueness in the time it took to put it together. *Superman* was planned long before *Batman* appeared on the TV tube, but it seemed old hat by the time we presented it."

Soon Superman was back on the tube too, but this time in a series of inexpensive cartoons for Saturday morning television. Filmation's *The New Adventures of Superman,* with radio veteran Allen Ducovny back on the DC Comics payroll as executive producer, got its start on CBS in September 1966. In a nod to tradition, Bud Collyer provided the voice of Superman, as he had for the old radio program and the classic cartoons of the 1940s. Yet economics made it impossible for TV animators to equal the quality of their predecessors; instead, they were forced to rely on limited animation, in which most of the image remained static while only

This montage of art and photography on a *Playbill* cover introduced Superman to New York theatergoers.

A cartoonist created caricatures of people imitating comic book characters in this drawing by Broadway chronicler Al Hirschfeld.

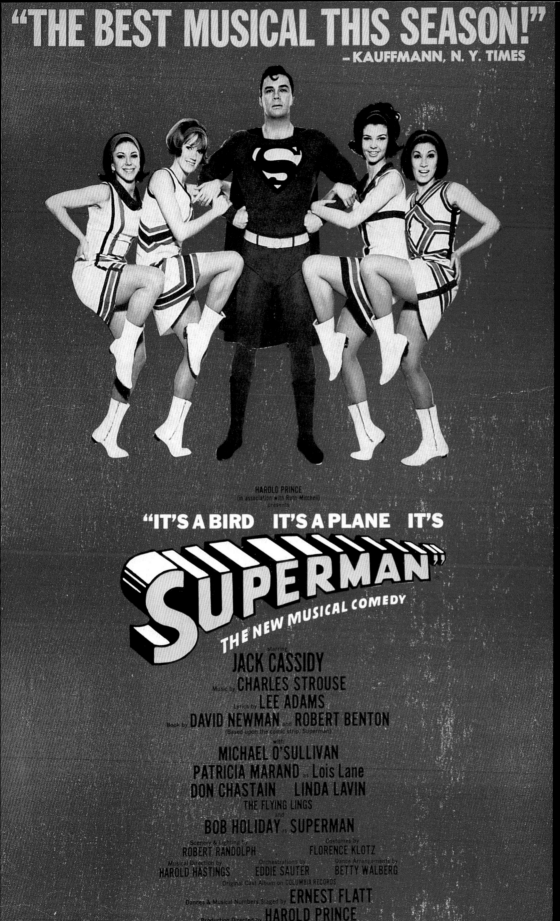

"THE BEST MUSICAL THIS SEASON!"
— KAUFFMANN, N. Y. TIMES

HAROLD PRINCE
(in association with Ruth Mitchell)
presents

"IT'S A BIRD IT'S A PLANE IT'S

SUPERMAN"
THE NEW MUSICAL COMEDY

starring
JACK CASSIDY
Music by **CHARLES STROUSE**
Lyrics by **LEE ADAMS**
Book by **DAVID NEWMAN** and **ROBERT BENTON**
(Based upon the comic strip, Superman)

with
MICHAEL O'SULLIVAN
PATRICIA MARAND as Lois Lane
DON CHASTAIN LINDA LAVIN
THE FLYING LINGS
and
BOB HOLIDAY as **SUPERMAN**

Scenery & Lighting by Costumes by
ROBERT RANDOLPH **FLORENCE KLOTZ**
Musical Direction by Orchestrations by Dance Arrangements by
HAROLD HASTINGS EDDIE SAUTER BETTY WALBERG
Original Cast Album on COLUMBIA RECORDS

Dances & Musical Numbers Staged by
ERNEST FLATT

Production Directed by
HAROLD PRINCE

ALVIN THEATRE 52nd ST. W. OF B'WAY
MATS. WED. & SAT.

Bob Holiday gets a kick out of a quartet of chorus girls in a lobby card for the 1966 musical that's winning new fans today in regional revivals.

LEAPS ATOP
CABOOSE

TRAIN ROLLING
BACKWARDS,
CAPE FLOWING..

71·6 RESTAGE PAGE 14

SCENE
NUMBER

280

'SUPERMAN'
TEARS OUT
ORANGE
TREE

NIGHT

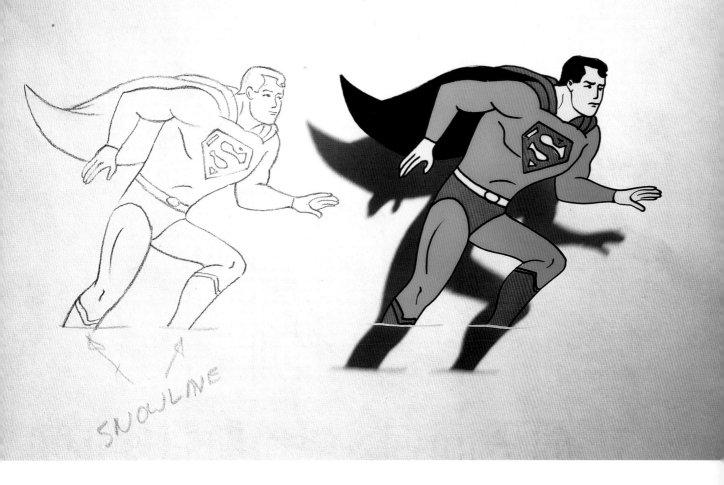

SNOWLINE

selected portions were in motion. Mort Weisinger was listed as story consultant, and the scripts by DC writers were the strongest part of the program. In spite of the weak visuals, the cartoons were recycled in subsequent years for *The Superman-Aquaman Hour* and *The Batman-Superman Hour.* ABC got into the act in 1973 with the Hanna-Barbera series *Super Friends,* which kept showing up under varying titles until 1984. The stories were attenuated to accommodate several heroes other than Superman, not to mention a pair of kids and their dog. The design of the animation was somewhat improved, and certainly no worse than what was available on competing shows. A generation would pass, however, before super hero cartoons on TV began to look really good.

• • •

Mort Weisinger left DC in 1970, almost a decade after the wave of innovations that made his regime so memorable. The most interesting policy he adopted in his last years as editor consisted of recruiting young talent. Editorial assistant E. Nelson Bridwell, a serious fan, encouraged reprints from DC's backlog to make the company's history come to life. Writer Roy Thomas, a schoolteacher brought in from the Midwest, took such a dislike to Weisinger's bullying tactics that in a few days he defected to rival Marvel Comics, where he eventually became editor of the company's entire line. Jim Shooter, who later rose to head other comics publishers, was first hired to create scenarios for the Legion of Super-Heroes at the age of thirteen. He was still a teenager when he wrote some of the last Superman stories to be drawn by veteran Wayne Boring.

Superboy's almost snowbound in this finished animation cel, shown beside the original pencil drawing that inspired it.

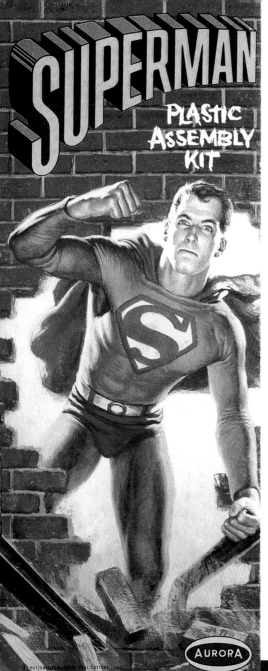

SUPERMAN
PLASTIC ASSEMBLY KIT

AURORA

© NATIONAL PERIODICAL PUBLICATIONS, INC.

AURORA PLASTICS CORP. ■ WEST HEMPSTEAD, L. I., NEW YORK

As for Weisinger, before he retired he developed an ulcer, went to a psychiatrist, and decided he knew what was wrong. "I was jealous of Superman. I was his satellite," he said. "The type of story I became fondest of was the one where somehow Superman lost his powers and had to survive on his natural wits. I'd do that repeatedly." Weisinger eventually found some measure of satisfaction in writing books and magazine articles that had nothing to do with anyone from Krypton, but today those are forgotten while his work with Superman lives on. His successor as the character's editor was his oldest friend, from the days almost forty years earlier when they were kids who loved pulp magazines, and nobody had ever heard of Superman.

SUPERBOY
AND HIS SUPERDOG KRYPTO
ALL-PLASTIC ASSEMBLY K

AURORA

SUPER BOY AND KRYPTO

Superman knocks on a bad guy's door on the lid of this Aurora Model Kit box, from 1966.

TWELVE STEPS TO THE APARTMENT DOOR-- DROP MY HAT ON THE BUST NEXT TO THE DOOR...

EVENING, MORTY!

Years after his retirement, editor Mort Weisinger still adorned Clark Kent's apartment in *Superman* #273 (March 1974). Pencils: Curt Swan. Inks: Dick Giordano

Superboy and Krypto find a new playmate in this Aurora model kit from 1967.

Opposite: Loaded with the gimmicks that made the Weisinger era so memorable, this story from *Action Comics* #245 (October 1958) features the Fortress of Solitude, the bottle city of Kandor, a lovelorn Lois, and an evil twin for Superman. Script: Otto Binder. Art: Wayne Boring.

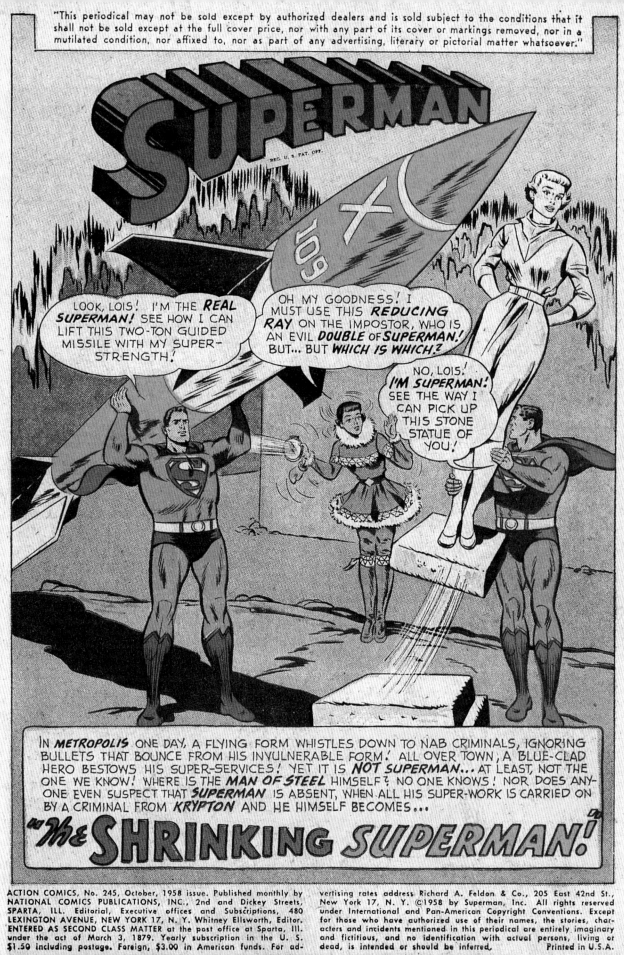

ACTION COMICS, No. 245, October, 1958 issue. Published monthly by NATIONAL COMICS PUBLICATIONS, INC., 2nd and Dickey Streets, SPARTA, ILL. Editorial, Executive offices and Subscriptions, 480 LEXINGTON AVENUE, NEW YORK 17, N. Y. Whitney Ellsworth, Editor. ENTERED AS SECOND CLASS MATTER at the post office at Sparta, Ill. under the act of March 3, 1879. Yearly subscription in the U. S. $1.50 including postage. Foreign, $3.00 in American funds. For advertising rates address Richard A. Feldon & Co., 205 East 42nd St., New York 17, N. Y. ©1958 by Superman, Inc. All rights reserved under International and Pan-American Copyright Conventions. Except for those who have authorized use of their names, the stories, characters and incidents mentioned in this periodical are entirely imaginary and fictitious, and no identification with actual persons, living or dead, is intended or should be inferred. Printed in U.S.A.

IN *METROPOLIS* ONE MORNING, AT THE *DAILY PLANET* OFFICE, REPORTER LOIS LANE DONS A FUR PARKA...

WELL, CLARK, I'M READY FOR MY TRIP TO THE ARCTIC WITH *SUPERMAN!* I HOPE HE'S ON TIME TO PICK ME UP!

HE WILL BE, LOIS! I...ER...GUARANTEE IT!

CLARK KENT CAN EASILY GUARANTEE IT, FOR HE IS SECRETLY *SUPERMAN!* SLIPPING AWAY, HE SWIFTLY CHANGES TO HIS FAMED COSTUME...

I PROMISED TO SHOW LOIS MY *FORTRESS OF SOLITUDE* UP NORTH! SHE WANTS TO WRITE IT UP AS A NEWSPAPER FEATURE!

AND IT WOULD PROBABLY TAKE AN ARMY OF MEN TO PUSH OPEN THAT GIANT STEEL DOOR! ONLY A TRUSTED GUEST LIKE ME CAN EVER SEE THE SUPER-WONDERS INSIDE *SUPERMAN'S* PRIVATE FORTRESS!

AFTER A SWIFT FLIGHT NEAR THE NORTH POLE...

THE KEY TO MY FORTRESS IS DISGUISED AS THAT AIRPLANE MARKER, LOIS! IT WEIGHS TONS.

CLEVER, *SUPERMAN!* EVEN IF CROOKS SUSPECTED IT WAS THE KEY, THEY COULD NEVER LIFT IT OR USE IT TO ROB YOUR PLACE!

WITHIN, THE GIRL REPORTER FEASTS HER EYES ON THE AMAZING MARVELS *SUPERMAN* HAS CONSTRUCTED!

THAT SUPER TOOL-CHEST COMES IN HANDY WHEN I HAVE TO BUILD BIG THINGS IN A HURRY!

2

NEXT...

FOR RECREATION, I HAVE MY OWN BOWLING ALLEY! INSTEAD OF TEN-PINS, YOU MIGHT CALL THIS *HUNDRED PINS*!

NATURALLY, ORDINARY BOWLING IS TOO TAME FOR YOU!

FINALLY, THERE IS A SUPER-SURPRISE FOR LOIS...

A...A *LOIS LANE ROOM*? YOU'VE COLLECTED TROPHIES OF ME!

WHY NOT, LOIS? AFTER ALL, YOU'RE ONE OF MY CLOSEST FRIENDS!

LOIS LANE ROOM

BIGGEST SCOOP OF 1958

IN A SUPER-GYM...

I BUILT THIS ATOMIC-POWERED ROBOT FOR A SPARRING PARTNER! HE GIVES ME A GOOD WORK-OUT!

GOODNESS! THE ROBOT'S PUNCH WOULD CAVE IN THE SIDE OF A BATTLESHIP! *SUPERMAN* DOESN'T FEEL IT!

I...I WISH I WERE *MORE* THAN A CLOSE FRIEND... HIS *WIFE*! ≶SIGH!≶

BROWSE AROUND BY YOURSELF NOW, WHILE I TAKE CARE OF A FEW APPOINTMENTS BACK HOME! YOU CAN ALWAYS CONTACT ME WITH THAT *CRYSTAL BALL*...IT'S REALLY A TWO-WAY *TV* SET!

3

SUPERMAN
DC
NATIONAL
COMICS

Action COMICS

SUPERMAN
DC
NATIONAL
COMICS

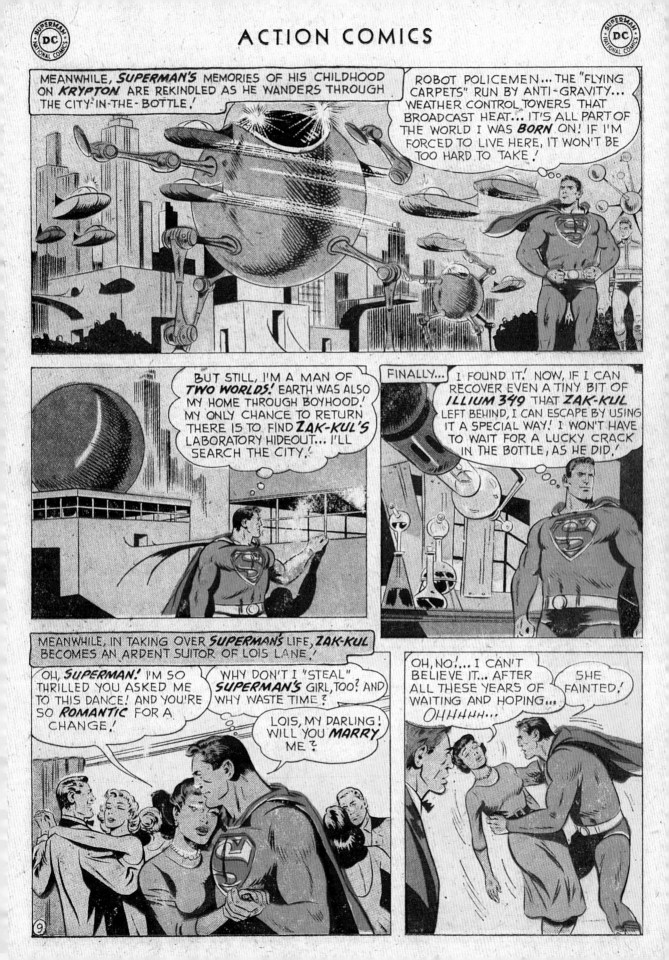

MEANWHILE, *SUPERMAN'S* MEMORIES OF HIS CHILDHOOD ON *KRYPTON* ARE REKINDLED AS HE WANDERS THROUGH THE CITY-IN-THE-BOTTLE!

ROBOT POLICEMEN... THE "FLYING CARPETS" RUN BY ANTI-GRAVITY... WEATHER CONTROL TOWERS THAT BROADCAST HEAT... IT'S ALL PART OF THE WORLD I WAS *BORN* ON! IF I'M FORCED TO LIVE HERE, IT WON'T BE TOO HARD TO TAKE!

BUT STILL, I'M A MAN OF *TWO WORLDS!* EARTH WAS ALSO MY HOME THROUGH BOYHOOD! MY ONLY CHANCE TO RETURN THERE IS TO FIND *ZAK-KUL'S* LABORATORY HIDEOUT... I'LL SEARCH THE CITY!

FINALLY...

I FOUND IT! NOW, IF I CAN RECOVER EVEN A TINY BIT OF *ILLIUM 349* THAT *ZAK-KUL* LEFT BEHIND, I CAN ESCAPE BY USING IT A SPECIAL WAY! I WON'T HAVE TO WAIT FOR A LUCKY CRACK IN THE BOTTLE, AS HE DID!

MEANWHILE, IN TAKING OVER *SUPERMAN'S* LIFE, *ZAK-KUL* BECOMES AN ARDENT SUITOR OF LOIS LANE!

OH, *SUPERMAN!* I'M SO THRILLED YOU ASKED ME TO THIS DANCE! AND YOU'RE SO *ROMANTIC* FOR A CHANGE!

WHY DON'T I "STEAL" *SUPERMAN'S* GIRL, TOO? AND WHY WASTE TIME?

LOIS, MY DARLING! WILL YOU *MARRY* ME?

OH, NO!... I CAN'T BELIEVE IT... AFTER ALL THESE YEARS OF WAITING AND HOPING... *OHHHHH...*

SHE FAINTED!

9

LOIS CAN HARDLY BE BLAMED! BUT MOMENTS LATER, RECOVERING...

THE ANSWER IS YES... YES... A MILLION TIMES *YES!* HURRY... TAKE ME TO THE JUSTICE OF THE PEACE AT SUPER-SPEED... BEFORE YOU CHANGE YOUR MIND!

SURE, MY DEAR!

MEANWHILE, IN THE MINIATURE *KRYPTON* CITY, *SUPERMAN* HAS HOOKED UP A LONG-RANGE TV IN *ZAK-KUL'S* LAB... JUST IN TIME TO PICK UP A SHOCKING SCENE!

DO YOU, LOIS LANE, TAKE THIS MAN... ER... *SUPERMAN*... TO BE YOUR HUSBAND?

GREAT SCOTT! LOIS WILL BE MARRIED TO THAT *KRYPTON* CRIMINAL, THINKING HE'S ME!

I STILL HAVEN'T FOUND ANY BITS OF *ILLIUM 399!* I... I CAN'T GET OUT OF THE BOTTLE TO SAVE LOIS! (CHOKE!)

AND AS THE CEREMONY ENDS LOIS IS UNAWARE THAT HER FONDEST DREAM HAS *NOT* COME TRUE!

I NOW PRONOUNCE YOU MAN AND WIFE!

I'M THE HAPPIEST GIRL ON EARTH! *SUPERMAN* IS MY HUSBAND!

BUT *ZAK-KUL* MEETS AN UNEXPECTED PROBLEM WITH HIS NEW BRIDE!

NOW THAT I'M YOUR WIFE, DARLING, TELL ME WHAT I'VE BEEN DYING TO KNOW ALL THESE YEARS... YOUR *SECRET IDENTITY!*

SECRET IDENTITY??? I... I DIDN'T KNOW *SUPERMAN* HAD ONE! I'LL STALL HER...

HMMFF! THAT'S SILLY, DEAR! AS YOUR WIFE, I'LL FIND OUT SOON ENOUGH ANYWAY!

I'LL TELL YOU... ER... LATER, LOIS!

THIS IS BAD! THIS GIRL IS TOO INQUISITIVE... CURIOUS... SNOOPY! SHE'LL BE ASKING QUESTIONS ABOUT *SUPERMAN'S* PAST... AND WILL EVENTUALLY EXPOSE ME! IT WAS A MISTAKE TO MARRY HER! HMM... ONLY ONE THING TO DO NOW...

JUSTICE OF THE PEACE

10

WHAT IS THE FALSE *SUPERMAN* RUTHLESSLY PLOTTING IN ORDER TO AVOID BEING EXPOSED?

I'M GOING TO...UH...BUILD US A NEW HOME OUTSIDE THE CITY, DEAR! I WANT TO SURPRISE YOU, SO DRIVE OUT IN AN HOUR! TAKE THE NORTH ROAD!

SHORTLY, OUTSIDE THE CITY ALONG THE NORTH ROAD...

I MUST GET *RID* OF LOIS, BUT I'LL HAVE TO MAKE IT LOOK ACCIDENTAL! I'LL SHEAR OFF THE NORTH ROAD, FORMING A STEEP CLIFF IN FRONT OF HER CAR!

DRIVING THERE PRESENTLY, LOIS SEES THE DEATH-TRAP TOO LATE!

EEK! I...I WENT OVER THE EDGE OF A CLIFF!

YOUR SUPER-HUSBAND DID IT, MY DEAR! GOODBYE...FOR-EVER! HA, HA!

AS THE CAR TUMBLES DOWN TOWARD DOOM, THOUGHTS FLASH THROUGH THE GIRL'S MIND AT LIGHTNING SPEED, FROM ONE SHOCK TO A GREATER... AND THEN THE GREATEST!

DID *SUPERMAN* TURN KILLER? NO...IT'S IMPOSSIBLE! IT MUST BE *ZAK-KUL* WHO DID THIS! I GOOFED WHEN I REDUCED *SUPERMAN* BECAUSE HE COULDN'T ANSWER MY QUESTION ABOUT "GUNNER" GATES!

OH, WHAT HAVE I DONE? I MYSELF AM RESPONSIBLE FOR *SUPERMAN* BEING TRAPPED IN THE BOTTLE! AND I'M THE ONLY ONE WHO KNOWS, BESIDES *ZAK-KUL!*

... BUT IT'S TOO LATE! IN ANOTHER SECOND I'LL HIT THE ROCKS! AND *SUPERMAN,* TRAPPED IN THE *KRYPTON* BOTTLE AT THE FORTRESS, CAN'T SAVE ME...! *GULP!*

BUT MIRACULOUSLY, THE *MAN OF STEEL* ARRIVES OUT OF NOWHERE!

SUPERMAN!!? OH, THANK HEAVEN! IT MUST BE THE REAL ONE...*ZAK-KUL* LEFT! BUT HOW DID YOU ESCAPE FROM THE BOTTLE AND REGAIN YOUR FULL SIZE?

11

LUCKILY, I FOUND THREE SPECKS OF *ILLIUM-349* THAT ZAK-KUL HAD LOST IN HIS LAB!

BUT STILL, YOU COULDN'T *ENLARGE* YOURSELF INSIDE THE BOTTLE...NOT WITHOUT CROWDING AND SMASHING THE CITY BEFORE YOU BURST FREE!

NO, BUT I COULD *REDUCE* MYSELF EVEN *TINIER* THAN I ALREADY WAS, UNTIL...

I'M NOW *SO SUPER-SMALL*, THAT I CAN SQUEEZE BETWEEN THE *ATOMS* OF THE GLASS BOTTLE AND ESCAPE!

"THEN I USED THE SECOND SPECK IN *ZAK-KUL'S* RAY DEVICE, WHICH WAS LEFT AT MY FORTRESS, TO RESTORE ME TO MY NORMAL SIZE..."

I'LL SOON BE MY NORMAL SIZE! ALSO THE *ENLARGING RAY* WILL MAKE THIS THIRD SPECK OF *ILLIUM-349* BIG ENOUGH TO RE-CHARGE THE DEVICE ONCE MORE!

BUT MEANWHILE, ZAK-KUL CHECKS BACK WITH HIS TELESCOPIC VISION AND SUPER-HEARING, TO BE SURE HIS DEATH-TRAP WORKED...

I'M SAVING THE FINAL *REDUCING* RAY CHARGE TO USE ON *ZAK-KUL* WHEN I FIND HIM IN METROPOLIS!

GREAT *KRYPTON!* LOIS IS ALIVE, AND *SUPERMAN* ESCAPED THE BOTTLE! HE'S AFTER ME! HOW CAN I...I HIDE FROM HIM?

AH, I HAVE IT! I'LL SMASH THROUGH THIS WALL INTO A MEN'S CLOTHING SHOP! A FLYING BRICK KNOCKS THE CLERK OUT! HE WON'T SEE MY CLEVER TRICK!

SALE SOCKS 50¢

THERE! I DISGUISED MYSELF IN AN *ORDINARY* OUTFIT! I REMOVED MY TELL-TALE SUPER-SUIT SO THAT *SUPERMAN'S* X-RAY VISION WOULDN'T DETECT IT! NOW, WHEN I PUT ON THESE GLASSES, HOW CAN *SUPERMAN* PICK ME OUT OF MILLIONS OF *AVERAGE* MEN IN THE CITY? HA, HA!

12

YET, A MOMENT LATER, SUPERMAN UNERRINGLY SEIZES HIS QUARRY! CAN YOU GUESS WHY IT WAS EASY?

MR. ZAK-KUL, I PRESUME? I'LL USE THE REDUCING RAY ON YOU!

BUT HOW IN THE...

...NAME OF KRYPTON...

...COULD YOU PENETRATE MY UNKNOWN DISGUISE?

LATER, AT THE FORTRESS OF SOLITUDE...

IT WAS HARDLY AN "UNKNOWN" DISGUISE! BY AN IRONIC TWIST OF FATE, ZAK-KUL USED HORN-RIMMED GLASSES... WHICH MADE HIM THE DOUBLE OF CLARK KENT! THAT NOTE WILL EXPLAIN ALL TO THE KRYPTON POLICE!

KRYPTON POLICE

FINALLY, AS THE REAL CLARK KENT RETURNS TO THE DAILY PLANET...

(SIGH!) I WAS MARRIED TO SUPERMAN FOR A WHILE...BUT THE WRONG ONE! THE COURTS, OF COURSE, ANNULLED THE MARRIAGE! OH, CLARK, WILL THE RIGHT SUPERMAN EVER PROPOSE TO ME?

ER...HOW WOULD I KNOW, LOIS?

THE END

REINCARNATION

While the course of Superman's career had run with surface smoothness during editor Mort Weisinger's regime, the entire comic book business had been undergoing a series of artistic and economic upheavals. At the center of these storms was longtime DC editor Julius Schwartz, who in 1970 was poised to replace Weisinger as Superman's boss. Originally an agent for some of science fiction's most important writers, Schwartz had joined DC's sister company, All American, in 1944, just before the two branches merged. Interest in super heroes began to slump with the close of World War II, yet the popularity of comic books themselves continued to increase as publishers experimented with a variety of genres from humor to romance to westerns. "We put out what I now consider strange products," observed Schwartz. Yet the diversity at DC in the early 1950s enabled him to produce two superior science fiction comics, *Strange Adventures* and *Mystery in Space*. With publishers proliferating and titles targeted toward almost every segment of the population, American comic books achieved peak sales in 1953, with an estimated 70 million copies appearing every month, but they were about to take a fall.

the author of THE SHOW OF VIOLENCE and DARK LEGEND

SEDUCTION OF THE INNOCENT

Fredric Wertham, M. D.

the influence of comic books on today's youth

In 1954 a psychiatrist treating juvenile delinquents, Dr. Fredric Wertham, argued in his book *Seduction of the Innocent* that the "unwholesome" elements in comics were responsible for all kinds of social ills. Wertham's main targets were crime and horror comics, but he also attacked super hero comics. Finding fascistic tendencies in the Man of Steel in the comics and on TV, Wertham declared, "Actually Superman (with the big S on his uniform— we should, I suppose, be thankful that it is not an S.S.) needs an endless stream of ever new submen, criminals and 'foreign-looking' people not only to justify his existence but even to make it possible. Superman has long been recognized as a symbol of violent race superiority. The television Superman, looking like a mixture of an operatic tenor without his armor and an amateur athlete out of a health-magazine advertisement, does not only have 'superhuman powers,' but explicitly belongs to a 'super-race.'"

Attacks on any form of entertainment that finds favor with the young are commonplace today (and often based directly or indirectly on Wertham's questionable tactics), but none have had the same devastating effect as his original diatribe. Wertham's book was surprisingly influential, leading to hearings in the U.S. Senate and a public outcry. The comics industry responded by creating a self-censoring body called the Comics Code Authority, but the damage was already done. Distribution dried up, publishers went bankrupt, and by the time parental indignation was redirected toward rock 'n' roll a few months later, the comic book industry appeared to be on its last legs. "We were really suffering," said Julius Schwartz. Still, DC was one of the few publishers still standing, and it fell to Schwartz to pump some new blood into the business.

Starting in 1956, Schwartz introduced new versions of such Golden Age DC characters as the Flash, Green Lantern, the Atom, and Hawkman. Because the popularity of these modernized characters revitalized comic books while reestablishing super heroes, today this era is described as

The original Superman would bid the world farewell in *Action Comics* #583 (September 1986). Pencils: Curt Swan. Inks: Murphy Anderson.

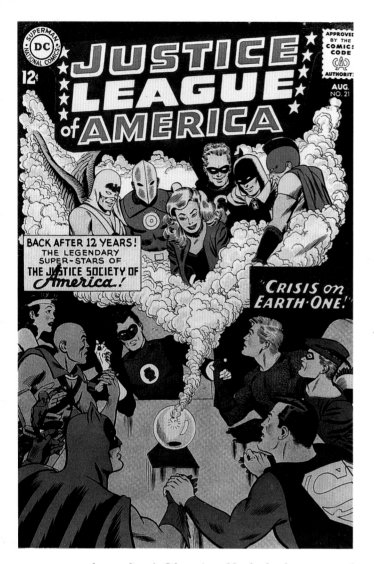

rival company, reduced to distributing its few titles through DC, to try some super heroes and reinvent itself as Marvel Comics.

Schwartz went from strength to strength, taking over Batman in 1964 and restyling him with the help of one of DC's top artists, Carmine Infantino. The incredibly successful *Batman* TV series that made its debut in 1966 owed its inspiration in no small measure to Schwartz's comic books. So it seemed only natural that he would have the inside track when the time came to refurbish DC's flagship character, the Man of Steel himself. "Mort always wanted to quit," said Schwartz, but publisher Jack Liebowitz inevitably persuaded Weisinger to stay with salary increases. "And this went on until 1970, when Mort again went in for the annual ritual and said, 'Jack, I really have to leave.' And Liebowitz said, 'Okay, now you can leave, because I'm leaving too.'" The change in management had begun in 1967, when DC was sold to Kinney National Services, which in 1968 purchased Warner Bros. The first building blocks of today's conglomerate Time Warner were in place, and one of the last decisions Liebowitz made before retirement was to appoint an artist, Carmine Infantino, as editorial director. By 1972, Infantino would be publisher.

Infantino broke precedent by selecting several artists to serve as editors, but when it came to Superman he turned to Schwartz. There was only one problem. "I was called in and I objected. I really didn't want to do Superman," Schwartz insisted. "It had been going on for so many years. What could I really contribute? So I said I would do it if I could make changes." When Infantino asked for an example, Schwartz says, "I gave him an analogy. The way Mort did Superman, he could balance the earth on one finger. But when I did Superman, he would have to use *both hands* to hold up the earth." Warming to his topic, Schwartz began to extrapolate. "I said, 'I want to get rid of all the kryptonite. I want to get rid of all the robots that are used to get him out of situations. And I'm sick and tired of that stupid suit Clark Kent wears all the time. I want to

the medium's Silver Age. No doubt the success of Schwartz's new wave helped inspire his friend Mort Weisinger to introduce some of the innovations that appeared in the Superman comics in the late 1950s. In addition, Schwartz himself put in some Silver Age time with Superman, who was one of the members of the Justice League of America, which got its start in 1960. This super group of several DC stars included characters ordinarily handled by various editors, but Weisinger had no input into Superman's adventures with the team. Nonetheless it was out of deference to his old friend's sense of territoriality that Schwartz kept Superman off the covers of *The Justice League of America* until the new editorial director, Irwin Donenfeld, insisted that things change. Meanwhile, the popularity of the Justice League helped encourage a moribund

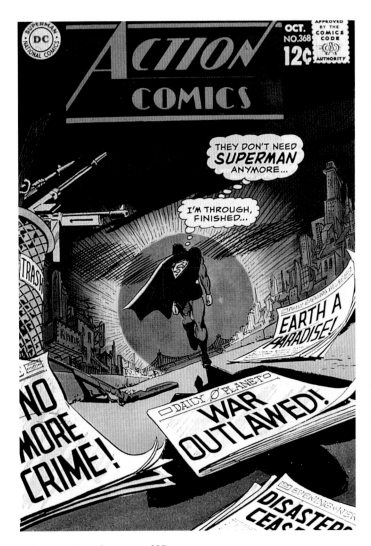

give him more up-to-date clothes. And maybe the most important thing I want to do is take him out of the *Daily Planet* and put him into television.' I said, 'Our readers are not that familiar with newspapers. Most of them get their news on television, and I think it's high time after all these years.'"

Once he had DC's permission to make substantial alterations in the company's flagship character, Schwartz proceeded to assemble his creative team. "I wanted the best writer at the moment. That was Denny O'Neil." O'Neil was part of a new generation of talent entering the comic book field, and his arrival led to a few awkward moments, including the times he was berated for showing up in the office without a necktie. "I was never quite as much of a hippie as people thought I was," O'Neil recalled, "but I don't know that I owned a tie back then." Julie Schwartz was one executive who could look past appearances to appreciate the value of new blood: he and O'Neil had already worked together on some atmospheric Batman stories, as well as an innovative series in which super heroes Green Lantern and Green Arrow confronted the social problems of the day. "I saw myself as a journalist," said O'Neil, who never planned to stay in comics but ended up making a career in the medium.

O'Neil was even more concerned than his editor about working on Superman. "There's no problem he can't solve," O'Neil complained. "So you end up writing stories that are either internally inconsistent or bogged down in explanations." Just about the only way to impede the Superman juggernaut was with kryptonite, and O'Neil agreed with Schwartz that "it was too easy." Trying to get along without that gimmick, the collaborators were determined to produce a less overpowering hero. "One of the first things Julie and I agreed on was the story line that would scale him back almost to what Jerry and Joe started with in 1938. Actually, we never got him quite that far back. For example, he never lost his power to fly," said O'Neil. Acknowledging that "my fantasies are very modest, and I never imagined being omnipotent," the writer admitted that one reason for scaling back Superman was "making the

job interesting for yourself."

The final members of the team would be doing the drawing. "I wanted Curt Swan and Murphy Anderson to do the artwork because I liked them very much," said Schwartz, "and I wanted Neal Adams to do the first cover." The era's top cover artist, Adams had also demonstrated a striking way with a layout for O'Neil's Batman and Green Arrow scripts, while his art style, employing Madison Avenue advertising techniques, made comics look less like cartoons and more like illustration. Curt Swan, who had been drawing Superman for almost two decades, said, "I tried to enhance or improve on my art as I went along, but I never tried to analyze the reason for it." Swan developed a new look for this new incarnation, in part perhaps because his pencils were now being embellished by Schwartz's favorite inker, Murphy Anderson. An accomplished

Editor Julius Schwartz (right) and
writer Dennis O'Neil conspire over a
plot in Schwartz's office.

artist in his own right, Anderson was also expert at bringing out the details in someone else's drawings, and seemed to inspire Swan to a more elaborate style than he had previously attempted. They worked together so seamlessly that they began

signing their work with a single name: "Swanderson." In short, the team assembled for the new Superman was something like the "supergroups" of rock virtuosos that were in vogue at the same time. And like those notable aggregations, it was not destined to last for long.

In *Superman* #233 (January 1971), the new Man of Steel was revealed. The Neal Adams cover showed Superman bursting out of a green chain,

while a blurb proclaimed, "Kryptonite Nevermore!" For many readers the interior's most memorable moment came when Superman cheerfully chowed down on a chunk of the element that once was his nemesis. Still, there was more than that to the story, including a spiffy new wardrobe for Clark Kent that earned a write-up in *Gentleman's Quarterly* and got Denny O'Neil an interview on the *Today* show. The plot involved a scientist's attempt to use kryptonite as an energy source, but the resultant chain reaction neutralized its power.

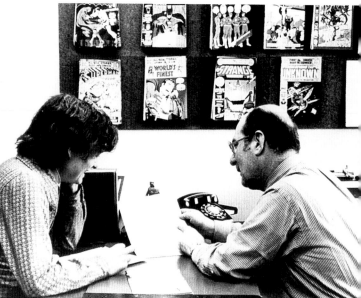

However, the same event also created a mysterious pseudo-Superman made of sand, and battles between the Man of Steel and the Man of Sand in subsequent issues would eventually cause a substantial reduction in Superman's powers. Meanwhile, the autocratic new owner of the *Daily Planet,* Morgan Edge, yanked Clark Kent off the paper and put him on camera at WGBS-TV, where changing identities without anyone noticing was more of a problem than ever before. Schwartz and his cohorts had kept this story line in motion for a year, when there was a major defection: Denny O'Neil dropped out. "I didn't think I was doing the stuff justice and it was just very difficult to do,"

The new owner of the *Daily Planet* tries to turn Clark into a TV newsman in *Superman* #233 (January 1971). Script: Denny O'Neil. Pencils: Curt Swan. Inks: Murphy Anderson.

Overleaf: This striking plastic sculpture of Superman, under three inches high, was manufactured in 1966 by the Ideal Toy Corporation.

said O'Neil. "I think Julie remembers that we decided from the outset that I would only do a finite number of issues. We frequently have different memories of how certain things happen . . . nobody was taking notes."

In any case, bucking more than three decades of tradition was a daunting task, and DC management was beginning to wonder whether it was all worth the trouble. "After a year or so they decided I was making too many changes," Schwartz recalled. "They wanted me to do more the type of

story Mort had been doing after all, which I sort of compromised on." Another problem was that while he was renovating issues of *Superman,* Schwartz was not editing the other comic books featuring the character, including *Lois Lane, Jimmy Olsen,* and especially *Action Comics.* "Murray Boltinoff was editing *Action,* which also had Superman in it, and neither of us knew what the other one was doing,"

Newly immune, Superman is about to take a bite out of kryptonite in the iconoclastic *Superman* #233.

NEVER-NEVER LAND?

"At one point we thought we'd have a rival to Disneyland called Supermanland," recalled Superman's editor Julius Schwartz. Planned attractions included a visit to Smallville, a rocket ride to the planet Krypton, and a tour of the Fortress of Solitude. "We'd have built this in the one city in the United States that was called Metropolis, in southern Illinois. And this is the concept that Neal Adams drew. Unfortunately, we didn't go ahead. This was during the period of the gas crunch, and the only way you could get out to Metropolis was by car, and we felt that not enough people would be willing to spend the money to get the gas to go. And so we put it on hold. It's still on hold."

said Schwartz. "There was no coordination." For instance, in a story by fledgling writer Cary Bates from *Action Comics* #403 (August 1971), Superman was still using robot duplicates of himself to outsmart a villain. Boltinoff and Leo Dorfman, his chief writer, had their own ideas about updating, which often involved heavy-handed attempts to be hip. In a story from *Action*

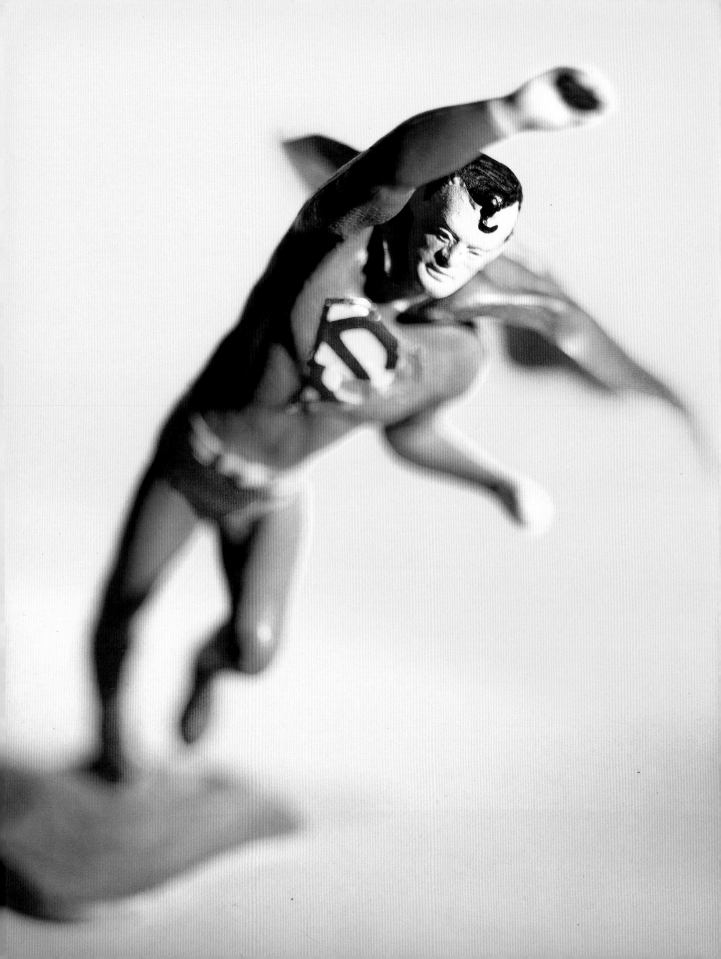

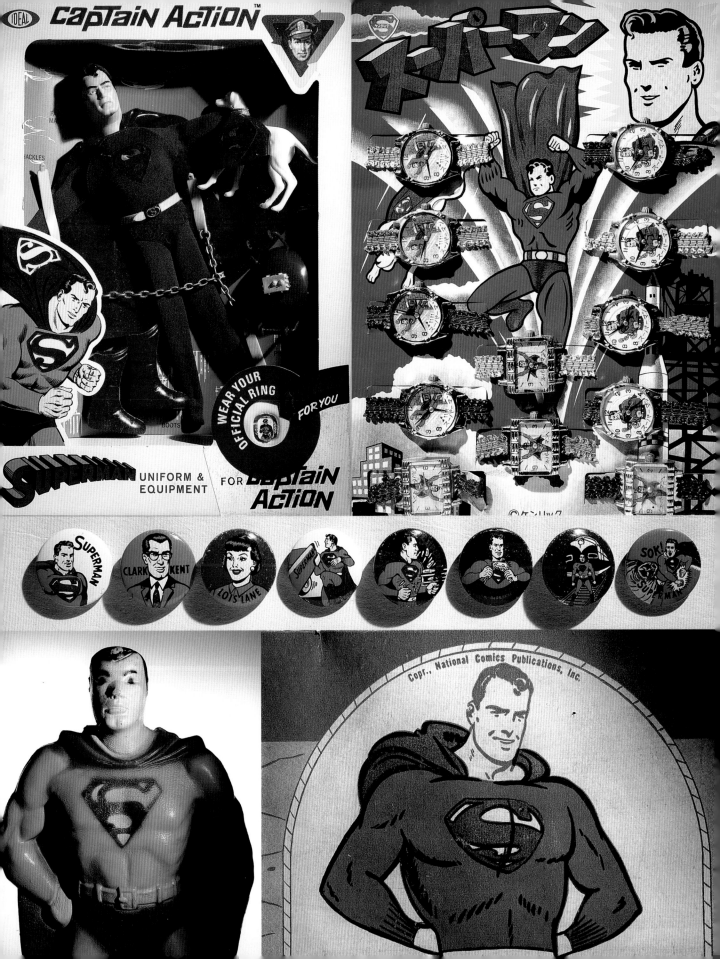

Eventually Schwartz got control of *Action Comics* and then *The Superman Family*, a title that absorbed both *Lois Lane* and *Jimmy Olsen*. Schwartz cultivated a stable of young writers to follow in Denny O'Neil's footsteps, especially Cary Bates. Veteran artist Curt Swan enjoyed working with Bates: "He had a good story sense, and he also had picture sense." In a playful tribute to one of Superman's inspirations, Bates introduced Captain Strong, a muscular sailor reminiscent of Popeye, in *Action Comics* #421 (February 1973). Other new writers included Marty Pasko and Elliot S! Maggin, who wanted the exclamation point after his middle initial because periods seemed to have no place in American comic books. Maggin's more serious side came out in *Superman* #247 (January 1972), where a story called "Must There Be a Superman?" showed the hero beginning to wonder whether he was helping or hurting the people of earth by solving so many of their problems for them. Eventually Bates and Maggin would collaborate on scripts, but Curt Swan lost his partner when inker Murphy Anderson left comics in 1974, and no replacement had quite the same touch.

Meanwhile, the initial impulse behind Schwartz's revamping of Superman was gradually weakening. Kryptonite crept back into stories, and eventually Clark Kent lost his job on TV and went back to print journalism. Sometimes Superman seems more powerful than anyone who works to create his adventures. "Nobody should do more than seven

Comics #398 (March 1971) called "The Pied Piper of Steel," Clark Kent covered a music festival whose hordes of mindless fans were driven to crime by rock's relentless rhythms. This could hardly qualify as satire, and was certainly no way to please young readers. There was also the stunt of turning Lois into an African-American for a day in *Lois Lane* #106 (November 1970), but this was more awkward than enlightening.

Overleaf (clockwise from top left): 1966 Captain Action figure from Ideal, Japanese wristwatch store display, complete set of gumball machine tin litho buttons, art from snorkel box, 1966 plastic bank from Transogram.

years," Schwartz declared. Like his predecessor, however, he stayed on the job much longer.

• • •

By the mid-1970s the buzz on Superman had less to do with the comic books than with plans for a motion picture that was being designed as a lavish, big-budget spectacle with top stars and state-of-the-art special effects. Alexander and Ilya Salkind, the father-and-son executive producers who had scored international success with their back-to-back hits *The Three Musketeers* (1973) and *The Four Musketeers* (1974), grandly announced that *Superman* would be one of the most expensive movies ever made. There was much speculation about who would play the Man of Steel (stars mentioned included Robert Redford, Warren Beatty, and Olympic athlete Bruce Jenner), but Julie Schwartz was more concerned about the script. He recommended his friend Alfred Bester, a top science fiction writer as well as a comics veteran, but the Salkinds wanted a big name and signed Mario Puzo, author of *The Godfather*. The Salkinds told Puzo to take Clark Kent off TV and make him a newspaperman after a survey revealed that's how most adults remembered him.

Nobody was following the plans for the movie with more interest than Jerry Siegel and Joe Shuster. They were now in their sixties and not in good health; Jerry was employed as a clerk, and Joe was nearly blind and keeping house for his brother. Shuster bemoaned their fate to anyone who would listen. "The biggest mistake of our lives was when we signed over those rights for the $130 we received for the original story," he said. Siegel was less melancholy than manic, bombarding the press with letters in which he proclaimed that his "curse" was on the extravaganza that was being produced with no compensation for Superman's creators. His protests did not fall on deaf ears. Journalists inflated the image of innocent boys deceived by a giant corporation—even if things weren't quite that simple, it made for a good story. Siegel and Shuster found allies in two successful colleagues: artist Neal Adams and newspaper cartoonist Jerry

Robinson, who had begun his career years earlier as an assistant to Batman artist Bob Kane. The growing clamor about Siegel and Shuster was an embarrassment to Warner, and a new generation of executives was inclined to be more compassionate. Warner head Steve Ross, executive vice president Jay Emmett, and general counsel Marty Payson were sympathetic. "We are not indifferent to their plight, and we intend to do something about it," Emmett said. "Legally, nothing has to be done. Morally, I think something should be done." In such an atmosphere it seemed only natural that Siegel and Shuster would be awarded pensions and have their names restored as creators of Superman. "We're very, very grateful to everyone," Joe Shuster said.

There was also a new regime at DC. In 1976 Jenette Kahn had been appointed publisher (within

This well-intentioned but unsuccessful story, inexplicably named after a sexually explicit film, was written by Robert Kanigher, DC's top writer of war comics. Cover by Curt Swan and Murphy Anderson.

THE GREATEST SUPERHERO TEAM-UP OF ALL TIME!

DC AND MARVEL PRESENT

THE BATTLE OF THE CENTURY $2.00

SUPERMAN VS. the AMAZING SPIDER-MAN

COMPANY'S COMING

In 1976, when the United States was celebrating its bicentennial, two rival companies got into the spirit of unity by bringing their flagship characters together for the first time. The result, billed as "The Battle of the Century," was *Superman vs. the Amazing Spider-Man,* published jointly by DC and its chief competitor, Marvel Comics. Created by writer Stan Lee and artist Steve Ditko, Spider-Man first appeared in 1962 and rapidly became one of the greatest successes of the Silver Age. Superman may have helped inspire his red and blue costume, or his secret identity as a bespectacled nerd who worked on a newspaper (the glasses were eventually dropped), but Spidey's adolescent angst made him unique. Cooperation between the companies surprised many readers, but both Marvel's publisher, Stan Lee, and his DC counterpart, Carmine Infantino, had started as creative types and understood the value of a good story. Besides, the industry was in a bit of a slump, and the ninety-six-page, two-dollar tabloid was a moneymaker. As for the vaunted fight, it revealed that Superman was clearly stronger, but ended inconclusively when the two heroes realized they were being manipulated and banded together to go after their real enemies. The boys got back together again in 1981. Since then, crossovers between DC and Marvel have become increasingly common. The first time, though, it was something nobody expected to see.

Cover art by Ross Andru and Dick Giordano.

five years she would be president as well). She worked with progressive people within the company, notably Paul Levitz, who began as a writer with a business education and went on to become a DC vice president. Executives like Joe Orlando and Dick Giordano had begun as artists, and plans were eventually put in motion to provide benefits and royalties for the DC talent.

Meanwhile, Mario Puzo had completed his movie script, explaining that he had seen the material as a Greek tragedy. The producers hastily called on Robert Benton and David Newman, who'd written the *Superman* Broadway musical eleven years earlier. Newman's wife Leslie was also brought in to punch up Lois Lane's part. Director Richard Donner took a look at the result, decided it was a tad too frivolous, and brought in "creative consultant" Tom Mankiewicz for last-minute rewrites. Multiple screenwriters are hardly uncommon, but in this case they produced a fairly schizophrenic script, part epic science fiction, part rural nostalgia, part romantic comedy, and part pop parody. The amazing thing is that director Donner managed to hold it all together and to evoke most moods effectively.

Oscar-winning actor Gene Hackman portrayed Lex Luthor broadly, which tended to undercut the rest of the film's demonstration that comic book material could be played straight. Marlon Brando, the other big name in the cast, was paid a then record-breaking salary of $3.7 million for what was basically a cameo. As Superman's father, Jor-El, Brando brought dignity and conviction to the key opening segments on a crystalline Krypton designed by John Barry. Reportedly Brando's participation also helped the producers to raise a budget estimated at $40 million.

The real casting coup, however, proved to be Christopher Reeve as Superman. Richard Donner cast the young actor with considerable trepidation, and Reeve himself was somewhat reluctant to take the role. The son of a Yale professor, Reeve was a graduate of Cornell who studied at Juilliard; he had performed at the Old Vic in London, at the Comedie Française, and opposite Katharine Hepburn on Broadway. Worried that the role of Superman would not offer "a genuine acting opportunity," Reeve reasoned "that there must be some difference stylistically between Clark and Superman.

Otherwise you just have a pair of glasses standing in for a character, and I don't think that's enough for a modern audience." The challenge for a performer was not only to balance the two characters, but also to project goodness without appearing hopelessly naïve, and in this Reeve was triumphant. He credited the script. "I found I was wrong about this material. I mean, my perceptions were wrong," said Reeve. Especially in the interplay with Lois Lane (Margot Kidder), Reeve saw something "that I wouldn't want to miss. I did see it as a chance to play a real character and to reinvent something for the time I was cast in. George Reeves was, I'm sure, the right Superman for the fifties, and Kirk Alyn

was the right Superman for the forties, and I think I was the right Superman for the late seventies and eighties."

Released in 1978, *Superman* was a lavish spectacle that ranged from Krypton to the wheat fields of Kansas for nearly an hour before the costumed hero even appeared. By its very size the movie accommodated the fantastic figure of Superman and made him seem plausible. "It had a lot of texture," said Christopher Reeve, who credited the Salkinds. "What they accomplished by thinking big, and coming in and spending money, was they set the stage for the film to be successful, because it would appeal to adults as well as kids. You could see it more than

This 1978 figure from Madelman was released only in
Europe and has become a pricey collector's item.

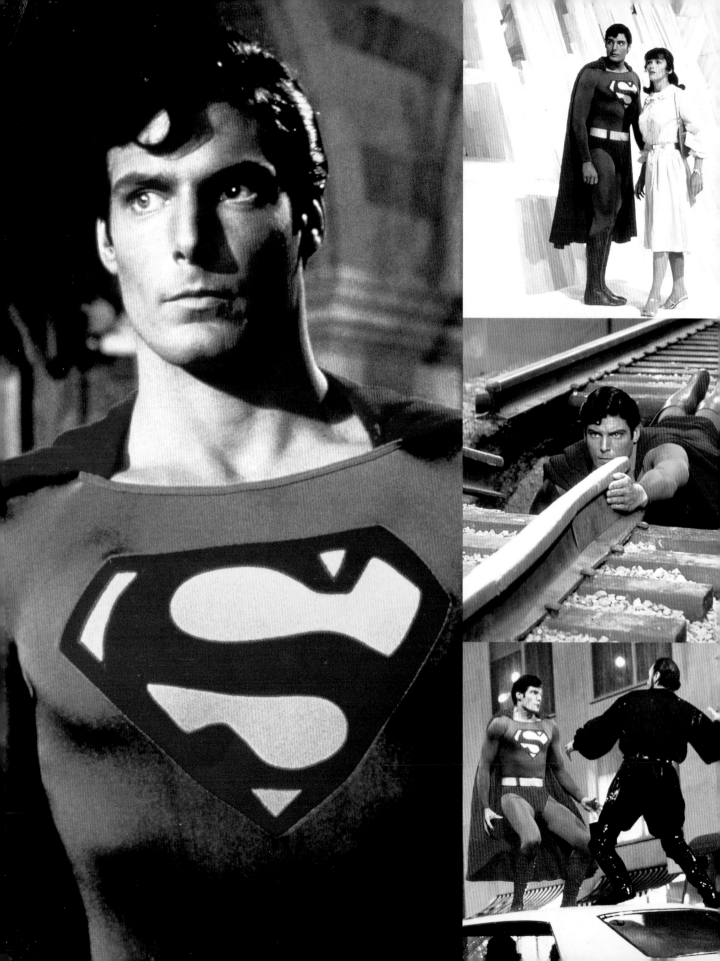

once and enjoy it. And it did get that repeat business." In fact, *Superman* was a huge hit, which was just as well since during its production a number of scenes had already been shot for a sequel.

Superman II (1980) featured three Kryptonian villains seen briefly at the start of the first film; they pursue Superman to Earth and challenge him to a battle of superpowers. The sensational fight scenes in which Metropolis was torn apart constituted the most important new footage created for the sequel; older footage consisted of scenes shot on the sets of the *Daily Planet* offices and Luthor's hideout. Expensive actors like Gene Hackman did most of their scenes during the initial production. "Those were pretty much in the bank," said Reeve. "It was the economics of it." Although the two films seem to be a whole, the direction of the sequel was credited to Richard Lester rather than Richard Donner. And according to Reeve, Lester directed the effects-laden action sequences that made *Superman II* the closest cinematic equivalent of a comic book to date. "It was fun for us to think of gags," said Reeve. "The fact that there was humor in this—in both parts and particularly in part two—was what made it enjoyable for me."

Richard Lester returned to direct *Superman III* (1983), but by this time the series was beginning to slow down. Part of the problem may have been that the script, written by David and Leslie Newman alone, placed too much emphasis on comedy. The idea of a lovable bumbler who becomes a computer whiz and falls under the spell of a master criminal was a little light for a 125-minute movie, no matter how many effects were employed to make a colossal computer come to life. Casting comedian Richard Pryor as Superman's foil was an interesting idea, but he failed to rise to the occasion. Perhaps the most pleasing performance came from Annette O'Toole as a sincere and straightforward Lana Lang (apparently the character was in the film only because of a salary dispute between the producers and Margot Kidder, the usual Lois Lane). Christopher Reeve's favorite segment involved a chunk of synthetic kryptonite that divided Superman into two characters, one good and one bad. "I enjoyed that very much, to see this twisted, evil persona come out of the hero," Reeve recalled. "This evil Superman, literally trying to destroy the other one in the machinery in the automobile junkyard, is very good. That was David Newman's idea." The doppelgänger is a comic book staple that Newman could have found in many back issues of *Superman* or *Action Comics,* but it's archetypal stuff, and it gave Reeve a chance to turn his dual role into a triple.

"I feel we sort of got into a bit of a mess with *Superman IV,*" said Reeve. For this 1987 outing, which proved to be the last in the series, the rights to the character had been acquired by a different production team, Menahem Golan and Yoram Globus, whose Cannon Group was noted for

Ma

modestly budgeted films. "I didn't hear them saying things that made me confident in terms of what they were going to do and what they were interested in," Reeve said. "They just wanted to secure me to play the part again." Reassured when they agreed to produce another script he was interested in, *Street Smart* (1987), Reeve agreed to pull on the blue tights again, and decided "maybe this will work better if I come in with a story that I believe in." His suggestion about Superman getting involved with nuclear disarmament was developed and inevitably altered by writers Lawrence Konner and Mark Rosenthal; ultimately, the film seemed to concentrate on Superman slugging it out with Lex Luthor's stooge Nuclear Man. "It is probably best, in retrospect, not to have Superman politicized in any way," suggested Reeve. "I mean, the intentions were good at the beginning." Overall, the movie was a disappointment, from script to special effects. "There are moments in part four that work quite nicely," Reeve said, "but for overall, sustained achievement, I think parts one and two work very well and are a kind of landmark because they created a new genre." The idea of turning comic books into cinematic spectacles had been well and truly launched.

• • •

By the time this pioneering film series had come to an end, the Superman comic books had passed some landmarks themselves. In 1985, editor Julius Schwartz turned seventy. To celebrate this birthday, and his more than forty years of creative work, DC personnel concocted an incredibly elaborate scheme. The impetus came from writer Elliot Maggin, who approached executive vice president Paul Levitz with the idea of putting out a special Julie Schwartz issue of *Superman*. Maggin and artist Curt Swan began secretly preparing a story that DC would publish instead of the one Schwartz was expecting to see. "So comes the day," recalled Schwartz, "and all of a sudden Jenette Kahn's administrative assistant comes in and says we're having a special meeting in the conference room." Anticipating some sort of crisis, Schwartz entered the room to discover champagne on ice and publisher Kahn carrying a copy of *Superman* #411 (September 1985). "And she holds the issue up and I see I'm on the cover, and then I see the story is about my having an adventure with Superman." Ever conscientious, Schwartz initially responded with dismay. "My first thought was, *My God! How could you do this to me? I'm in the middle of a three-part story about Luthor!* Everyone started to laugh, and then I started to laugh. That was one of the highlights of my career."

This wonderful stunt was soon to be followed by a serious shake-up in the career of Superman, one that made the changes Schwartz had instituted in 1971 look like no more than cosmetic surgery. In effect, it would mean putting an end to the Superman saga that had been running for nearly half a century, and starting again from scratch. Yet in a way Schwartz was responsible for this new policy as well, because back in the 1960s, in titles like *The Justice League of America,* he had initiated a trend of connecting all DC's characters, past and present, into a vast mosaic that came to be known as the DC Universe. Trying to explain the existence of characters like the Flash, who appeared in both Golden Age and Silver Age versions, the writers

This secretly prepared, special issue of *Superman* celebrated the long and fruitful career of editor Julius Schwartz. Pencils: Curt Swan. Inks: Dick Giordano.

Neal Adams drew the legendary athlete, Muhammad Ali, also seen here in person wearing a Superman jacket.

A CHALLENGE TO THE CHAMP

Superman has a long tradition of sharing his comic book adventures with real-life celebrities, from writer-director Orson Welles to President John Fitzgerald Kennedy. However, none of these encounters was accompanied by the same fanfare that greeted the 1978 publication of *Superman vs. Muhammad Ali*. This book-length, tabloid-sized adventure was created by writer Denny O'Neil and writer-artist Neal Adams, who traveled together to a hotel in New York's Catskill Mountains to interview the heavy-weight champion for the project. O'Neil and Adams did a creditable job with a story about alien invaders who demand that Earth supply a fighter to engage their extraterrestrial champion in trial by combat. Both Superman and Ali volunteer, and end up battling for the honor, with Ali clearly the better fighter when Superman trains under a red sun where his special powers are inoperative. The two have teamed up by the time of the fight with the alien, however, with Ali stalling for time in the ring while Superman defeats the enemy's plans for a sneak attack on mankind.

came up with the ideas of other dimensions and parallel lives. Before long, though, countless contradictions popped up in stories as young writers (many of whom were fans and even scholars of the old comics) tried to hold together so much accumulated lore. The DC Universe became so top-heavy that it threatened to topple. As a result, the decision was made to fix things up by introducing a fictional cosmic event that would in effect wipe out the past, thus enabling all DC's continuing characters to start again with a clean slate. The event was depicted in a twelve-issue miniseries called *Crisis on Infinite Earths,* which ran from April 1985 to March 1986. Its appearance meant a new team on Superman, and the end of fifteen years of editing Superman for Julie Schwartz, and more than thirty years of drawing him for Curt Swan. "I consider Curt the definitive Superman artist," said Schwartz. "He told a story better than anyone else."

For Schwartz, the swan song had to be memorable. "I realized I was going to give up Superman," he said, "and I like to go out with something monumental. I said, 'What the hell am I going to put in the last issues?' So at about three o'clock in the morning I woke up and it occurred to me. What I would do is make believe that these issues of *Superman* and *Action* are the last issues." It was the chance to provide the climax to an epic that had been running since 1938.

"Now that I had it, I had to figure out who was going to write it," said Schwartz. Writer Alan Moore made an unusual pitch for the assignment. "If you let anybody but me write that story I'll kill you," he told Schwartz. "Since I didn't want to be an accessory to my own murder, I agreed," Schwartz explained. By 1986, Alan Moore was gaining a reputation as the hottest writer working at DC. He was in the vanguard of the British writers who were beginning to invigorate American comics, and was about to make an indelible impression with his scripts for *Watchmen.* This trenchant examination of comic book commonplaces, set in a world where super heroes were outlawed

IT'S A BIRD, IT'S A PLANE, IT'S A TURKEY!

Audiences who saw Helen Slater take flight only a short while into the movie *Supergirl* had every right to take heart. The effects by Derek Meddings and John Evans were superior to anything seen in the Superman films, conveying a real sense of exhilaration that was enhanced by Slater's performance (and any actor who's tried it will tell you that flying even with special effects is a grueling experience). The rest of the movie, unfortunately, never got off the ground. The 1984 film seems to have been intended by executive producers Alexander and Ilya Salkind to start a new franchise, but it ended up driving them out of super hero movies altogether.

The faults begin with David Odell's script, which brings Supergirl to Earth only to get her involved in a ridiculous love triangle with a gardener and a witch. In fact, the story is full of sorcerers, all played for comedy, and the excess of fantasy destroys all chances for credibility. Slater is blameless, but everyone else in the cast camps it up in what they must think is "comic book" style (Faye Dunaway as the chief nemesis is so extreme that the original idea of casting Dolly Parton begins to sound positively restrained). It's too bad, because with better backing Slater might have become a big star, and Supergirl might have survived. As it was, DC Comics killed off the character in 1985 (the one you see around these days is a shape-shifting alien who assumed her identity).

"HE LOOKED AS IF HE'D BEEN *CRYING*."

In the Fortress of Solitude, the Man of Steel awaits his personal Armageddon with only the faithful Krypto for company. Alan Moore's script for Superman #423 (September 1986) was pencilled by Curt Swan and inked by George Pérez.

A *MINUTE?*

NO, NO, MY DEAR...

I WAS THINKING MORE ALONG THE ORDER OF A *MONTH.*

WH... *WHAT??*

I *NOTICED* YOU WHEN I FIRST CAME IN... *JENNY,* IS IT?

I ASKED FOR ONE OF YOUR TABLES, *SPECIFICALLY.*

NOW, I'M INVITING YOU TO COME *WITH ME.*

COME BACK WITH ME TO *METROPOLIS.*

FOR *ONE MONTH.*

M-MR. LUTHOR! I...I HAPPEN TO BE *MARRIED!*

AND... AND EVEN IF I *WASN'T...*

I'M...WELL, I'M *NOT THAT KIND OF GIRL!*

OH, *TOSH,* JENNY! IF I'VE LEARNED *NOTHING ELSE* FROM MY *EIGHT* WIVES...

IT IS THAT *EVERYONE* IS "*THAT KIND OF GIRL.*"

IT'S ONLY A MATTER OF *PRICE.*

FOR SOME IT'S A *WEDDING RING.*

FOR SOME A *HOLLYWOOD CONTRACT.*

I'M PREPARED TO OFFER YOU...

OH, LET'S MAKE IT... *ONE MILLION DOLLARS,* SHALL WE?

ONE MILLION DOLLARS IN EXCHANGE FOR *ONE MONTH* OF YOUR LIFE.

FAIR?

M-MISTER LUTHOR...!!

Y-YOU MAY BE THE *RICHEST* MAN IN THE WORLD...

YOU MAY BE *USED* TO GETTING YOUR OWN WAY ON EVERYTHING...

BUT IF YOU THINK YOU CAN JUST COME *WALTZING* IN HERE AND...

3

6

Superman, The helium-filled giant floats through Times Square, New York, during a

BLOWING UP SUPERMAN

Superman got so hot so fast that he was lighter than air by 1940, when he made his first appearance in the streets of New York in the famous Macy's Thanksgiving Day Parade. He may have been a celebrity only two years after his comic book debut, but the first Superman balloon bore only a vague resemblance to the original model. Subsequent versions were somewhat more convincing, and the massive modern balloon was also the largest (and apparently most expensive) one ever created for the holiday celebration. It took 14,000 cubic feet of a helium-and-air mixture to fill Superman's fourteen separate compartments, and he measured 104 by 35 feet. A victim of inflation, the Superman balloon made its last appearance in 1987.

producers on *Superboy* were Alexander and Ilya Salkind, the same father-and-son team responsible for Christopher Reeve's Superman movies. The Salkinds decided to take another crack at a character from Krypton despite the failure of their 1984 film *Supergirl.* The new TV series contradicted the current DC continuity, especially since the exploits of the young Superman seemed to be set in the present, but it nevertheless evolved into a show that came closer than most to creating a real comic book ambience.

As it turned out, comic book writers had more input into *Superboy* (later *The Adventures of Superboy*) than any other dramatization of a super hero. An industry-wide strike by the Writers Guild didn't affect the Salkinds because they were new to television, but the guild did request that the producers give work to some new writers. Mike Carlin and Andy Helfer were among the first beneficiaries, explained Carlin, "partly because of that deal and partly because halfway through the first thirteen episodes, they decided to change the focus of the series. They threw out some scripts that they had bought, and we were hired just because we knew all the material, as DC's liaisons and the people who made the creative commentary on any scripts that they generated." The first script Helfer and Carlin wrote together was so popular that they were called on to write a two-part sequel, thus inaugurating the format that would be responsible for some of the best Superboy stories. Their success also paved the way for other DC writers like Denny O'Neil, Cary Bates, and J. M. DeMatteis, and for the introduction of classic comics characters like Bizarro and Mr. Mxyzptlk.

In a series marked by changes, none was more radical than the replacement of the leading actor. After playing Superboy for twenty-six episodes, John Haymes Newton demanded a raise; he was replaced by Gerard Christopher. A student of Superman lore who was familiar with the performances of his predecessors, Christopher's fan background brought something extra to the show, which consistently placed among the top ten

Editor Mike Carlin created this cartoon storyboard promoting the idea of Superboy as a super spokesmodel.

syndicated programs. The part of Lex Luthor was also recast (the entertaining Sherman Howard took over), scripts continued to improve, and the effects began to rival those found in feature films. Superboy was allowed to get out of school and into the real world (Christopher was thirty-two by the time the last episode was filmed), and, despite its title, the show developed into a succession of well-crafted and authentic Superman stories. True, the hero spent his time with Lana Lang rather than Lois Lane, but the many male fans who were smitten with redhead Stacy Haiduk had no complaints.

Lois was faring considerably better in the comics, where plans were actually in the works for her to marry Superman. Nothing as earthshaking had been suggested before, not even when the ongoing saga had been revamped. In fact, it would take years to put all the pieces in place. Some commentators expressed doubts about doing anything so dramatic, since the tension between these two characters had provided plots for countless stories over the years. John Byrne was among the skeptics, but actually his plan of making Clark Kent more prominent was partly responsible for setting things in motion; ultimately the proposal that Lois accepted came not from Superman but from Clark. This story line came out of a meeting that editor Mike Carlin held with writers Jerry Ordway, Roger Stern, and Dan Jurgens to discuss the fiftieth issue of the new *Superman* comic book. Ordway was assigned to write this expanded issue, continuing a story arc in which Superman lost his powers and

Not knowing he's Superman, Lois still accepts Clark's proposal in *Superman* #50 (December 1990). Script: Jerry Ordway. Art by Jerry Ordway and Dennis Janke.

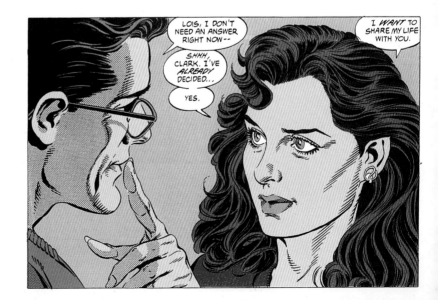

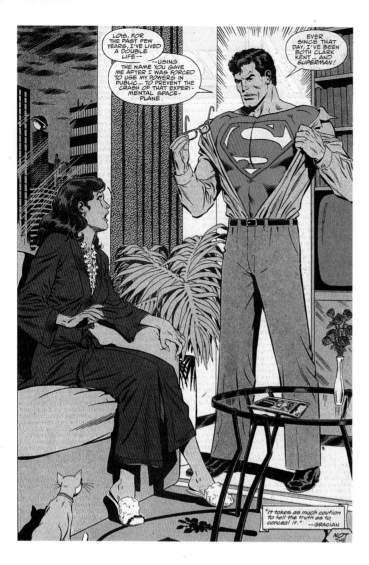

After keeping it a secret for more than half a century, Clark finally reveals his secret identity in *Action Comics* #662 (February 1991). Script: Roger Stern. Art: Bob McLeod.

then felt free to consider marriage without concern about his dual identity. The plan was for Lois to turn him down, but Ordway had a brainstorm: "What if she said yes?"

In *Superman* #50 (December 1990), readers got the answer. Over soda and tuna in Dooley's restaurant at the base of the *Daily Planet* Building, Clark popped the question. Lois stalled, and by the time she agreed, Superman had been restored to full strength in an adventure with Lex Luthor and the omnipotent imp Mr. Mxyzptlk. By the time Clark slipped the ring on Lois's finger, he had something else to say to her. It took him a few issues to let her know that he was Superman, giving readers time to suspect that the engagement might be terminated, but when he finally spilled the beans things began to look serious. Lois just had time to let her jaw

drop at the end of *Action Comics* #662 (February 1991), but there was a lengthy discussion during *Superman* #53 (March 1991), and even the cynical fans began to wonder if the impending nuptials might actually be for real. They were indeed intended to be, but a force stronger than Superman intruded.

What put Superman's marriage on hold was television. DC president Jenette Kahn had been working for years to sell the concept for a new kind of Superman program (originally to be called *Lois Lane's Daily Planet*), which would evolve into *Lois & Clark*. "The idea of the show was to focus on their relationship," she said. In 1991, the concept was sold to the ABC network through the efforts of Les Moonves, then creative head of Lorimar Television, and writer-producer Deborah Joy LeVine. *Lois &*

The Man of Steel is getting the worst of it in this deadly battle with Doomsday from *Superman* #75. Pencils: Dan Jurgens. Inks: Brett Breeding.

Clark: The New Adventures of Superman didn't air until 1993, but the mere fact of its pending existence began to have an effect on the comics. "DC's decision was that it would be a good idea to hold off the wedding and do it at the same time as the TV show, if it got that far," explained editor Mike Carlin. On the other hand, he was faced with four monthly comic books and no story line. The writers and artists had occasional Superman summit meetings to thrash out ideas, and "there was one where we literally came into it hoping to talk about the wedding with the TV people, but the show got put on hold for a while and they weren't there. We were stuck. And I do think that there was some resentment from the talent that they weren't able to do what they had planned," Carlin said. That might be the reason that, when somebody made a joke heard at

every meeting, the group finally took it seriously. They decided to kill Superman, and thus launched what proved to be the most widely discussed and publicized story in the history of the medium. "And those were the issues where we would have been getting Superman married," Carlin said.

Instead, Superman got involved in the fight of his life. In *Superman: The Man of Steel* #17 (November 1992), artist Jon Bogdanove and writer Louise Simonson introduced the antagonist Doomsday with panels showing a massive fist smashing its way out of a steel prison. Doomsday's origin and purpose remained enigmatic as he went on a rampage through issues of the various Superman comic books, until ultimately the stage had been set for the final showdown in the streets of Metropolis. *Superman* #75 (January 1993), written and illustrated by

Handwritten vertical note (right margin): NOTHING WORKS... BODY IS... ALWAYS THERE! (EXCEPT ACTION 687!)

MONTH	MAN OF STEEL # 19	SUPERMAN # 75	ADVENTURES # 498	ACTION # 685
JAN 1993	FIGHT HITS METROPOLIS	**DEATH OF SUPERMAN!**	OPEN IN CRATER... DUBBILEX PRONOUNCES SUPERMAN DEAD "HE'S GONE..."	CLARK "MISSING"... BUT SO ARE MANY IN DEBRIS OF FIGHT!
	SUPES + D.D. BATTERED.	"THREE MINUTES TO DEATH" {ALL SPLASH PAGES} F I G H T !!!!! ②	EVERYONE AFRAID OF D.O.,... IS IT DEAD? IF NOT WE GOTTA KILL IT! BODIES MOVED.	SUPERGIRL TRIES TO TAKE UP SUPES' POSITION AS HERO OF METROPOLIS... LE BACK IN CHARGE "TOO EASY." LEX HAS SUPER-GIRL BUILD HERO'S TOM
	{2 PANEL PAGES} FIGHT!!!! ①	FINALLY,.. ON THE DOORSTEP OF DAILY PLANET...SUPES MANAGES TO KILL DOOMSDAY... SUPES SLUMPS TO KNEES, HAVING SAVED METROPOLIS... HE TOO FALLS DOWN DEAD. J.O. GETS PHOTO	JIMMY GOT BEST PHOTO OF CAREER... "WHY'D IT HAVE TO BE THIS?" ③ LOIS VERY STRONG EVERYONE WEARS BLACK S-SHIELD ARMBANDS.	METROPOLIS TRIES TO RECOVER... BIBBO REACT
FEB	MAN OF STEEL # 20	SUPERMAN # 76, ⁹⁶	ADVENTURES # 499	ACTION # 686 ⁹⁶
	SUPERHERO STUDDED FUNERAL OF SUPES... AND SUPES' BURIAL ⑤	LOIS, MA + PA GO TO CLARK'S APARTMENT TO PACK UP HIS STUFF.	④ "WHO IS BURIED IN SUPES' TOMB?" ⑧	
	MA + PA NOT AT FUNERAL ...CAN'T GET BODY... GRIEF OF OUTLIVING SON! THEY "BURY" CLARK (HIS STUFF) AT SITE OF ROCKET CRASH. M+P GO TO BE WITH LOIS...STILL DOING BEST TO BE STRONG	LOIS LOSES IT! ⑥ LANA SHOWS UP,... "GRIEF ISSUE!" SET UP WESTFIELD STUFF AS SUPES'S BODY IS STOLEN FROM TOMB...FROM UNDERGROUND LOIS, LANA, M+P GO TO SUPES' TOMB ON LAST PAGE	S-GIRL CAN'T REALLY CUT IT AS METROPOLIS HERO. LEX GETS PARANOID ABOUT SUPES REALLY BEING DEAD -- "AFTER ALL I GOT AWAY WITH THIS GAG ONCE."--ORDERS SUPERGIRL TO CHECK TOMB. IT'S EMPTY. S.C.U. INVESTIGATES UNDERWORLD A POSSIBLE BODYSNATCHERS... U.W. GUY FIGH TURPIN -- TURPIN REAFFIRMED AS TOUGHEST C MA+PA BACK TO SMALLVILLE	OTH METH POLI HEA GETTA WORK OUT IN WORLD! U.W. PROVES IT AIN'T GOT SUPES' BOD!
MAR	MAN OF STEEL # 21	SUPERMAN # 77, ⁹⁶		LEGACY O' SUPERMA
	SUPES'S BODY IS IN DUBBILEX SPENDS SIGN OF LIFE! ⑨	CADMUS... AND ⑩ DAYS WAITING FOR "TWO HEART BEATS"	This chart helped editor Mike Carlin and the creators of four comic books stay on track during the death of Superman story line.	5 ELEVEN PAGE STORIE 1 - GUARDIAN + N-BOY. 2 - ROSE & THORN 3 - SINBAD 4 - GANGBUSTER 5 - LINEAR MEN!
	IN SMALLVILLE PA KENT'S BEEN NEGLECTING FARM DUTIES... MA TELLS HIM LIFE GOES ON... SHE'S BEING OPTIMISTIC ... AN ARGUMENT ENSUES AND PA KENT HAS A HEART ATTACK! PEOPLE CAPITALIZE ON SUPES DEATH SUPERMAN IS STILL DEAD!!!!	MXY COMES TO EARTH... BUT SUPERGIRL DOESN'T GET IT... MXY LEAVES NO FUN WITHOUT SUPEY MONGUL ARRIVES ON EARTH... SPITS ON GRAVE. LEAVES... (TO FORTRESS) PA KENT'S HEART IS STOPPING ...GHOST OF SUPERMAN APPEARS.		DOUBLE-SIZED ISSUE!

AD: WHERE WERE YOU WHEN SUPERMAN DIED?

BLACK ARM BANDS ON ALL DC CHARACTERS

DATE REVISED 9-16-92

Dan Jurgens, used full-page panels to show the blistering battle that ended with both Superman and Doomsday deceased, but by the time the issue appeared in stores, the death of Superman was already national news.

Cynics suggested that Superman's demise was devised as a publicity stunt, but DC executives insisted the firestorm caught them by surprise. "Characters die every day in comics. This is old news to us. If it had been a new idea, I would have been worried about it, but this really is one of our cliché stories," said Mike Carlin. Countless comic book covers over the years have proclaimed that the hero's doom was impending, and fans have learned to be skeptical. Yet to the mainstream press,

whose reporters perhaps didn't realize that modern comics told stories over many months, an issue that ended with the Man of Steel dead meant that he intended to stay that way. "The real newspapers started getting hold of the story and actually believing it," Carlin recalled. "We were stunned. I can't believe that people went for it as hard as they did."

"We clearly had some magic in a couple of things," said DC president Jenette Kahn. One was the peaking market for comics as collector's items, which generated a lot of sales for what looked like a landmark issue. The gullibility of the press helped too, but perhaps the key factor was the goodwill that Superman had built up over the years. When people heard that he might be gone for good, they

flocked to see the end of the story. *Superman* #75 was reprinted again and again, and when the smoke cleared it had sold a staggering 6 million copies. "Once it started to happen, there was not a single person here at DC who did not pitch in on this and make it an amazing year," Kahn said. "I think it's a piece of history."

"There is no way that anybody could plan what happened. All we could do was try to keep up with it, and that's what we did," Mike Carlin said. "For a long time the sales on the books were up over a million, week after week, for months." He was most proud of eight issues devoted to the funeral, which showed Superman's supporting cast (and the rest of the DC Universe) in mourning, with the title character still resolutely gone. "We thought that was the most daring part of our whole plan." Meanwhile, the Superman staff met to concoct a more elaborate version of their hero's resurrection than what had been originally intended.

Each creative team on the four comic books had ideas for new characters who might plausibly become replacements for Superman, and ultimately it was decided that all of them should have their chance. "It was a kind of freedom for guys who have to collaborate all the time, to actually have a couple of months where they could call the shots," admitted Carlin. At the climax of the story arc, in *Superman* #82 (October 1993), the cyborg Man of Tomorrow was revealed as a villain, and the mysterious Last Son of Krypton proved true to his name, sacrificing himself to bring Superman triumphantly back to life. It's a tribute to the strength of these stories that the other two substitute Supermen both went on to get their own comic books. The armor-plated African-American John Henry Irons made the grade with *Steel* #1 (February 1994), while the teenage clone got an old name to balance his new attitude in *Superboy* #1 (February 1994). "I'm really proud of what we were able to pull off," Carlin said. "We came up with a lot of good stuff. I don't think we're ever going to top the death of Superman."

SUPERMAN IS BACK

BUT IS ANY OF THEM THE REAL MAN OF STEEL?

REIGN OF THE SUPERMEN!

ACTION COMICS. #687 — MAN OF STEEL #22 — SUPERMAN #78 — ADVENTURES OF SUPERMAN #501

172

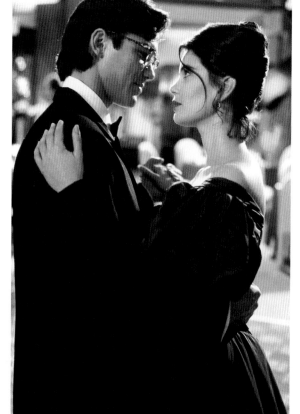

Dancing and romancing with the stars of *Lois & Clark: The New Adventures of Superman.*

Lois & Clark, the television program that inadvertently inspired DC's top seller of all time, made its debut on September 12, 1993. The ABC network embarked on a massive publicity campaign, and its centerpiece was a poster showing the title characters in a scantily clad embrace. Only a tattoo of the famous Superman logo on Clark's arm served to identify the pair. They looked very young, very modern, and very hot, which seemed designed to counteract the opinion that, after more than half a century, Superman could be out of date.

The notion that Superman might belong to a past generation, that he might indeed be dead and buried, was bandied about by commentators as *Lois & Clark* made its first appearance against stiff Sunday night competition. On CBS was *Murder, She Wrote,* an established hit with solid appeal for older viewers. Opening up on NBC was *seaQuest DSV,* a science fiction show presented by superstar director Steven Spielberg, the most successful filmmaker in Hollywood history. Conventional wisdom held that NBC's Spielberg would grab the kids, CBS's traditional mystery would keep their parents, and ABC's Superman would soon be history. And for a while, that's how things played out. The first time the

shows went head-to-head, *Lois & Clark* had only half the audience of *seaQuest DSV.* A few weeks later, when the novelty had worn off, *Murder, She Wrote* was trouncing both of the new shows. Yet something surprising happened as the months went by: *Lois & Clark* was picking up viewers while *seaQuest* was losing them. The trend continued, and Superman finally proved to be a powerhouse, driving both competing shows into different time slots as networks scrambled to defeat something that now seemed invulnerable.

What happened? For one thing, the mass audience was not expecting the changes that the comics had introduced years earlier. Gone was the old wimpy Clark Kent, who chose to hide all his best qualities, and gone was the old lovelorn Lois Lane, obsessed with an alien and conniving to outsmart him. Instead, the TV series presented two smart, sexy people who weren't interested in secrets and were obviously going to jump on each other just as soon as they got through with the fun of fencing. There were still fight scenes, but now it was likely to be Lois beating up the bad guys; there were still flight scenes, but now they weren't as erotic as the dialogue. Jerry Siegel's idea that unprepossessing people could have hidden depths

Look! Up In The Sky!

On the set of the TV show, Mike Carlin spots something, and it's not a plane.

Dean Cain as Superman strikes the
official and obligatory pose.

173

was pretty much abandoned, but in an age of instant gratification nobody seemed to miss it. *Lois & Clark* was mainly about gorgeous people getting it on, but at least it had a sense of humor.

Casting was key, as it is in most television shows where the audience tunes in week after week to spend time with the stars. Neither lead had made much of an impact before, but Teri Hatcher and Dean Cain turned out to be perfect for their parts. "*Lois & Clark* is really more about Lois than Clark," suggested *TV Guide,* and the sentiment would no doubt have been echoed by tens of thousands of teenage boys downloading pictures of Teri Hatcher on their computers, earning her the title of "Queen of the Internet." Previously best known for an appearance on Superman fan Jerry Seinfeld's hit sitcom as a woman whose spectacular breasts were the subject of endless speculation, Teri Hatcher turned out to have a light touch that sparked the *Lois & Clark* trend toward romantic comedy. Dean Cain, a Princeton graduate headed for a pro football career before an injury sidelined him, was interested in writing and turned to acting only to gain access to

Hollywood, but his rugged good looks and earnest demeanor earned him plenty of fans. "The producers thought I was too young at first," he said, "but they changed their minds." In fact, it was an unexpected audience of young women, the favorite demographic of sponsors everywhere, that put *Lois & Clark* over the top.

Given the amorous ambience of the program, it seemed only a matter of time before matrimony struck, but in fact a few years elapsed. The second season was specifically designed to add more action, science fiction, and special effects to the mix, yet nonetheless ended up with Clark proposing. Events that postponed the nuptials in subsequent shows ranged from Lois getting amnesia to Lois getting cloned and Lois becoming the masked Ultra Woman. The wedding finally took place in October 1996, in an episode entitled "Swear to God, This Time We're Not Kidding." Actually, there was plenty of kidding, in an episode written by John McNamara that jumped jarringly back and forth from spoof to sentiment. As the happy day approached, a maniac known as Myrtle Beach, "The Wedding Destroyer"

Teri Hatcher as Lois seems to be all wrapped up in her work.

More than half a million copies of *Superman: Deadly Legacy* (1996) were produced by DC Comics, printed in Serbo-Croatian by the U.S. government, and distributed by NATO to warn children about land mines. Cover by Kieron Dwyer and José Luis García-López.

ning to jilt her when he was killed. Logically this should have been even more annoying, but somehow Myrtle was mollified and surrendered her weapon. At which point the entire cast was magically whisked into the countryside by a creepy little man (David Doyle) who had been popping up throughout the episode in various guises, mouthing cheerful clichés. Declaring himself to be everybody's guardian angel, he proceeded to marry the pair, "to help you both get what you have wanted for so long." The deed was done at last, and Clark announced "This is when our lives really start," but he was wrong.

TV weddings are often viewed as desperate attempts to boost the ratings of shows on their last legs, and as such they sometimes seem to be the kiss of death. *Lois & Clark* had been intended from the start to build toward marriage, yet still stumbled and fell; it didn't outlast the season that had started with vows about eternity. The honeymoon episode demonstrated how wrong things could go, as H. G. Wells showed up in a time machine to warn the couple that they couldn't consummate the marriage until they had traveled back through the centuries to rearrange the lives of their past incarnations and thus avoid a curse. The ensuing hour saw Clark deprived of his powers and doing imitations of Robin Hood and the Lone Ranger; it was all pretty silly, and about the only time Superman did his stuff was while running errands for his wife. There was a cute bit at the end

(Delta Burke), escaped and vowed to take "revenge of operatic proportions" against the pair of *Daily Planet* reporters who had put her away. Her madness had been caused when her fiancé was killed in a crash on their wedding day, and her plans included a substitute wedding ring that could electrocute Lois by remote control. While Jimmy Olsen played "The Wedding March" on the organ and Lois lay writhing in the aisle surrounded by blue sparks, Clark patiently explained to Myrtle that in fact her impending groom had actually been plan-

about the couple levitating as they finally made love, but the series settled into domesticity; once the sexual tension was gone nobody felt obliged to watch.

Self-portrait of Joey Cavalieri, Superman's latest editor.

• • •

Connubial bliss in the comic books proved to be a different matter. Comics characters from Blondie to Dick Tracy have survived their weddings, which are often postponed for so many years that they seem almost obligatory. After more than half a century, the comic book Lois and Clark were certainly ready. And in marked contrast to the TV version, the wedding that DC arranged was a comparatively dignified affair, with no lunatics disrupting the proceedings and no divine intervention at the last minute. Many notable characters made their appearance in the ninety-six-page *Superman: The Wedding Album* (December 1996), but even perennial menaces like Lex Luthor and Mr. Mxyzptlk were willing to keep out of mischief on the happy day. Comics may have a reputation for melodrama, but on this occasion DC sensibly decided that no aspect of the story could, or should, be more impressive than the marriage itself.

Putting together the wedding issue was the responsibility of Joey Cavalieri, who became Superman editor after Mike Carlin was promoted to the post of executive editor for the entire DC Universe. When it was revealed to Cavalieri that the leads on the TV show were about to take the plunge, he and the Superman writers had to scramble to get their version of the tale told simultaneously. "There were original plans that were put on hold before I got here," Cavalieri said. "We just sort of resuscitated that story line and did it in the space of a month instead of a year." One way of achieving speed while pleasing the fans was to produce an all-star wedding issue employing the talents of five writers (Dan Jurgens, Karl Kesel, David Michelinie, Louise Simonson, Roger Stern) and thirty artists, including current chroniclers Ron Frenz and Tom Grummett, along with past masters Curt Swan and Al Plastino.

Although the timing was coordinated with *Lois & Clark*, Cavalieri noted that the show was "meant for a different demographic than the comics are," and consequently "by no means were they the same

stories." In fact, some of the original momentum for the marriage had dissipated at DC, which had postponed its original plans to accommodate the TV series, then had to rush to catch up. "If you polled all the writers," said Cavalieri, "I think they would give you very different answers. I don't know that a lot of the same people who were pushing to get them married, if they had that decision to make over, would do it again." A bit of symbolism emphasized the point: Superman had come back from the dead with his hair longer than ever, but he trimmed it for his wedding day. Since he was at that point bereft of his powers (as he had been years before when he proposed), his condition might have suggested the biblical tale of Samson shorn of his strength.

Something much more certain is that Cavalieri doesn't miss the old plots about Lois trying to expose Superman's secret. "I could slam the door on those types of stories forever. I think it always tended to make Lois a jerk. At least now she is center stage and sharing her life with Superman," he said. "She is the intrepid, brave reporter you always hoped she would be, and with a weekly comic book we can give her attention without pulling the spotlight away from Superman." Of course there are still some readers who feel sure that the marriage won't last. As Cavalieri says, "I can't walk into a comic book store where they know me without having someone come up to me and say, 'So when are you guys killing Lois?' But I can promise you that won't be happening."

• • •

Meanwhile, just to keep everybody guessing, yet another television series showed up, and in this one Superman stayed single. What's more, it began in October 1996, at the same time when both *Lois & Clark* and the comics were busy tying the knot. The new show was a half-hour animated program, and like many new Superman sightings, it owed its existence at least in part to other activity in the Warner entertainment empire. In 1992, the Warner Bros. animation studio had presented *Batman: The Animated Series,* a new and creative approach to super hero cartoons whose high quality had won it large audiences and also Emmy awards. Following up with a similar stab at Superman was common sense, but it didn't prove to be a simple matter. As Paul Dini, writer and producer for both shows, put it, "Superman's a different hero with a different set of rules. Even though Superman and Batman are from the same universe, they are really from two different worlds."

Superman made an ambitious debut with a fea-

THE STEEL SHAQUILLE O'NEAL

Since only the most famous comic book characters have traditionally made the transition from the printed page to the silver screen, the emergence of *Steel* as a 1997 film was something of a surprise. After all, the character had first been created by writer Louise Simonson and artist Jon Bogdanove to serve as one of four substitute Supermen during the original hero's apparent death, and he had been appearing in his own comic book for a mere three years. However, the popular Los Angeles Lakers star Shaquille O'Neal was a fan of the series. When he expressed his enthusiasm to producer Quincy Jones, the motion picture project quickly got a green light.

"Without basketball, none of this would happen," admitted O'Neal, who was on his third film. His popularity, imposing stature, and apparent good nature were not enough to carry *Steel*, which opened to bad reviews and modest business. However, younger viewers may respond to this naïve narrative with its oversize armor-clad hero, or even find positive social messages in the supporting characters: a decent young boy, a feisty grandmother, and a pretty scientist in a wheelchair. The only reference to Superman is the familiar shield tattooed on O'Neal's massive arm, along with the words *Man of Steel.*

ture-length segment called "Superman: The Last Son of Krypton" (not to be confused with the mysterious pseudo-Superman from the comics). Close to half the film was devoted to an elaborate retelling of Superman's origin—perhaps this was a mistake since the story had been told too often to be really interesting. Things improved after the adult Superman was established and could devote himself to some solid action against Luthor's robots; a scene of a plane careening out of control among the skyscrapers of Metropolis was outstanding animation.

Dini, who cowrote and coproduced this opening show, admits that writing for *Superman* is tricky. "It's very easy to fall into the trap of making Clark Kent really blasé, and then have Superman become this boy scout who shows up to save the day." A traditionalist, Dini admits that "my favorite version of Superman is still the George Reeves show. It's so fun and charming, and it was the very first Superman I saw as a kid." Some of that show's directness has spilled over into the cartoons, alongside the banter between Lois and Clark, but animation is perhaps best suited to the kind of big menaces that the old Reeves show could hardly attempt, as in shows spotlighting the cyborg Metallo or the life-draining Parasite. The latter episode features a wonderful bit when Kent strips to reveal his Superman suit and that characteristic curl automatically unfurls to fall over his forehead. With ingenious scripts, imaginative animation, impassioned music, and impressive vocal talent (Tim Daly plays Superman, Dana Delany plays Lois Lane), this animated *Superman* is the best thing of its kind on TV beside its compatriot *Batman*. Still, Dini admits "grudgingly" that the work of half a century ago has yet to be surpassed: "The Fleischer cartoons are still the best animated version of the character."

The cartoons inspired yet another Superman comic book, *Superman Adventures,* with art by Rick Burchett and Terry Austin. Dini wrote the first issue, then turned it over for the next year to Scott McCloud, whose trenchant analysis *Understanding*

Comics (1993) is one of the most important studies of the medium. With its clear, cartoonish art, and its concise stories usually complete in one issue, *Superman Adventures* represents a return to the simpler comics of an earlier day. Edited by Mike McAvennie, it serves as an entry-level comic for new recruits, and also a nostalgic treat for older fans.

At the opposite end of the spectrum, the mainstream Superman comics embarked on a long and complex story arc that would keep readers guessing for an entire year. As a result of strenuous efforts to regain his powers, Superman began to undergo a transformation in *The Adventures of Superman* #545 (April 1997). He was turning into a being of pure electrical energy, and to prevent his disintegration, scientists created a high-tech containment suit to hold him together in *Superman* #123 (May 1997). "When you make a big change in a character, people need to recognize that a big change has been made," said writer Louise Simonson. "That was part of the reason for coming up with the idea to change the costume." A new, blue-and-white one-piece outfit, sans cape and surrounded by crackling bolts of electricity, left no doubt that Superman was not the same. "I think it was the aim of the writers to make life tough for Superman again. There's something really charming about the time when a super hero first gets his powers, and is unfamiliar with them and has to learn how to use them," said editor Joey Cavalieri. "There's a tremendous amount of very human story potential there."

Superman was now able to move at the speed of light, pass through solid objects, and

"TITLE SEQUENCE"

PAN
BG

BG

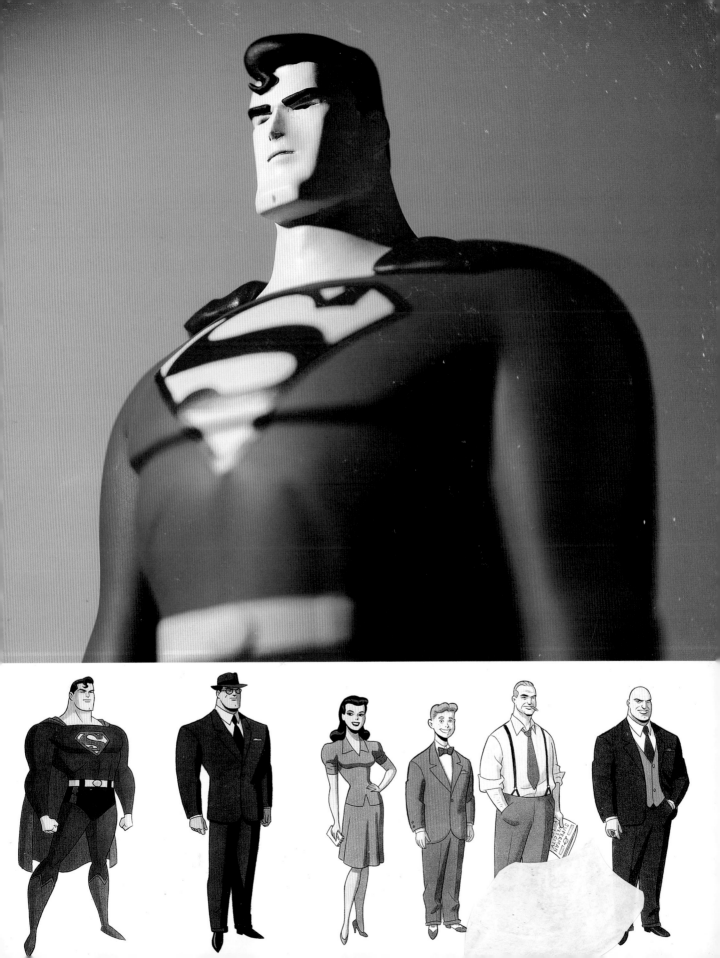

EXT. METROPOLIS CITY Day
WB 09 (DOWN SHOT) Final DASKAS

Final 407.
12-21-95

BG-C59

OL-C59

JOR-EL'S HOUSE — ROCKET LAB — NIGHT

JOR-EL'S HOUSE — ROCKET LAB (OL)

407-001

407-001

> IN OUR **ABSENCE**, A **NEW BREED** OF **METAHUMANS** HAS ARISEN ... A **VAST PHALANX** OF SELF-STYLED "HEROES" **UNWILLING** TO PRESERVE **LIFE** OR DEFEND THE **DEFENSE-LESS** ...

> ... A **LEGION** OF **VIGILANTES** WHO HAVE **PERVERTED** THEIR GREAT POWERS ... WHO HAVE **FORSWORN** THE RE-SPONSIBILITIES **DUE** THEM.

ARMAGEDDON: READY FOR THE BIG ONE

Decades ago, DC began publishing "imaginary stories" in which Superman's life would take dramatic turns, and the concept has recently been institutionalized with a number of special projects published under the "Elseworlds" banner. The most popular and highly praised of these has proven to be *Kingdom Come* (1996), a four-issue miniseries in which all the panels are paintings. The concept originated with artist Alex Ross, who described it as "the last stand of the super heroes." As ultimately developed in collaboration with writer Mark Waid, the story was set in a future where characters like Superman and Batman have retired and been replaced with a new breed of nihilistic heroes whose recklessness is threatening the world. A grim, aging Superman ultimately returns to fight an apocalyptic battle that Ross acknowledges is "a metaphor for today's comic market and how the current, more violent, flashy super heroes have changed the playing field." It is also an epic adventure story involving virtually every super hero DC has ever published, and the art took Ross almost two years to produce.

"Superman as an older man is something we've never really dealt with in depth," said Waid, but the original super hero became the moral compass for the story, and his values were something that *Kingdom Come* was designed to reaffirm. "Alex and I are both devotees of real heroes," said Waid. "Heroes who don't kill, heroes who do things to save people, heroes who work for the common good."

let bullets shoot through him harmlessly. Through sheer willpower he could condense himself down into the solid form of Clark Kent, but in that state he had no special strengths and was vulnerable to everything from bombs to bruises. Writer Karl Kesel was behind the idea of the new powers, while writer/artist Dan Jurgens was pushing for a different costume design; the fusion of their interests kicked off the story line, which was intended to run indefinitely. And just when the hero and his fans were growing accustomed to the changes, the new Superman split in two, creating a red Superman to join the blue, and leaving Lois Lane

Painter Alex Ross sculpted this metallic, monochromatic version of the world-weary Superman who appeared in the comic book series *Kingdom Come*.

caught in a strange sort of comic book bigamy. "It certainly enforces that eternal triangle, doesn't it?" asked Cavalieri. "Having completely enraged everyone over changing the classic Superman costume and losing that cape for a little while, this was our way of saying we aren't ready to go back yet. In fact, there's another way we're going to make your life miserable."

The idea for the twin Supermen came from an unlikely source, longtime colorist Glenn Whitmore. At every planning meeting of the Superman staff, Whitmore would recall a favorite story from the Silver Age and ask, "Why don't we do Superman Red and Superman Blue?" This was perennially dismissed as the whim of a colorist until, at a meeting Whitmore wasn't able to attend, everyone suddenly decided it was a great idea. "The Blue was more solemn, more sober, more serious. The Red was more flip, more fun-loving," said Cavalieri, but neither was intended to be the "real" Superman at the expense of the other. "We tried to split him right down the center." The two made their debut in a special *Superman Red Superman Blue* #1 (February 1998), with a red-and-blue 3-D cover and contribu-

Top: The new costume on the left helped control Superman's new powers during a long story arc. Pencils by Stuart Immonen and inks by Jose Marzan Jr. Superman then split into red and blue versions, as he had decades ago, producing the matching cover on the right by Jon Bogdanove and Dennis Janke.

Canada honored Joe Shuster, native son and co-creator of Superman, with a 1995 postage stamp, while the United States Postal Service commemorated Superman with a first class stamp in 1998.

Superman Arrives 1938

32 USA

tions from most of the Superman staff.

For a few weeks the two Supermen were having their own adventures, but they eventually joined forces, along with other DC heroes, to defeat the apocalyptic power of the Millennium Giants. "It's the culmination of a very elaborate and spectacular story line," explained Cavalieri. "The only way the two Supermen can keep the Earth together is by releasing their energy, by being willing to make that final sacrifice." And from the ensuing cataclysm the original Superman emerges, battered but intact. The Kents are there to make him a copy of his old costume, and Superman returns, in time for his sixtieth anniversary, in *Superman Forever,* a ninety-six-page special dated June 1998, sixty years after his debut in *Action Comics* #1. The spectacular cover, featuring seven images in lenticular animation, is by painter Alex Ross.

Opposite: The one and only Superman returns. Script by Louise Simonson. Art by Jon Bogdanove and Dennis Janke.

SUPERMAN'S PAL, JERRY SEINFELD

"He idolizes me. It's embarrassing." So said an animated Superman about Jerry Seinfeld, his costar in a 1998 TV commercial that aired during NFL playoffs and the Super Bowl. Viewers of Seinfeld's hit comedy series know that it was full of verbal and visual references to the Man of Steel, yet the pair had never appeared together until Seinfeld requested his hero's presence in one of the ads he was preparing to do for American Express. Seinfeld requested that Superman be drawn in the style of comic book artist Curt Swan, and he also suggested an appearance by Jack Larson, the actor who had played Superman's other pal, Jimmy Olsen, in the 1950s television series.

In the resulting sixty-second spot, prepared for the Ogilvy & Mather agency by copywriter Chris Mitton and art director David Laden, Seinfeld and Superman are called on to rescue Lois Lane, who's trying to buy groceries but has gone out without any cash. Superman looks down at his costume in dismay and announces, "I can't carry money in this. I'm powerless!" Seinfeld saves the day with his American Express card, but demurs when a huge shadow passing over bystander Larson indicates that a comet is hurtling toward Earth. "I think you'd better handle this one," says Seinfeld to his pal.

Among forthcoming Superman events is writer/artist Barry Windsor-Smith's large-format book, *An Evening with Superman*, an account of the hero's first meeting with Lois Lane. "It's a love story," says Windsor-Smith, "told in a way that will appeal to all readers, not only to comics fans. I'm excited to be undertaking a sophisticated exploration of a pivotal event in the history of America's most enduring icon."

Superman may be sixty, but he's clearly not approaching
retirement. He has more comics bearing his name than
ever before, he has his own TV show, and a new feature film is in
the works. The director will be Tim Burton, the filmmaker behind two
Batman blockbusters, and he promises to bring his own perspective to the
Man of Steel. "You strip away everything, all the surface things, and what you
have is a man from another planet who's unlike anybody else on Earth," he said.
This suggests Burton will be working against the characterization employed in the last
dozen years of comics, yet at the same time the script is reportedly based on the comics
stories about the death of Superman. That makes sense, for Burton is a cartoonist himself,
and no doubt recognizes that, even in an age of multiple media adaptations and multi-
million-dollar budgets, Superman will always retain his roots in the comic books.
"I remember very much what it was like to buy these books," says Joey
Cavalieri. "I know how kids think about Superman. I know how they
project themselves into the character. That's a real trust, and you try
not to betray that trust." It means staying in touch with a myth
that has endured for generations, one that began with a
couple of kids in Cleveland and now has traveled
around the world. It's a bizarre story, about
a strange visitor from another world,
but at its heart it's a very human
story too, about the dream
of having power, and
the hope of
knowing
love.

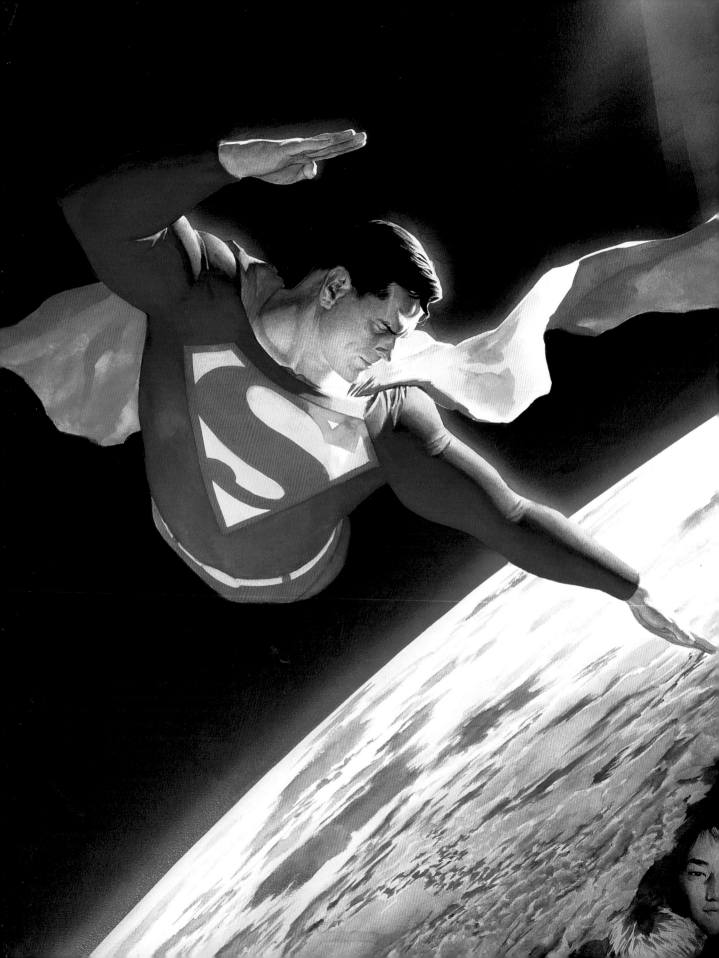

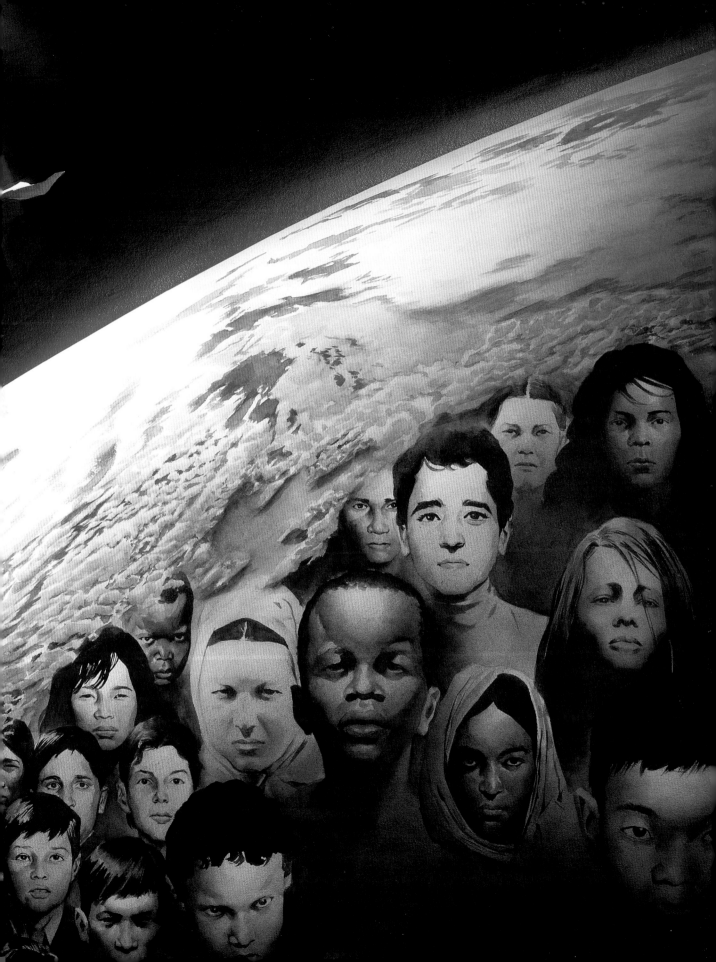

ACKNOWLEDGMENTS

This book includes the work of many people, notably my inde-
fatigable editor, Steve Korté, who threw himself into the project
with enthusiasm and humor, and came up with some invaluable
discoveries. Chip Kidd made Superman look new again through
his handsome design concepts, and worked with photographer
Geoff Spear to create the many striking images of Superman
artifacts, old and new. Chin-Yee Lai provided expert design
assistance, Chris Ware offered typographical tips, and Alex Ross
produced the beautiful cover paintings (look under the jacket).
Marc Witz carefully shot some rare old comics.

Many contributors to the Superman saga provided quota-
tions and interviews; it's especially gratifying to present pre-
viously unpublished insights from Joe Shuster, Jerry Siegel, and
Joanne Siegel. Profound thanks also to John Byrne, Mike Carlin,
Joey Cavalieri, Paul Dini, Jenette Kahn, Jack Liebowitz, Noel
Neill, Dennis O'Neil, Julius Schwartz, Vin Sullivan, and Curt
Swan. Paul Levitz and Mark Waid not only offered their obser-
vations but kindly reviewed the manuscript as well.

An army of connoisseurs and collectors gave us generous access to their knowledge and their pos-
sessions. Allan Asherman, DC librarian and an expert in his own right, proved an invaluable advisor.
Thanks to Danny Fuchs for his remarkable treasure trove, to Jim Hambrick of the Super Museum in
Metropolis, Illinois, to Christopher Reeve aficionado Jim Bowers, and to Stephen Fishler at Metropolis
Collectibles. Further gratitude is extended to Jack Adler (rare photos), Anthony Tollin (pulps and radio),
Chuck Harter and Jim Nolt (early Kryptonian television), David Shayt (the Smithsonian), Eric Alberta and
Dana Hawkes and Jerry Weist (Sotheby's), Grant Geissman and Fred von Bernewitz and Ted. E. White
(for Gaines family info), and Gary M. Carter of *Comic Book Marketplace*. More tips of the hat go to Mike
Chandley, Ray Kelly, Margery Peters, Rick Roe, and Rob Yeremian, not to mention the bottomless pit
known as the Mad Peck Studio Archives. Thanks to Barry Windsor-Smith for providing a preview of a work
in progress.

In Superman's birthplace, Cleveland, investigations were aided and abetted by Mike Sangiacomo of
the *Cleveland Plain-Dealer,* Carolyn Johnson and Gail Turoso-Hummer of Glenville High School, and Dean
Zimmerman. And thanks to Henry Mietkiewicz of the *Toronto Star.*

More gratitude goes to Bruce Timm, Jenny Lynn Burnett, and Thomas Zellers at Warner Bros.
Animation, and to David Stapf and Caroline Ashasian at Warner Bros. TV.

At Chronicle Books, credit should go to Sarah Malarkey and Mikyla Bruder in editorial, and to Michael
Carabetta and Julia Flagg in design. And thanks to Merrilee Heifetz and Tracey Schatvet at Writers House
for amazing agenting.

And at DC, for efforts above and beyond the call of duty, salutes are due to Syndee Barwick, Ed Bolkus,
Dana Brass, Georg Brewer, Marc Campbell, Dale Crain, Dorothy Crouch, Chantal d'Aulnis, Marilyn
Drucker, Trent Duffy, Chris Eades, Annie Gaines, Bob Greenberger, Patty Jeres, Alyssa Kaplan, Charles
Kochman, Jay Kogan, Lillian Laserson, Brenda Manzanedo, Rich Markow, Eddie Ortiz, Sandy Resnick,
Bob Rozakis, Cheryl Rubin, David Tanguay, and Elisabeth Vincentelli.

And finally, this book is dedicated to NJ, who is super too.

Overleaf: Painting by Alex Ross for *Superman:*
Peace on Earth (October 1998).

INDEX